The story of Chicago and of America can be found in the history of the city's district court.

It is the story of do-gooders, scamps, geniuses, fools, and visionaries.

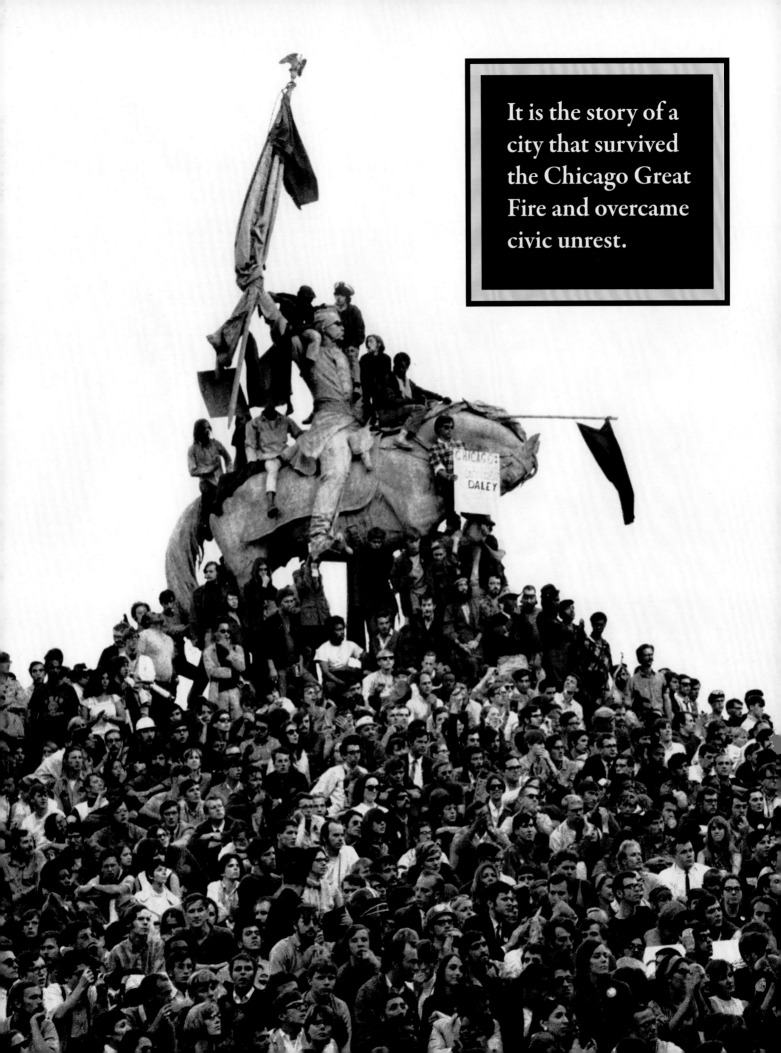

It is the story of a city that survived the Chicago Great Fire and overcame civic unrest.

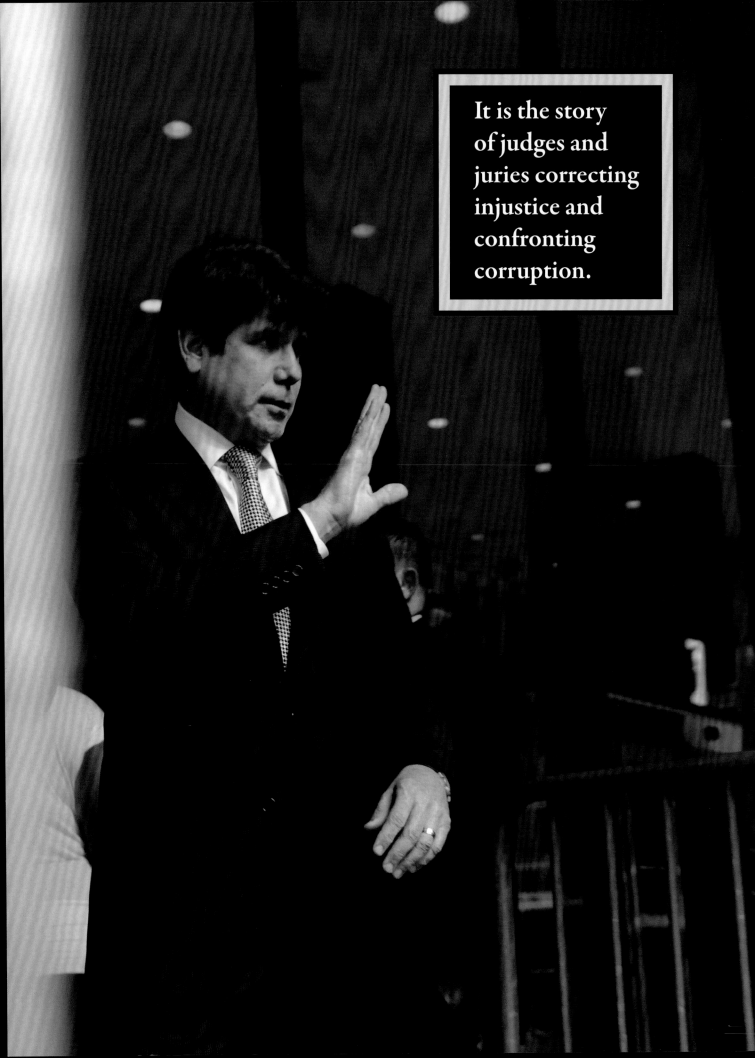

It is the story of judges and juries correcting injustice and confronting corruption.

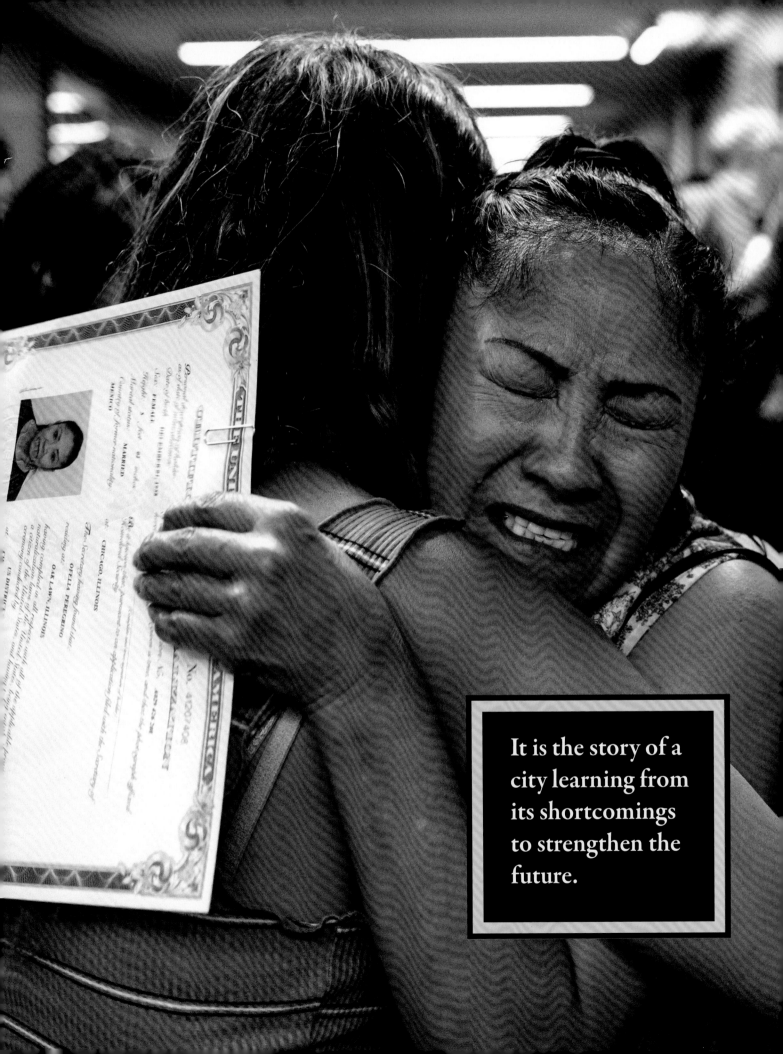

It is the story of a city learning from its shortcomings to strengthen the future.

CHICAGO
RULES

FEDERAL CASES THAT DEFINED THE CITY AND THE NATION

RICHARD CAHAN
MARK JACOB
MICHAEL WILLIAMS

FEATURING PHOTOGRAPHS
AND DOCUMENTS FROM THE
CHICAGO SUN-TIMES NATIONAL ARCHIVES

FOREWORD BY
REBECCA R. PALLMEYER

INTRODUCTION BY
SCOTT TUROW

CITYFILES PRESS
CHICAGO

BRONZE EAGLE FROM
THE OLD CHICAGO
FEDERAL BUILDING
BUILT IN 1905.

CONTENTS

JUDGES' GAVEL IN THE JAMES BENTON
PARSONS CEREMONIAL COURTROOM.

All rights reserved. No part of this publi-
cation may be reproduced or transmitted
in any form or by any means, electronic
or mechanical, including photocopy,
recording, or any information or storage
retrieval system, without permission of
the publisher.

Published by CityFiles Press,
Chicago, Illinois

Produced and designed by
Michael Williams

ISBN: 978-0991541898

First Edition

Printed in China

Cover and endsheets: From the earliest
surviving District Court docket book,
which dates back to the 1871 Great
Chicago Fire.

Photographs and illustrations
copyright © Chicago Sun-Times, James
Caulfield, Ron Gordon, Verna Sadock,
Bill Healy, and Mark Ballogg.

The views, thoughts, and opinions ex-
pressed in the text belong solely to the
authors, and do not reflect the opinions
or views of the U.S. District Court for the
Northern District of Illinois.

Brief sections of this book appeared in
the 2002 Northwestern University book
A Court That Shaped America by
Richard Cahan.

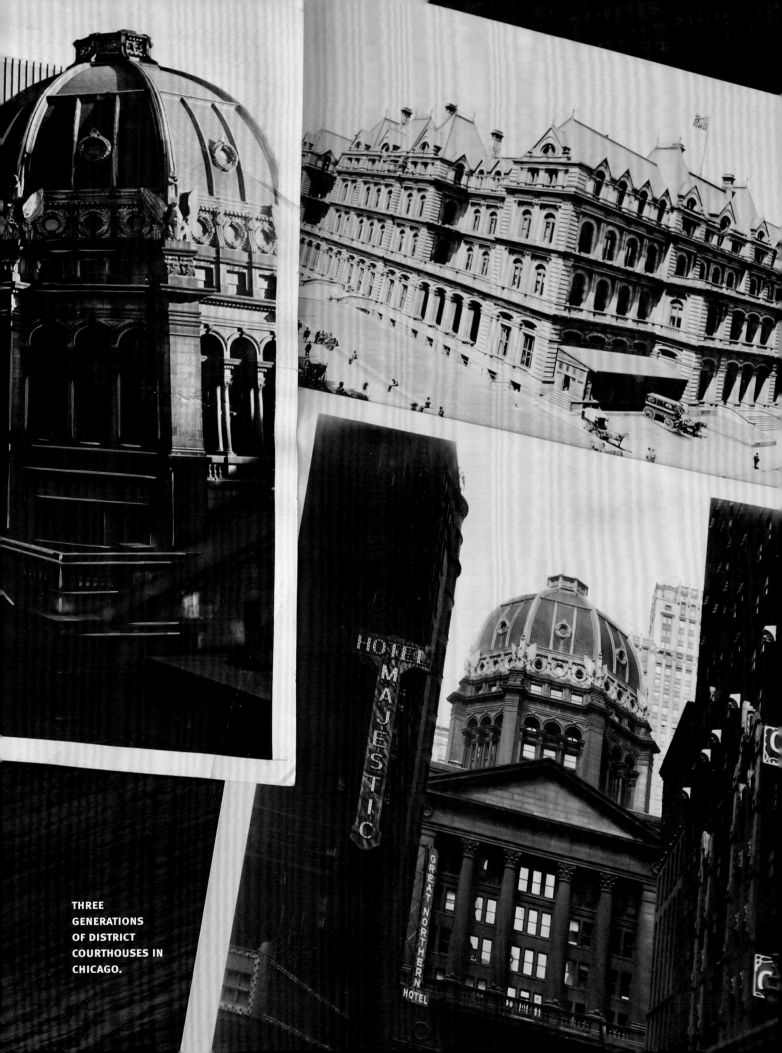

THREE
GENERATIONS
OF DISTRICT
COURTHOUSES IN
CHICAGO.

ACKNOWLEDGMENTS

The authors would like to thank Chief Judge Rebecca R. Pallmeyer and former Chief Judge Rubén Castillo for embracing history in this 200th anniversary year of the United States District Court for the Northern District of Illinois. This book actually began in 2001 when former Chief Judge Marvin Aspen asked us to gather the court's history. The result was the book *A Court That Shaped America.* This new book is an update and a new look at that history—relying on photographs and illustrations to show how the court defined Chicago and Northern Illinois.

To set the court in perspective, we relied on author-attorney Scott Turow, who loves the court as much as anyone.

To put this book together, we depended on the photo archives of the *Chicago Sun-Times* and were helped by Chris Fusco, Jon Rosenblatt, and Toby Roberts. We were also assisted by staff members of the National Archives in Chicago who ferreted out court documents that tell this story. Most helpful were Douglas Bicknese, Glenn Longacre, Leo Belleville, Sarah Kreydich, Elise Fariello, Jeremy Farmer, Betty Furimsky, and Lorraine Bates. Thanks also go to Pat Duffy, a volunteer who has organized and preserved decades of eighteenth-century cases.

Also helping us on our search was George Bathje, of the Rock Island County Historical Society, who tracked down and photographed the oil painting of the *Effie Afton* on the Mississippi River, as well as photographers James Caulfield, Bill Healy, and Ron Gordon, who provided photographs, and Verna Sadock, who let us use one of her superb courtroom sketches.

Seventh Circuit Librarian Gretchen Van Dam and her staff provided research support and Thomas Bruton provided administrative support.

We were also assisted by District Court Judges Sharon Johnson Coleman, Thomas Durkin, Sara Ellis, Ronald Guzman, Virginia Kendall, John Lee, Joan Lefkow, Philip Reinhard, and Manish Shah, as well as Magistrate Judge Sunil Harjani. District Judge William

A COURT REPORTER'S STENOGRAPH MACHINE, NOW IN THE NORTHERN DISTRICT OF ILLINOIS COURT HISTORY MUSEUM.

Hart, founder of the Court Historical Association, was the first to recognize the importance of the court's history.

Present and former court staff members who lent us a hand include Jeffrey Allsteadt, Larry Collins, Julie Hodek, Daniel Lehmann, Susan Kelly Lenburg, Vina-Gail Springer, Linda Surprenant, and Lauren Thiel, as well as court fans Felice Batlan, Steven Garmisa, Martin Sinclair, and Gary Wente.

This manuscript was overseen by Caleb Burroughs.

No account of the court's past could be accomplished without the work of newspaper reporters who provide daily accounts of what happens in the District Court. We were made to look smart by the work of reporters from the *Chicago Tribune, Chicago Sun-Times,* and *Daily Law Bulletin.* Long live journalists, who are the original historians of every age.

FOREWORD

Rebecca R. Pallmeyer

Chief Judge
United States District Court
for the Northern District of Illinois

On March 3, 1819, President James Monroe appointed Nathaniel Pope as the first federal judge in the new state of Illinois. From that day forward, men and—more recently—women have devoted their efforts to administering justice in this court. This book brings those efforts to life in words and images. In the events described in these pages, we see the forces and conflicts that shaped our state's history: railroads, steamboats, waves of immigrants, the Great Migration, labor unrest, civil rights disputes, public corruption charges, and so much more. History was, and is, shaped by these disputes and by their resolution, often in the federal district court.

Martin Luther King Jr. said:

> *Human progress is neither automatic nor inevitable. . . . Every step toward the goal of justice requires sacrifice, suffering, and struggle; the tireless exertions and passionate concern of dedicated individuals.*

This book celebrates the dedicated individuals—judges, clerks, court staff, marshals, and practicing lawyers—who have devoted their efforts to achieving the goal of justice. The path has not been a smooth one, and sometimes the steps have gone sideways, or even backwards. But the goal has not changed. For two hundred years, judges have sworn to "administer justice without respect to persons, and do equal right to the poor and to the rich," to the best of their "abilities and understanding." For two hundred years, the court has stood tall and determined. For two hundred years, the judicial system has enforced the Constitution and upheld the rule of law in this state and in this nation.

Read the court's stories and study the pictures that illuminate its history. The cases and conflicts featured here will surprise you, amuse you, trouble you, and perhaps even delight you. I hope they will also inspire you to passionate concern. ✳

DOORKNOB FROM THE OLD CHICAGO FEDERAL BUILDING.

15

INTRODUCTION

Scott Turow

Attorney and Author

If a pun can be forgiven: the Northern District of Illinois has always been "home court" for me. In the fall of 1978, I was hired as an assistant U.S. attorney in Chicago. It has always been a privilege to appear before the judges of the N.D. Ill. (as the name is abbreviated in legal citations).

I don't know how many cases I have tried at 219—as locals call the Everett McKinley Dirksen Courthouse at 219 South Dearborn— but it is certainly dozens, given my eight years as a federal prosecutor and the more than three decades since with a private firm. One of the thrills of practicing in the building is that it is an architectural landmark. The Dirksen Courthouse is the design of Ludwig Mies van der Rohe, who fled Nazi Germany and arrived here in 1938 to head the architecture department at the Illinois Institute of Technology. Chicago's longtime Mayor Richard J. Daley persuaded Mies to design a new federal plaza, which included 219, a post office, and federal office building. Mies brought Bauhaus design, which teaches that form follows function, and his design ideas inspired many modernist glass and steel tower skyscrapers in Chicago and across the nation. The courthouse is among these signature creations.

But it is the courtrooms that are the focus of my experience in the building. District Court judges sit in rooms two stories high, with walls clad either with acoustical rods of walnut that run floor to ceiling or unadorned walnut wainscoting. The simple contoured benches of the spectators' galleries are carved from walnut as well. Those seats are beautiful and remarkably comfortable—the apogee of Bauhaus intentions. For all my admiration of the modernist grandeur, I have one criticism of what Mies did: the courtrooms have no windows. Bright fluorescent lights beam down from above the plastic grids that form the ceiling. After a long day of trial, the intense light can make your eyes and temples throb.

Not only the architecture but the culture of the court is oddly intertwined with the first Mayor Daley. I am a lifelong Chicagoan. During my childhood and adolescence, Daley's Democratic machine had iron control. Payoffs to city officials were so routine that they were regarded as "the Chicago way." Legend has it that the mayor's influence was far-reaching enough that he sometimes had a hand in the selection of federal judges and U.S. attorneys—whom he wanted to "render unto Caesar" by sticking to federal business and not interfering with the machine's operation.

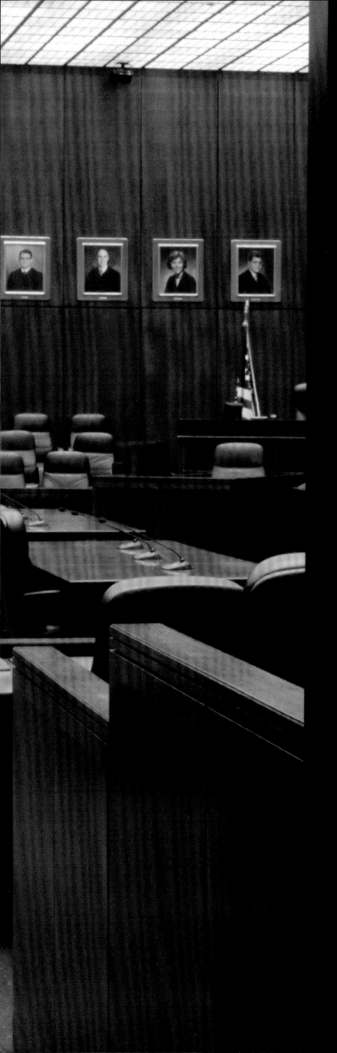

Yet beginning in the early 1970s, the Northern District established its political independence. William J. Bauer—first the U.S. attorney and later a judge of the District Court and of the U.S. Court of Appeals—and James R. Thompson, Bauer's first assistant and later his successor as U.S. attorney, began using the federal mail fraud statute against corrupt machine politicians. They accused them of cheating the public of its right to honest and faithful services. Judges of the Northern District sustained that enterprising legal theory. Soon, corruption prosecutions became the highlight of business at the courthouse, culminating in the conviction of Otto Kerner Jr., former U.S. attorney, ex-Illinois governor and, at the time of his trial, a judge on the Court of Appeals.

During the same period, the court entered the first "Shakman decrees," forbidding government hiring based on political loyalty and affiliation as a First Amendment violation. The court essentially outlawed the machine patronage system. As my mentor, former U.S. Attorney Thomas P. Sullivan, put it: the Northern District of Illinois became "the conscience of the community," the place where the law was applied fearlessly, independently, and without regard to politics.

As a result, coming out of law school I saw a job as a federal prosecutor in the N.D. Ill. as the most rewarding and important employment I could find. For talented lawyers from the Chicago area who had the ambition to be judges, a seat on the bench of the Northern District of Illinois was regarded as a dream job. And because criminal trials have first claim on a District Court judge's trial calendar, experience in the U.S. attorney's office has long been a common pedigree for roughly half the nominees to the federal trial bench in Chicago and across the country. Very often, colleagues I practiced beside in the U.S. attorney's office—or against, when I changed sides—have been elevated to the court.

For a few years, I was a member of the merit selection commission for the Northern District of Illinois, which made recommendations to our U.S. senators on their potential appointments to the N.D. Ill. bench. I have been enormously proud of the judges I had a connection with during their years in practice. I have not agreed with every decision they made, but I have watched those judges apply the law faithfully.

Among litigators around the country, the Northern District of Illinois is known as a great trial court. As I was preparing to leave the U.S. attorney's office, a renowned lawyer told me, "If you can try a case at 219, you can try a case anywhere." Why? Because you are going before smart judges who understand the rules of evidence, who value judicial demeanor, and who believe heart and soul in

THIS PAGE AND PREVIOUS:
THE JAMES BENTON PARSONS
CEREMONIAL COURTROOM.

following precedent. That culture of consistency is an enormous boon to practicing lawyers who can advise clients with greater certainty about the potential outcomes in cases litigated in that courthouse.

The following pages sample deeply from the court's distinguished history, which lies in the lawsuits and criminal cases disputed and decided there. A couple of the cases discussed are ones in which I had a role as a lawyer, but the point of any book like this is to illustrate the life of an institution. Its greatness is collaborative and based on the earnest participation by roughly one hundred judges and thousands of lawyers who have labored every day over two centuries to do justice. I am proud to have been just one of them. ✳

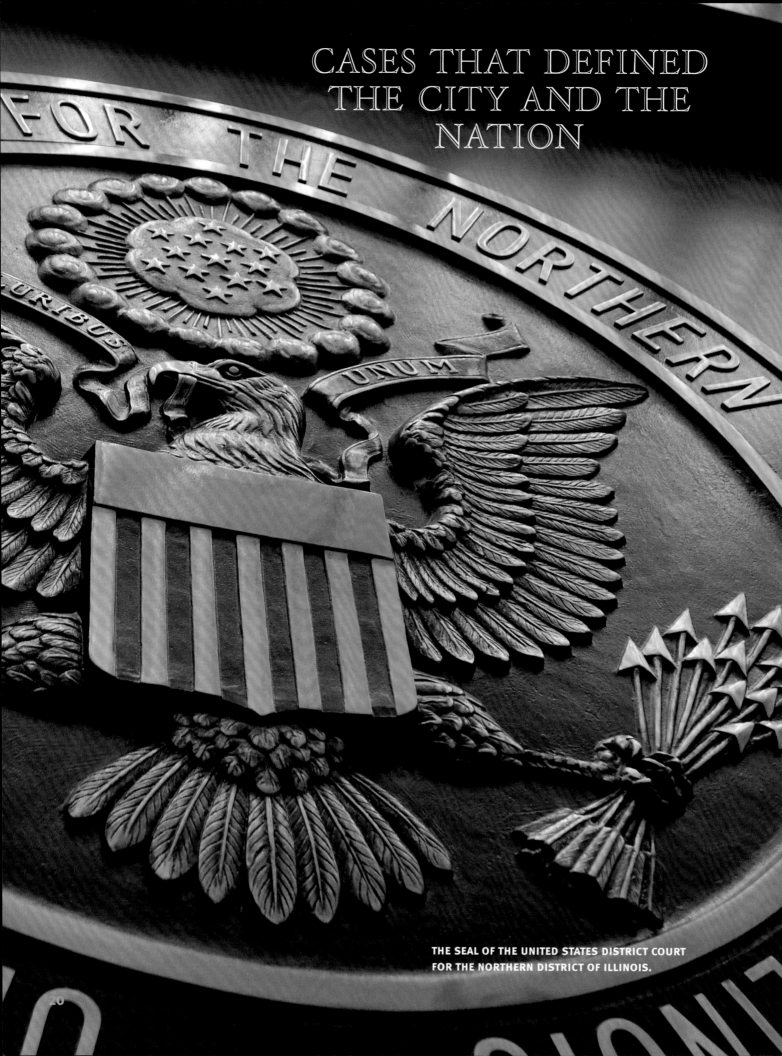

CASES THAT DEFINED THE CITY AND THE NATION

THE SEAL OF THE UNITED STATES DISTRICT COURT FOR THE NORTHERN DISTRICT OF ILLINOIS.

Dramas, both big and small, play out every day in the United States District Court for the Northern District of Illinois. This is where the federal government prosecutes the toughest of criminals, where the powerless assert their constitutional rights, and where citizens actually do make a federal case out of it.

The court is one of the busiest federal trial courts in the nation. It has played a pivotal role in every period of U.S. history. It was here where the Mormons won legal protection, however temporary, at a time when they were targets of religious persecution. It was here where one of the most eloquent opponents of slavery spoke out and where the rights of escaped slaves were acknowledged.

It was here where Abraham Lincoln changed the course of American history as Americans surged westward. Lincoln argued that east-west railroad traffic was as important and legitimate as north-south boat traffic. The court's decision helped determine the destiny of Chicago. This is where the West was won.

This is the court that determined the contour and ownership of Chicago's lakefront, and allowed for the destruction of an airport. The court stood up for immigrants, and gave neo-Nazis the right to march in the largely Jewish suburb of Skokie.

This is where four former governors, and dozens of judges, city aldermen, and police captains were convicted. Jimmy Hoffa met his fate here. Heavyweights Jack Johnson and Muhammad Ali as well as entertainers Oprah Winfrey and Michael Jackson have been judged in the Northern District.

Historians focus attention on the U.S. Supreme Court, where issues of national importance are finalized. But the district courts wield power on a daily basis. District judges, appointed for life, determine the makeup of schools, heel corporations and labor unions, infuriate presidents, and (sometimes) take a stand against centuries of discrimination.

Almost all of Chicago's historic institutions, from the Stockyards to the ball yards, have been altered by the District Court.

Nearly nine million people live in the eighteen counties that form the Northern District of Illinois. It extends across Northern Illinois from Lake Michigan to the Mississippi River. About 95 percent of its cases originate and are heard in the Everett M. Dirksen Courthouse in Chicago's Loop. The remainder are heard at the Stanley J. Roszkowski Courthouse in Rockford.

About 9,000 civil cases, 1,500 prisoner petitions, 1,000 *pro se* cases from non-lawyers, 900 criminal cases, and 800 intellectual property cases were filed in the court in 2018. In addition, more than 40,000 bankruptcy cases were docketed in the district's bankruptcy court.

Chicago's wood-paneled courtrooms, bathed in fluorescent light, are unlike any other place in the city. Enclosed and windowless, the two-story courtrooms evoke power through minimalism, not monumentality. Here are simple, austere, geometrically perfect rooms, their rectangular grids broken only by the large, circular symbols behind the judges' benches.

Here an American eagle rises, arrows and olive branches clutched in its talons, representing the rise and fall, the give and take, the constant daily challenge faced by the United States District Court for the Northern District of Illinois to find a balance for justice.

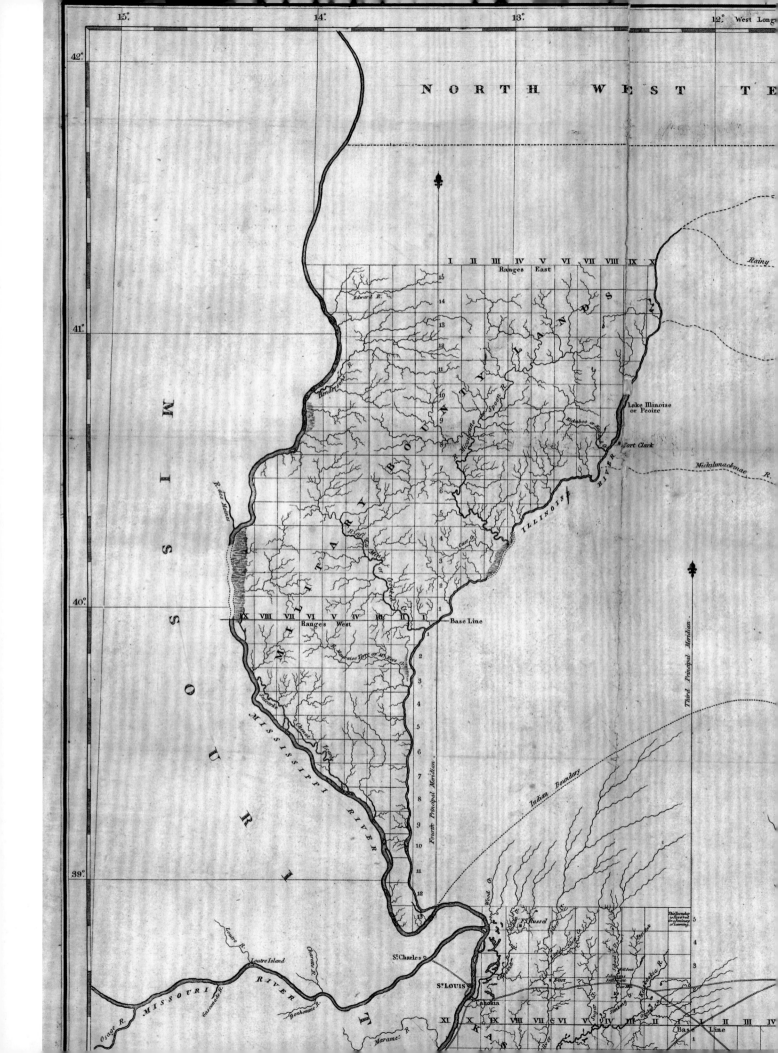

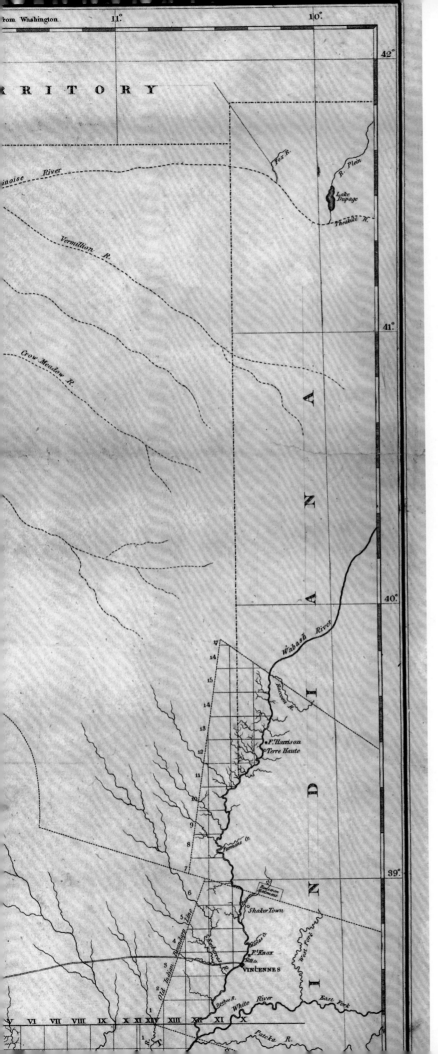

IN ILLINOIS' INFANCY, A COURT IS BORN

The United States District Court for the Northern District of Illinois dates back to 1819, one year after Illinois became a state. Federally appointed judges had worked in Illinois when it was a territory. But after statehood, Congress determined that a single federal judicial district should encompass Illinois.

President James Monroe nominated Nathaniel Pope to serve as the state's first judge. A delegate to Congress from the Illinois territory, Pope was the key figure in establishing Illinois' official borders. If not for Pope, the state's northern border would have bisected the bottom of Lake Michigan; Chicago would be part of Wisconsin.

Pope was paid $1,000 a year—good money in those days—and was based in the Mississippi River town of Kaskaskia, Illinois' first capital but now one of the state's tiniest towns. The capital soon moved to Vandalia and then to Springfield. By the late 1840s, an annual session of Illinois' federal court was held in Chicago. In 1855, the state's federal court jurisdiction was split, with the Southern District based in Springfield and the Northern District in Chicago.

The "military bounty lands" on this map show where veterans of the War of 1812 were granted property as payment for their service.

THE POTAWATOMI'S LAST STAND

As settlers moved west into Illinois, the U.S. government acquired Indian lands through treaties that proved to be bargains for the newcomers at the expense of the indigenous tribes. The final treaty sending the Indians westward from Chicago was signed in 1833, with the natives expected to be gone within two years.

In 1835, there was an amazing gathering. Indians wearing colorful face paint and armed with tomahawks and clubs gathered to collect an annuity payment and to bid Chicago farewell. They far outnumbered the whites, but still left peacefully. An era had ended. Shown here is a Potawatomi chief holding a tomahawk as he poses with another Native American during a visit to Washington, D.C., a decade or two after the evacuation from Chicago.

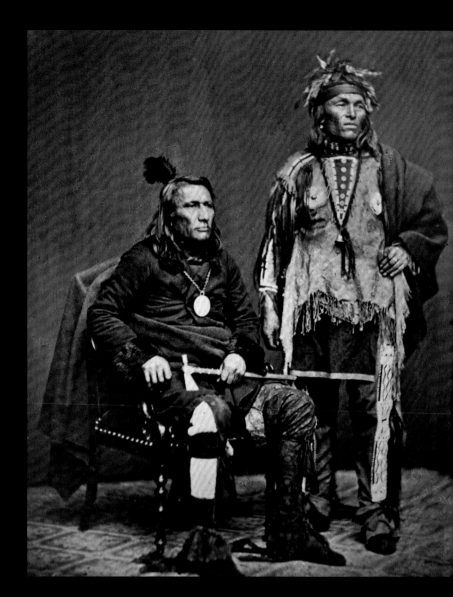

The issue of who owned Chicago was not quite settled, however. In 1914, the Pokagon branch of the Potawatomi tribe in Michigan and Indiana filed a federal lawsuit against the city of Chicago and lakefront landowners, raising a novel claim. The Potawatomi recognized that their tribe had sold off its Illinois land long ago, but it noted that the shoreline had been extended into the lake through landfill known as "lakefill." Some locations in the city such as Grant Park had not been part of the city when the treaties were signed; back then, they had been part of the lake. The Potawatomi argued that these parcels of land were theirs.

District Court Judge George Carpenter seemed unimpressed by the creative argument, dismissing the lawsuit and declaring: "The treaties made by the government with the Indians cannot be otherwise construed than that the Indians cannot claim land which they abandoned eighty years ago."

The Potawatomi appealed the decision to the U.S. Supreme Court, which affirmed Carpenter's ruling.

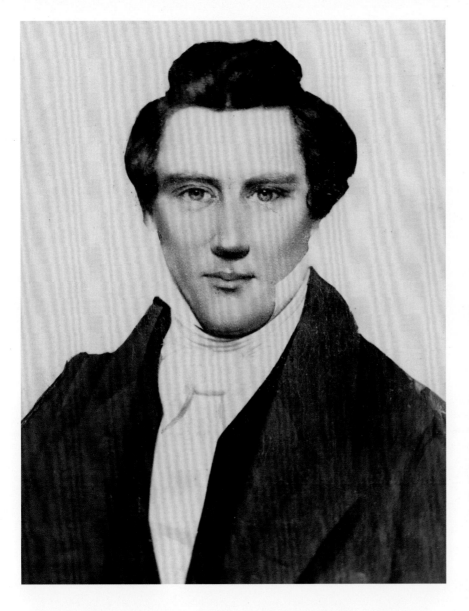

MORMON FOUNDER WAS SPARED – FOR A TIME

Joseph Smith, founder of the Church of Jesus Christ of Latter-day Saints, had plenty of enemies, but none more bitter than Missouri Governor Lilburn Boggs. In 1838, Boggs issued an "extermination order" against Smith's Mormons, forcing them to flee east across the Mississippi River to Nauvoo, Illinois, where they settled.

Four years later, one of Smith's bodyguards was charged with shooting and wounding the governor. Smith was accused of ordering the attack. The state of Missouri sought the Mormon leader's extradition, and Illinois' governor issued a warrant for Smith's arrest, leading to a hearing presided over by District Judge Nathaniel Pope.

Attorney Justin Butterfield displayed a showy style in arguing for Smith's freedom.

"I am here to address a 'Pope,'" he said, bowing to the judge.

"Surrounded by angels," he said, bowing even lower to ladies in the courtroom.

"In the presence of the holy apostles," he said, noting that Smith's twelve apostles were in attendance.

"In behalf of the prophet of the lord," he said, referring to his client.

After a four-day hearing, Butterfield won a stunning ruling from Pope that the Mormon leader should not be extradited to Missouri. The case was watched closely, since many assumed that Smith's extradition would be his death sentence. Pope's decision went against strong anti-Mormon public opinion, and served as a potent signal of the court's independence.

As it turned out, the Mormon founder lost his life just two years later when mob rule prevailed over the justice system. A group of men stormed a jail in downstate Carthage, where Smith was being held on a charge unrelated to the Missouri shooting, and Smith was shot and killed.

JOHN HOSSACK'S STAND AGAINST SLAVERY

In 1859, a slave named Jim Gray escaped near New Madrid, Missouri, and made his way north. Arrested in Illinois, Gray was taken to court in Ottawa, southwest of Chicago. Anti-slavery feeling was strong in that part of the state, but slaveholders had the right to reclaim their "property." The judge followed the law, keeping Gray in custody, but abolitionists in the courtroom helped Gray break away from his captors and escape to a waiting carriage. Gray fled town and safely made his way to Canada.

The white men who had instigated Gray's escape did not get away as easily. Prominent among them was John Hossack, a Scottish-born businessman. Hossack was charged with violating the Fugitive Slave Act by helping a runaway slave. The prosecution made him a focal point for the national debate over slavery. After his conviction in Chicago, but before his sentencing by District Judge Thomas Drummond, Hossack addressed the court.

He emphasized his immigrant status: "As a man who had fled from the crushing aristocracy of my native land, how can I support a worse aristocracy in this land? . . . The parties who prostituted the Constitution to the support of slavery are traitors; traitors not only to the liberties of millions of enslaved countrymen, but traitors to the Constitution itself, which they have sworn to support."

Hossack was sentenced to ten days in jail and fined $100. The short imprisonment in pro-abolition Chicago was cause for celebration, with Mayor John Wentworth and other luminaries taking him out to dinner.

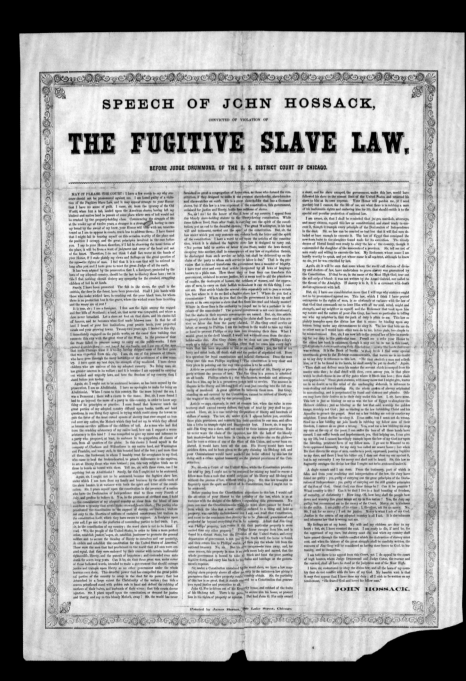

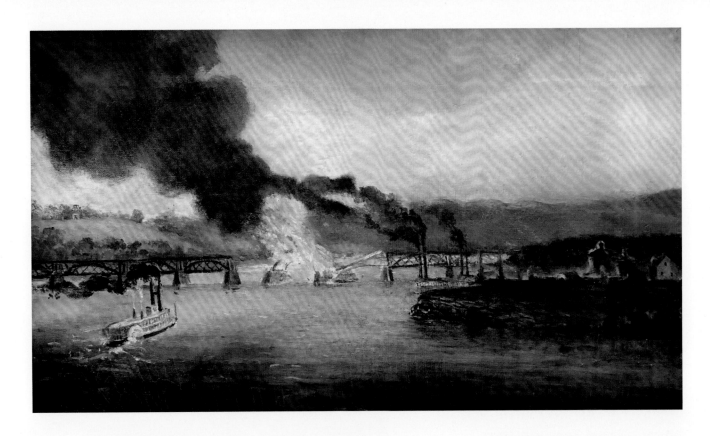

ABRAHAM LINCOLN, BRIDGETENDER

The first bridge built for trains to cross the Mississippi River opened on April 1, 1856, at Rock Island, Illinois. Just 35 days later, the steamboat *Effie Afton* slammed into a pillar of the bridge. It caught fire and sank. The blaze took down part of the bridge, too.

The boat's proprietors sued the bridge owners, calling the span a "permanent obstruction" to river commerce. The legal case shaped up to be a bitter battle between boats and trains over the role of each in westward expansion.

The bridge owners hired a downstate lawyer named Abraham Lincoln, known for his peculiarity as much as his persuasion. Lincoln demonstrated both in this federal trial in Chicago, whittling a piece of wood during testimony, while also offering profound remarks that displayed his command of the facts.

Arguing that rail traffic deserved preference, Lincoln said there was "a considerable period of time when floating or thin ice makes the river useless while the bridge is as useful as ever. This shows that the bridge must be treated with respect in this court and is not to be kicked about with contempt."

At the time, federal trials were conducted in district courts or an early version of circuit courts, which were made up of district judges and Supreme Court judges. Lincoln's bridge trial, in the courtroom of Circuit Judge John McLean, ended with a hung jury that leaned toward the bridge owners 9-3. Practically speaking, the outcome was a victory for Lincoln's side since there was no retrial. A separate lawsuit in Iowa's federal court went against the bridge owners, but the Supreme Court reversed that decision, paving the way for railroads to leap the Big Muddy and carry Americans west.

MRS. O'LEARY'S COW WAS NOT GUILTY

The 1871 fire that devastated Chicago didn't start when Catherine O'Leary's cow kicked over a lantern. That was just a myth. But the fire did start in or near O'Leary's barn, then roared east, jumped the Chicago River, incinerated the business district, jumped the river a second time, and destroyed homes, stores, and factories as far north as Belden Avenue near Fullerton. Three hundred people were killed, and one hundred thousand more were left homeless.

The walls of Chicago's courthouse remained standing, but the building's contents were destroyed, save for a few records found in the street. Christian Kohlsaat, a lawyer and later a federal judge, was shocked by the loss of the city's legal history, both federal and local. "It's so strange to have no deeds, no judgment cards, no anything," he wrote.

The federal court did its best to recreate files from sources outside Chicago, with Congress approving its methods. Sorting out the insurance issues was a legal headache. As the *Chicago Tribune* put it more than four years after the fire, "A large and jovial gathering of the creditors of the defunct Chicago Fire Insurance Company was had yesterday afternoon in the United States District courtroom."

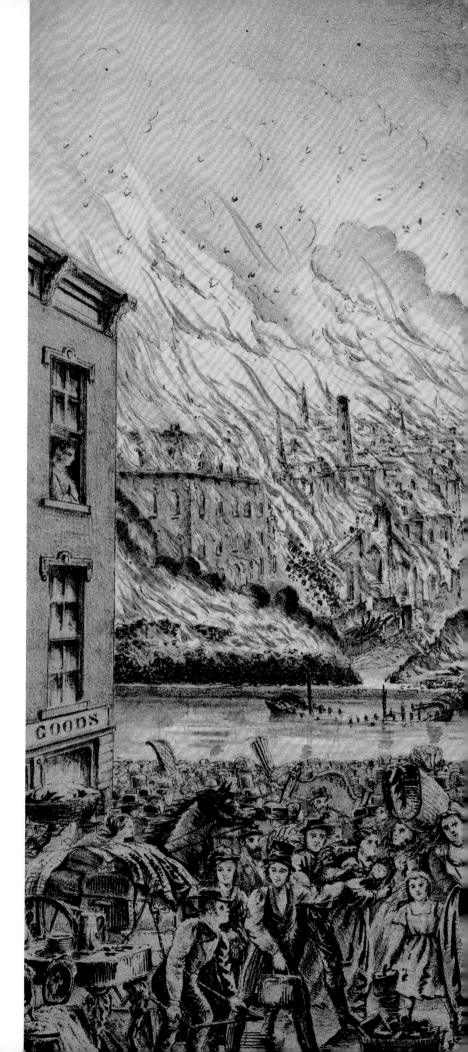

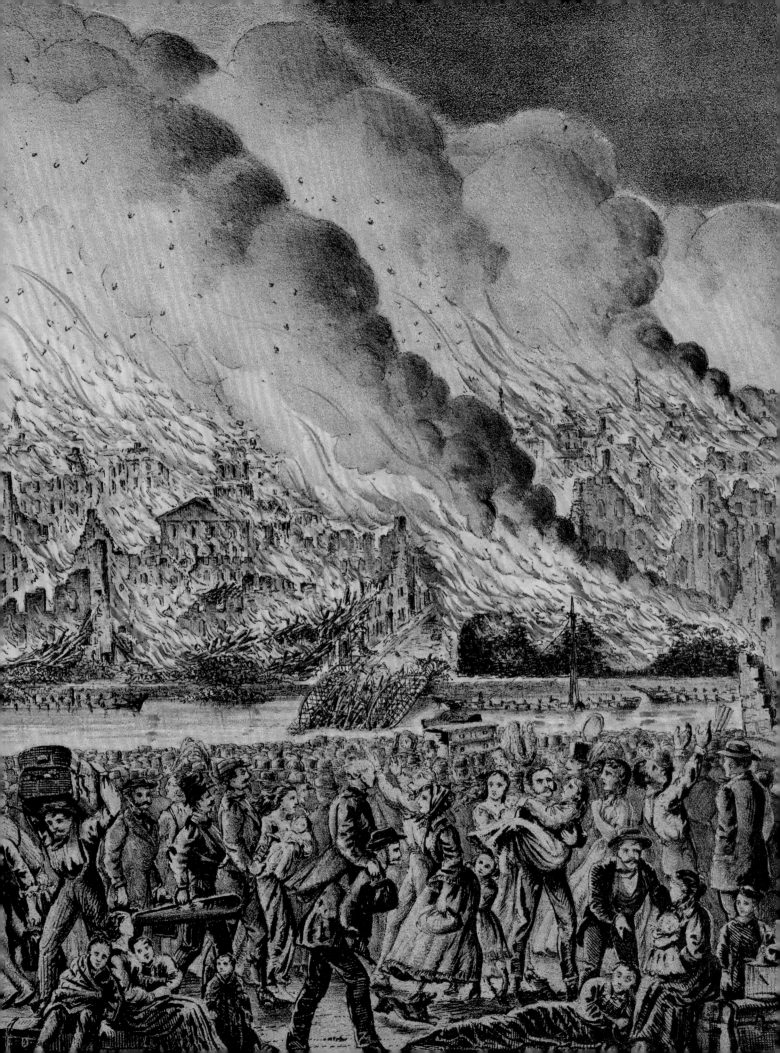

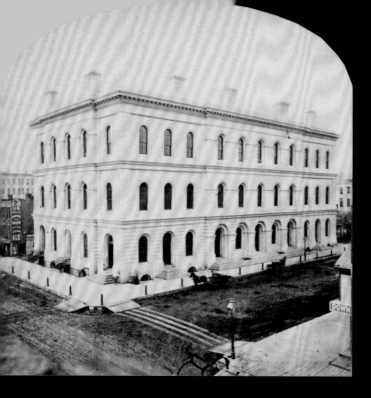

LOUSY LUCK WITH FIRST COURTHOUSES

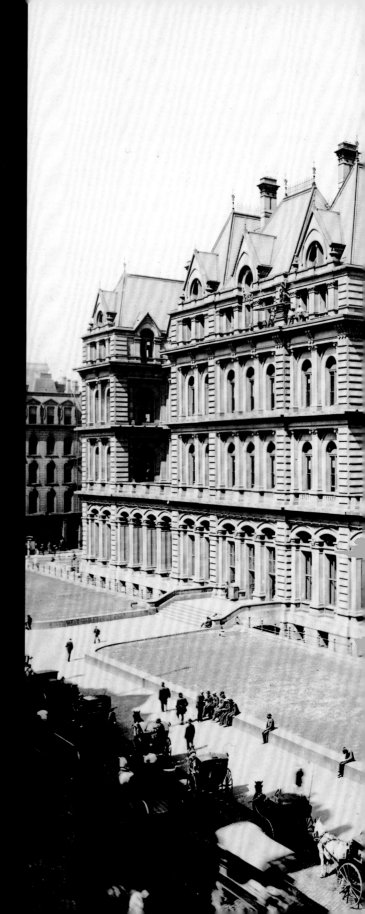

Chicago's federal courts had no permanent home until 1860, when a post office, customs house, and U.S. court building (above) opened at Dearborn and Monroe. That three-story structure burned in the Great Chicago Fire. Operations shifted to Congress Hall at Michigan Avenue and Congress Parkway. Three years later, Congress Hall went up in flames, too, forcing a temporary move to the Republic Life Building on LaSalle Street.

The courts got their second permanent home when a new post office, customs house, and U.S. court building (*right*) opened in 1880 on the block bounded by Clark, Adams, Dearborn, and Jackson streets. The structure looked impressive from a distance with its ornate features and gabled roof, but its weak foundation caused the building to settle unevenly, leading to broken pipes and flooding and a reputation as a "disgraceful old rattle-trap."

Rather than make repairs, the government tore it down just sixteen years after its opening.

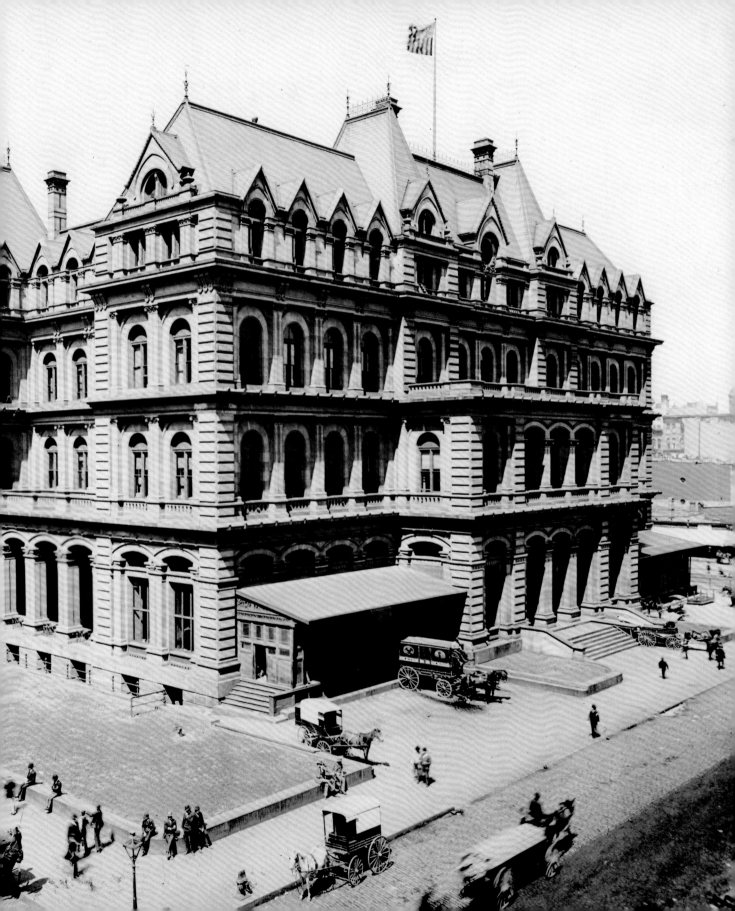

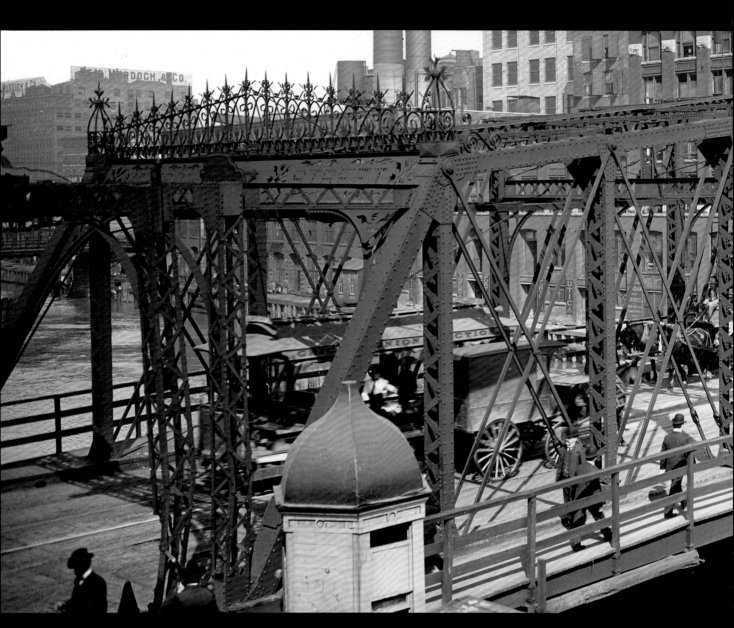

Chicago is at the edge of an inland sea known as the Great Lakes. In 1845, Congress passed legislation that applied federal admiralty or maritime law to the five lakes and to waters such as the Chicago River that connect to those lakes. The federal court became the exclusive jurisdiction of most things maritime.

Early Northern District admiralty cases tell of a nautical city long gone and of a narrow and crowded working river. In 1853, Judge Thomas Drummond presided over a case involving two steamers that collided in the thick smoke from ruins of a fire-destroyed warehouse along the Chicago River. A few

years later, he considered a lawsuit by the owners of a boat that was damaged by ice when it was stuck in the frozen river by the jammed Madison Street drawbridge (shown during warmer weather). The owners argued that Chicago was responsible for keeping the river open. A jury awarded damages to the ship owners.

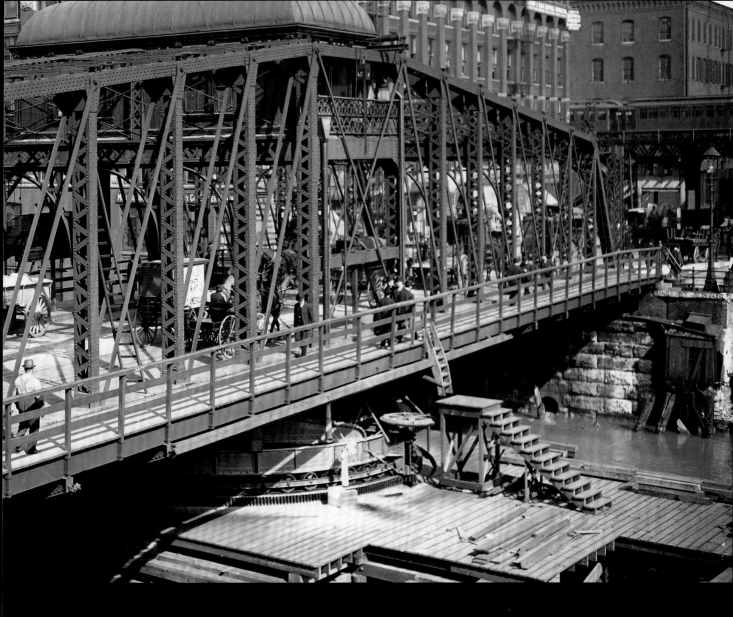

Life was dangerous in a city built around the river. In 1865, Judge Drummond heard a case in Circuit Court concerning the death of a man who attempted to cross a swing bridge at Clark Street. He stepped on the bridge as it pivoted to let a boat pass, lost his balance and fell. A lawsuit charged the city with negligence for not providing adequate protection or lighting. A jury agreed.

The maritime life of Chicago became news again after the 1992 Great Chicago Flood when District Judge Charles Kocoras ruled that the Great Lakes Dredge and Dock Company could not use admiralty law to limit its liability after workers accidentally pierced a tunnel beneath the Chicago River at Kinzie Street. That caused millions of gallons of river water to fill the tunnel and flow into the basements of about three hundred downtown buildings. The Court of Appeals and the U.S. Supreme Court reversed the ruling. The City of Chicago agreed to pay to settle most of the lawsuits.

ALEXANDER GRAHAM BELL RANG UP VICTORY

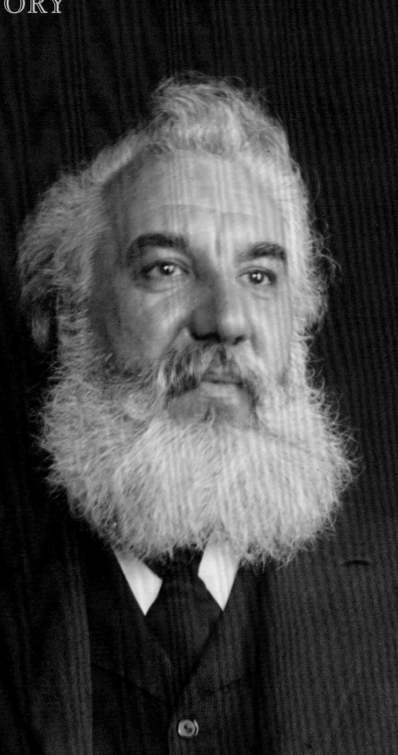

After Alexander Graham Bell announced his invention of the telephone in the late 1870s, he beat back more than six hundred lawsuits and administrative proceedings over his patents.

A key ruling came in Chicago in 1881. Sylvanus D. Cushman sued Bell, claiming that his invention of an electromagnetic telephone had preceded Bell's achievement by more than two decades. Cushman was part of an engineering group stringing telegraph lines in Wisconsin when he picked up the croaks from a frog in a prairie seven miles away. Realizing that voices could be transmitted over wires, he developed a device to do just that.

District Judge Henry Blodgett found Cushman's invention impractical. While it allowed for people to talk via magnet coils over short distances, the sounds were faint and conversation was "often a total failure." Blodgett ruled for Bell.

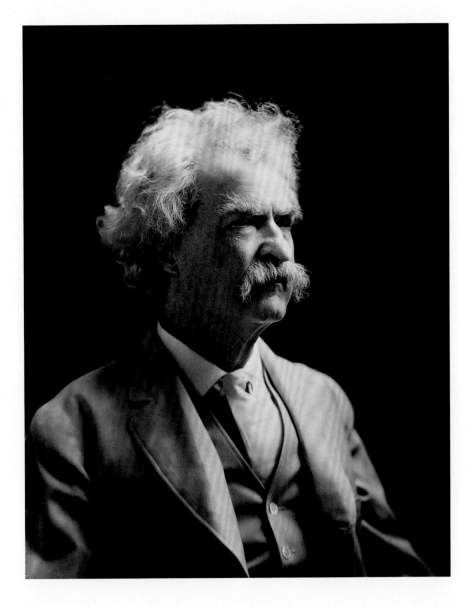

MARK TWAIN WRITTEN OFF

From a non-legal standpoint, Samuel Clemens seemed to have a darn good case when he filed a lawsuit in Chicago in 1881. A Chicago publisher, Belford, Clark & Co., had printed a book of his writings called *Sketches by Mark Twain,* without authorization from Clemens to publish the manuscript and use his pen name.

Problem was, Clemens had neglected to copyright those writings when they had been previously published. Clemens emphasized in his lawsuit that the use of the well-known "Mark Twain" pseudonym made it clear that the writings were his. District Judge Henry Blodgett rejected the argument, focusing on the copyright oversight: "If they were published without such protection, they become public property, and may be republished by anyone who chooses to do so."

Clemens' failure to secure legal protection for his book was surprising because he was a strong advocate for copyright.

Blodgett noted another irony: It was OK if the bandit publisher reprinted un-copyrighted work by Clemens and attributed it to Mark Twain. But if the publisher reprinted work that was not Clemens' and attributed it to Mark Twain, Clemens might have a more valid case. In other words, Belford's theft of Clemens' work left the actual author no recourse. But if Belford had stolen someone else's work and printed it under Clemens' name, Clemens would have a case.

In fact, Belford published a preface in the book that was not written by Clemens, but the writer's lawsuit did not address that point.

Chicago's federal courts have handled several other major copyright cases over the years. District Judge Rubén Castillo ruled in 2013 that Sherlock Holmes was in the public domain, despite the objections of Arthur Conan Doyle's estate.

A. H. HENDERSON, President.

◄CHICAGO►

🌼 Union :: Base :: Ball :: Ass...

BALL PARK, Thirty-Ninth St., Wabash and M...

CHICAGO, J...

Jno F Stafford Esq.
 Chicago Ills

Dr Sir:

 In reply to your fav...
The letter you refer to was ...
Mr Spaulding. My attention...
called to an article in ...
papers relating to the sui...
the United States Court, ag...
League Club playing gam...
ball on the Lake front...
was asked where would...

‹ E. S. HENGLE, MANAGER.

...ociation, ❋ ▦

...chigan Aves,

...ue 12" 188 4

...or of this date.

...ot written to

...had been

...e of the daily

...spending in

...inst the Chicago

...s of Base

...The question

...the Club play

LAKEFRONT 1, CUBS 0

The Cubs are Chicago's darlings now, but in the 1880s they were evicted from their ballpark along the lake. They weren't called the Cubs then—they were the White Stockings and were run by Albert Spalding, a baseball visionary who promoted the practice of fielders wearing gloves.

Their ball field, known as Lakefront Park or Lake Park, was near the southeast corner of Michigan Avenue and Randolph Street, where Millennium Park stands now. In 1884, the U.S. attorney argued the ballpark was illegally located because that site was designated to remain open public land when the feds sold it off. He said the city was "the mere custodian of said public grounds" with no right to turn it over to a private business.

District Judge Henry Blodgett agreed.

The letter shown here, from the court file, was written by A.H. Henderson, president of a different club, the Union Base Ball Association ("baseball" was two words back then). Henderson's Chicago Unions ball club was defunct, having played its only season in 1883, and he noted that the Unions' South Side ballpark was available to the White Stockings. Instead, the future Cubs decided to move to West Side Park, bordered by Congress Parkway, and Throop, Harrison, and Loomis streets. Two moves later, they settled in the North Side's Wrigley Field.

SETTLER GOT
NO SETTLEMENT

Catherine Beaubien never stood much of a chance.
A member of one of Chicago's first settler
families, Beaubien filed a lawsuit in U.S. District Court
in 1887 to press her old claim to extremely valuable
downtown land. By that time, Chicago's population
was near 1 million and growing rapidly. With so much
money being made, few people wanted an old lady's
complicated argument to disrupt things.

But Beaubien pressed on, even submitting this
map of the land she claimed — bordered on the north
by a rail fence south of Fort Dearborn, on the east
by the lake, on the west by State Street, and on the
south by Madison Street. Note the winding course of
the Chicago River before the route leading into Lake
Michigan was straightened.

Beaubien, who filed the lawsuit with her children,
was the widow of Colonel John Baptiste Beaubien,
a French Canadian fur trader whose son, Alexander,
was the first white male born in Chicago. The first
presidential polling in Chicago history took place
at the Beaubien home in 1828, with John Quincy
Adams winning locally but losing to Andrew Jackson
nationally. Though the balloting took place in Chicago,
there's no indication that any dead people voted.

The land where the Beaubiens lived was reserved
for military purposes in 1824, and they said they made
a claim in 1831 to buy it when it became available. But
in 1839, the land was divided up and sold to private
interests, with the Beaubien claim disregarded and
the family evicted. In 1854, Congress passed a bill
extinguishing the Beaubien claim but giving them a few
lots as a settlement. The Colonel died a decade later.

Catherine Beaubien argued in her 1887 suit that
her husband never agreed to any settlement, and she
offered to pay the price that had been charged when the
government sold off the land—$1.25 an acre.

Not surprisingly, the Beaubiens' claim went
nowhere.

m S. Beaubien, Phillip Beau-
n Fields, Margaret Robinson,
Beaubien, Isadore L. Beau-
ribed to the foregoing pe-
, depose and say that they
etition read, and that all the
knowledge they know to be
in stated upon information
to be true.
before me this **26"** day of

Tyler Powell
Notary Public

ed. Jas.
ois.
n and William S.
subscribed to the
duly sworn, depose
the foregoing petition
therein stated upon
and all the matters
on and belief they
are this 29th
writing my hand
of the Circuit
s for said District
ark
H. Bradley Clerk

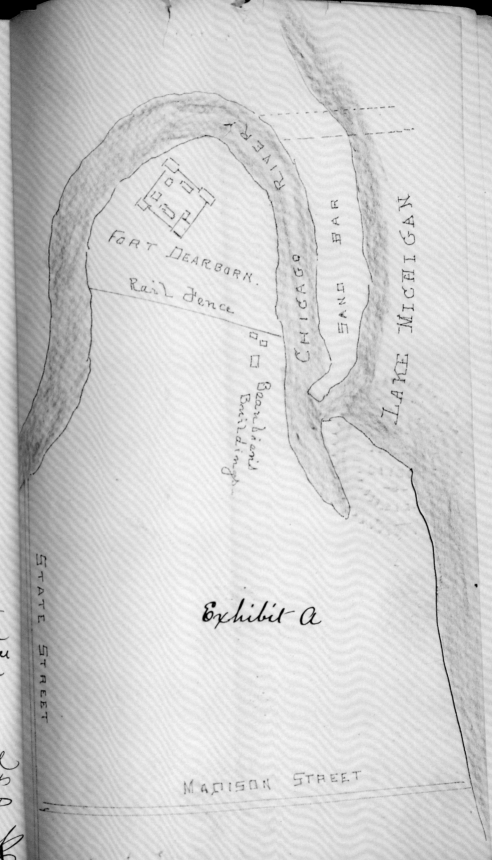

Exhibit A

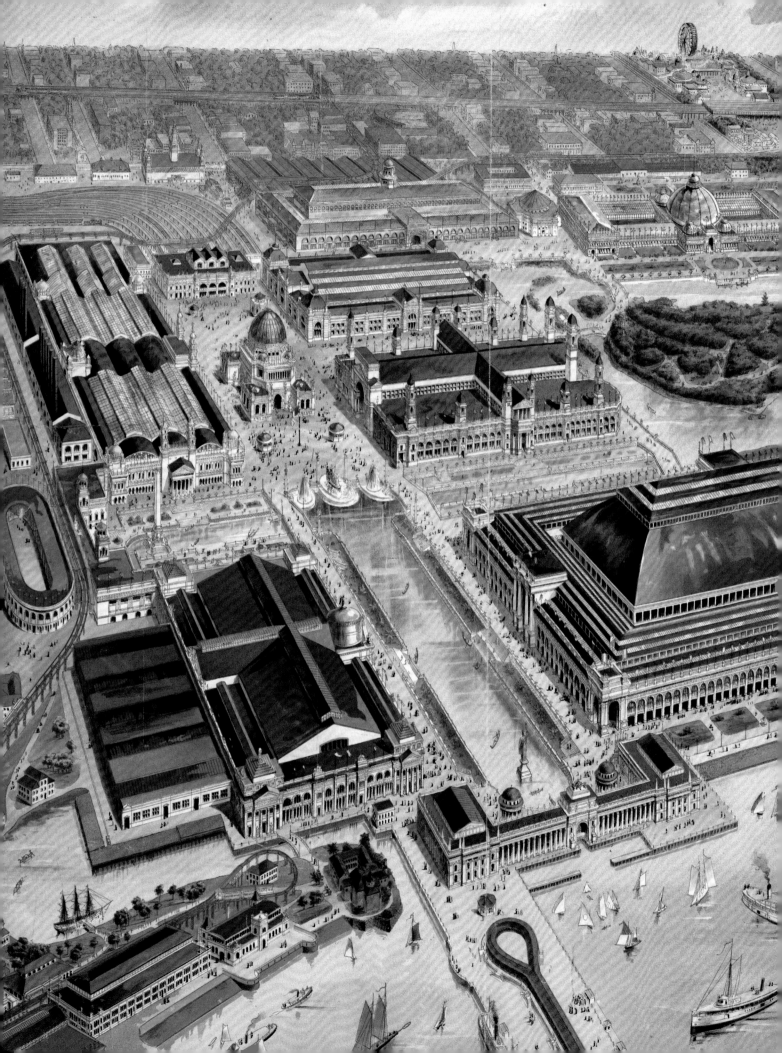

NO DAY OF REST AT THE WORLD'S FAIR

The 1893 world's fair, officially the World's Columbian Exposition, marked the 400th anniversary of Christopher Columbus' arrival in the New World. But the fair's purpose was to look forward, not back. About 20 million people flocked to Chicago to ride the first Ferris wheel and see a wondrous new entertainment called the motion picture, not to mention undulating belly dancers doing the hoochie-coochie.

Though a celebration of cultures, the fair didn't please everyone. The U.S. government sued to keep the fair closed on Sundays so it would not detract from religious services.

The national commission for the fair had approved rules that included the Sunday closing, and Congress had appropriated $2.5 million based on those rules. But local authorities believed Sunday openings would increase attendance—and revenue. They announced the fair would be open on Sundays, and the U.S. Justice Department took the issue to court.

The case went to a three-judge panel: Circuit Judges William Woods and James Jenkins, and District Judge Peter Grosscup. Woods and Jenkins ruled for closing, with Grosscup dissenting. On appeal, a three-judge panel including U.S. Chief Justice Melville Fuller reversed the earlier ruling. The fair stayed open on Sundays.

To soothe outraged and offended clergy, fair operators promised to host religious services on the Lord's Day.

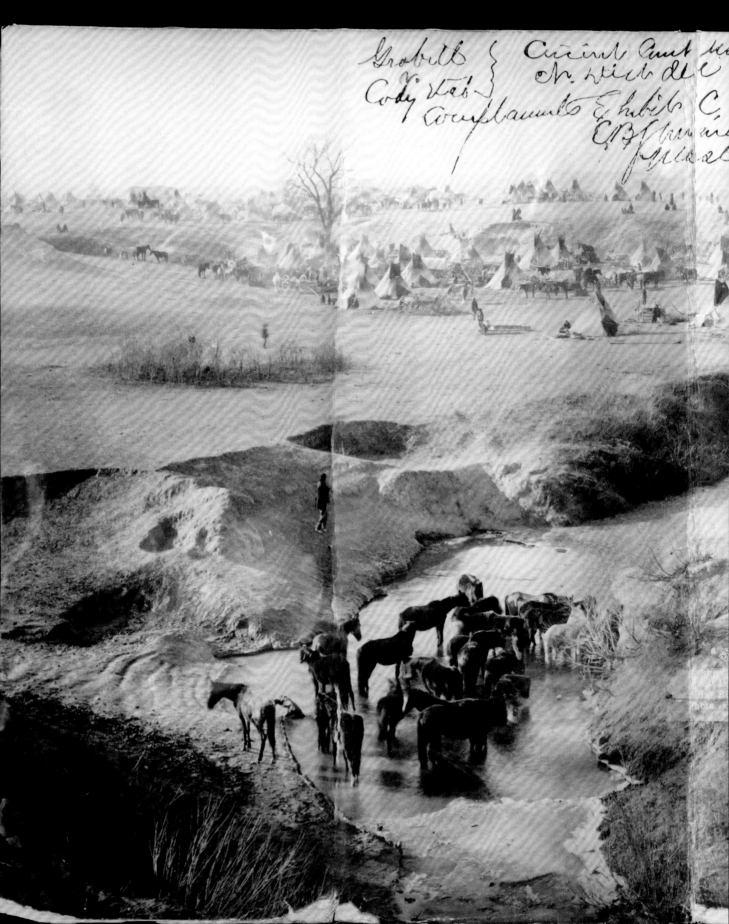

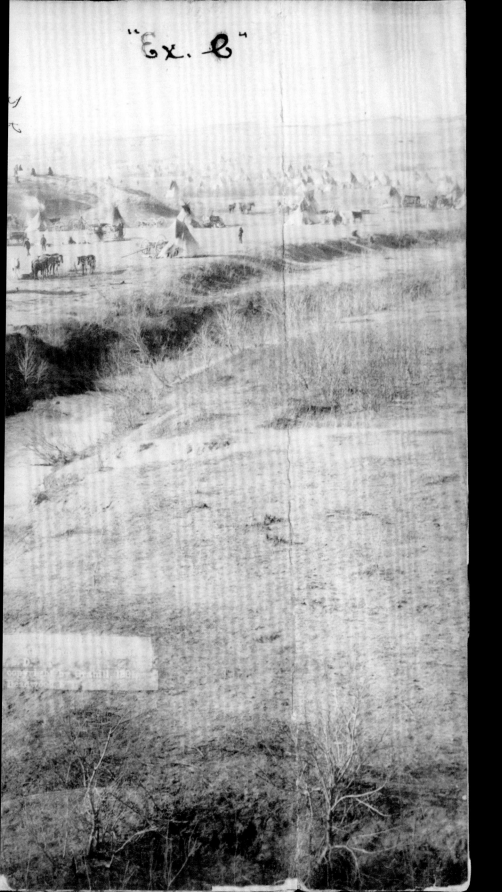

"Ex. B"

William Frederick "Buffalo Bill" Cody brought his Wild West show to the nation and Europe, thrilling audiences with dramatic depictions of cowboys and Indians. In 1893, a major stop was the World's Columbian Exposition in Chicago. Cody didn't get an official spot at the fair, but set up an arena nearby and drew big crowds.

A pamphlet advertising the Chicago show featured photographs by John Grabill taken while traveling with Cody in 1890-91, including this famous picture of the Sioux village of Brule, described as a "great hostile river camp near Pine Ridge, South Dakota."

Grabill sued in Chicago's U.S. Circuit Court, insisting he had copyrighted the images and had not allowed Cody to use them. Buffalo Bill countered that Grabill relied upon him while in Sioux country, and contended the photos were not "made by means of any skill, ability or intellectual conception on the part of said complainant."

As happens often in business-related cases, the lawsuit was likely settled out of court.

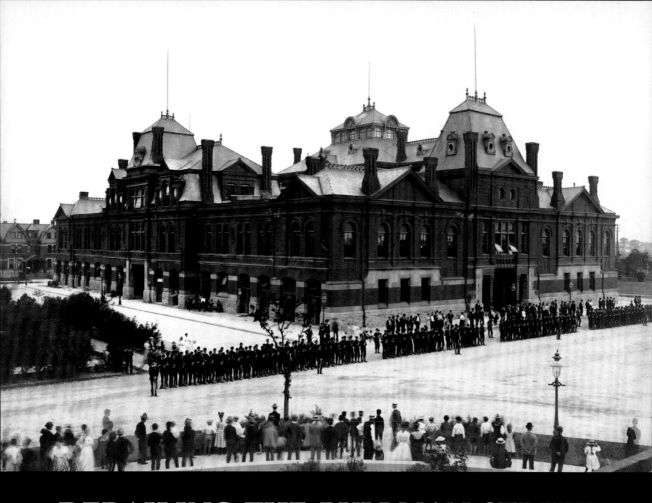

DERAILING THE PULLMAN STRIKE

The company town of Pullman, south of Chicago, was ground zero for class warfare.

George Pullman built his factory and housing for its workers in order to support his railroad-car business and maintain firm control over his employees. When the economy took a downturn, Pullman cut wages but refused to lower the rent, triggering an 1894 strike. The labor action spread when Eugene Debs' American Railway Union launched a boycott against handling Pullman cars. Rail traffic in Chicago was crippled.

District Judge Peter Grosscup and his Indiana counterpart issued an injunction to stop the "Debs Revolution." Federal troops were sent to Chicago. Clashes between strikers and authorities left dozens—mostly strikers—dead.

When Debs ignored Grosscup's injunction, he was charged with conspiracy against the U.S. Mail because the rail strike blocked postal deliveries.

His trial was ultimately dropped, but Debs served six months in jail for contempt of court.

The strike was broken by the courts' support for big business. The prevailing attitude of the country's power structure was expressed when judge and future President (and Chief Justice of the Supreme Court) William Howard Taft wrote to his wife: "It will be necessary for the military to kill some of the mob before the trouble can be stayed."

A TRICKY ESCAPE FROM THE CHINESE EXCLUSION ACT

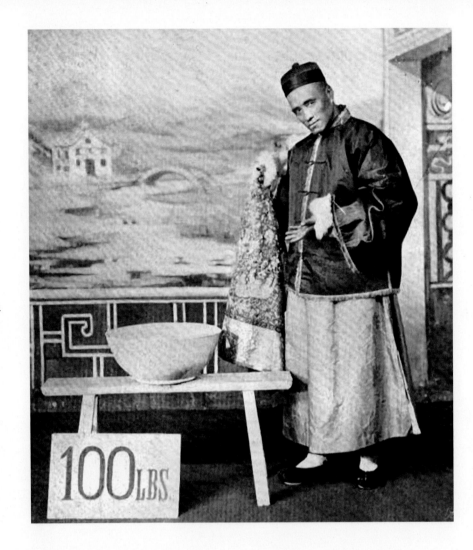

The Chinese Exclusion Act of 1882 severely restricted immigration from China, and caught up with touring magician Ching Ling Foo near the turn of the century.

In 1898, the showman won permission to enter the United States to appear at an Omaha exposition, but was supposed to leave the country within three months. Instead, he stayed and kept performing. The *Chicago Tribune* described his act this way: "Ching Ling Foo proceeded to produce large bowls of water containing living fish from beneath a flat rug, lighted lamps and all sorts of platters and dishes containing different articles of food from the same source, turning paper frogs into living ones, and similar feats."

Pure magic—until his arrest on illegal immigration charges. But Ching Ling Foo had one more trick up his sleeve. There was an exception in the law for merchants, and District Judge Christian Kohlsaat let him go to San Francisco to establish proof that he qualified. After a while, the magician was allowed to remain in the United States.

A strange footnote to the Ching Ling Foo story involves a New York-born imitator named William Robinson who billed himself as Chung Ling Soo to take advantage of Ching Ling Foo's fame. After assuming his new persona, Robinson only appeared in public dressed in Chinese garb. For eighteen years, Robinson pretended he could not speak English, communicating only through a translator. The faker's act grew more popular than the genuine conjurer's show. But Robinson's magic wore out during a London show in 1923. Chung Ling Soo invited two men onstage to fire rifles at him in an illusion in which he would appear to catch the bullets in his teeth. But something went wrong, and the fake Chinese magician was shot in the chest. He died the next day.

THE GHOST AND IDA CRADDOCK

In some ways, Ida Craddock was ahead of her time, pushing for women's equal access to education and creating sexual how-to guides to strengthen marriages. In another way, though, Craddock's outlook was far from mainstream. The unmarried Craddock insisted that she was the wife of a ghost named Soph, with whom she had frequent sex. Despite the unusual nature of her marital experience, Craddock dispensed her own brand of sexual advice.

To no one's surprise, Craddock clashed with famed decency crusader Anthony Comstock on a variety of topics, including the merit of belly dancing at the 1893 World's Columbian Exposition. But their biggest clash was over Craddock's mailing of sexual guides, which led to her arrest in Chicago and elsewhere. Shown here is the 1899 arrest warrant issued after Craddock attempted to mail *Right Marital Living,* described by prosecutors as "a certain obscene, lewd pamphlet and publication of an indecent character." Clarence Darrow defended her against the charges in Chicago.

In 1902, the 45-year-old Craddock faced a prison term after an obscenity conviction in New York. She died after inhaling gas and slashing her wrists.

District Court of the United States of America, } ss.
NORTHERN DISTRICT OF ILLINOIS.

THE UNITED STATES OF AMERICA

To the Marshal of the Northern District of Illinois—GREETING :

WE COMMAND YOU TO TAKE

Ida C. Craddock

if he shall be found in your District, and ~~him~~ her safely keep, so that you have ~~his~~ her body before

our Judge, of our District Court of the United States for the Northern District of

Illinois, at Chicago, in the District aforesaid, forthwith, to answer unto THE UNITED STATES

OF AMERICA in an indictment pending in said Court against ~~him~~ her for *Violating*

Sec. 3893 RS, in unlawfully and knowingly depositing and causing to be deposited in the Post Office of the United States, at Chicago, for mailing and delivery, a certain envelope, containing a certain obscene, lewd and lacivious pamphlet and publication of an indecent character

And have you then and there this writ, with your return thereon.

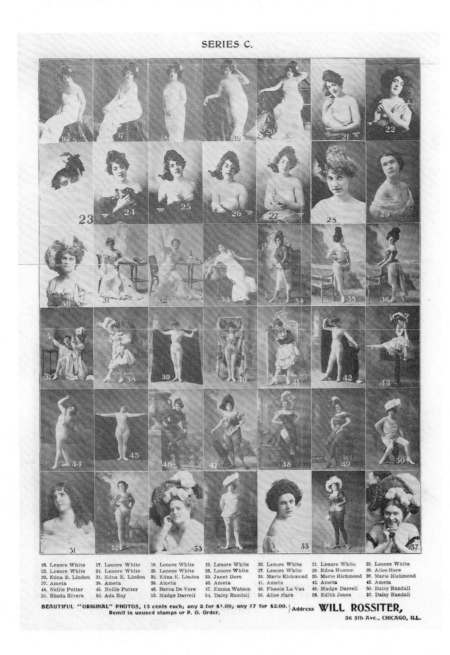

STAMPING OUT 'INDECENCY'

Sending this advertisement for "beautiful 'original' photos" got Will Rossiter indicted by a federal grand jury in 1901.

The government regularly used the post office to regulate the nation's morals. Postal inspectors were on the lookout for publications of "indecent character," which were banned from being mailed by federal law. Frequent Chicago targets: proprietors of immigrant newspapers, such as Hungarian-, Polish-, and Slovakian-language newspapers.

Prosecutors and judges took these cases seriously.

Two Chicago men found guilty of advertising an arcade machine peep show were sentenced to three years of hard labor at the Illinois State Penitentiary at Joliet.

"It is not necessary that the writing complained of should in terms describe obscene matter," wrote Judge J. Otis Humphrey for the Seventh Circuit Court of Appeals in affirming the conviction.

"The writing may be innocent and harmless on its face." But if it provided information about where "obscene matter" could be obtained, it could be considered illegal.

In another case, Frank Tammen was indicted for mailing an ad for Kola-ettes, a vegetable tonic "used in various Harems of the world" that cured "all nervous diseases of the generative organs such as Lost Manhood, Insomnia, Pains in the Back, Seminal Emissions."

It's unclear if Will Rossiter, charged with selling these lewd photos, beat the rap. But he went on to write more than five hundred songs, including "I'd Love to Live in Loveland with a Girl like You," which sold more than 2 million copies.

He also printed "The 'Jelly Roll' Blues," the first jazz tune published as sheet music.

47

THE POWER TO REVERSE RIVERS

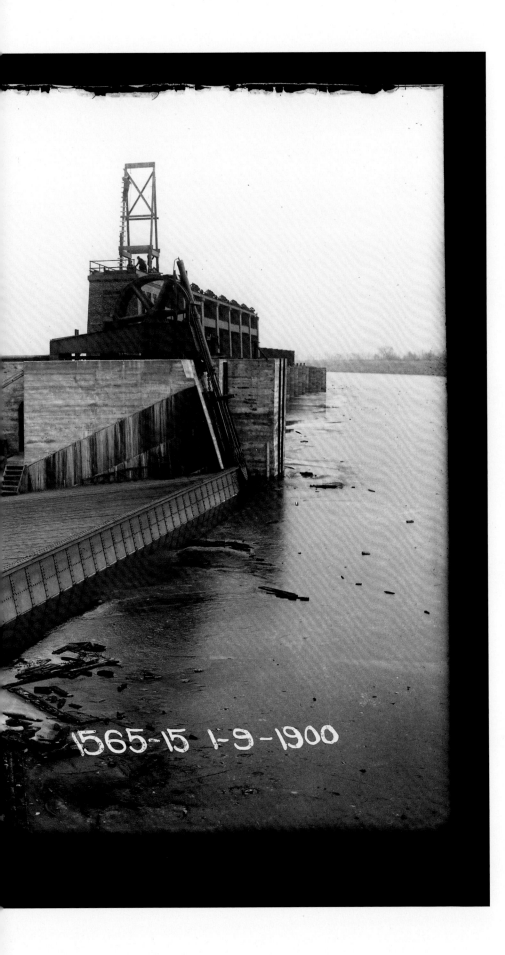

1565-15 1-9-1900

Chicago had a health problem. The city's waste from the Chicago River flowed directly into Lake Michigan, contaminating the city's source of drinking water.

So Chicago came up with an audacious solution: It reversed the river's flow and sent the dirty water into the newly built Chicago Sanitary and Ship Canal, then on to the Illinois River and ultimately the Mississippi River. The canal's construction took seven years and moved more earth than the Panama Canal project. The *New York Times* marked the river reversal in 1900 with this headline: "The Water in the Chicago River Now Resembles Liquid."

St. Louis, on the receiving end of that nasty water, asked Judge Christian Kohlsaat of the Northern District of Illinois to stop operation of the canal. But Missouri went straight to the U.S. Supreme Court, which refused to issue an injunction and ruled for Chicago five years later. The unanimous opinion, by Justice Oliver Wendell Holmes, said Missouri had a right to guard against pollution of its water by another entity, but it did not find that Chicago's action would significantly pollute water there.

DISPUTES OVER A STAGE PARODY...

In 1901, the New York entertainment firm of Klaw & Erlanger produced a Chicago stage version of Lewis Wallace's blockbuster novel *Ben-Hur: A Tale of the Christ.* Rival producer William Cleveland planned a burlesque version. He called it *Bun Her* or *Her Bun.* Cleveland's show was clearly parody, with characters such as Sand-Blast and Potato-Fromage.

Klaw & Erlanger got a restraining order from District Judge Christian Kohlsaat, who banned a show with "any name that simulates the name of 'Ben Hur.'"

The victors didn't escape unscathed, though. Marc Klaw was questioned under oath about whether his audience was "of high-grade intelligence." His answer: "We certainly got the best and the mediocre too." Asked about his play's target audience, he answered: "I should say that it would appeal to the religious element. That is to say, not the most intelligent."

Cleveland made sure the controversy didn't go to waste, citing the injunction in advertisements for a different show of "polite vaudeville" and "tip-top minstrelsy."

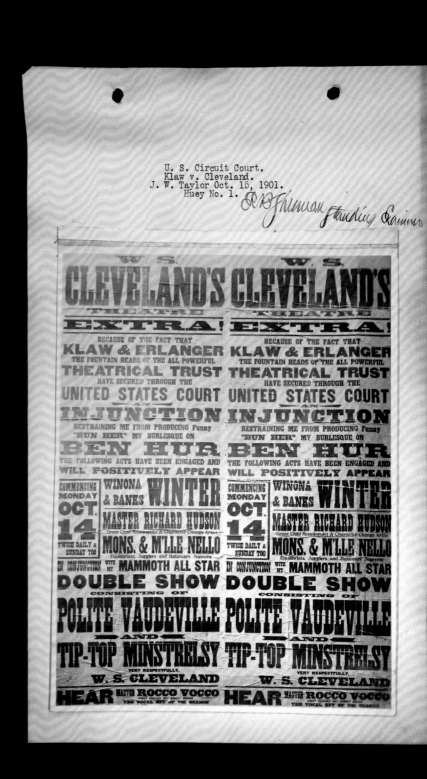

Circuit Court of the United States of America, } ss.
NORTHERN DISTRICT OF ILLINOIS,
NORTHERN DIVISION.

THE UNITED STATES OF AMERICA

To the Marshal of the Northern District of Illinois—Greeting:

WHEREAS, .. George R. Lawrence

..

Plaintiff , complain s that Curt Teich doing business under the name of

.... Curt Teich & Co., ..

Defendant , unlawfully and wrongfully ha s taken and do th detain the following described Goods and Chattels, to wit:

1000 copies of so called Post Cards like Exhibit "B", attached to

the declaration herein and also to this writ.

5000 copies of so called Post Cards like Exhibit "C", attached

to the declaration herein and also to this writ.

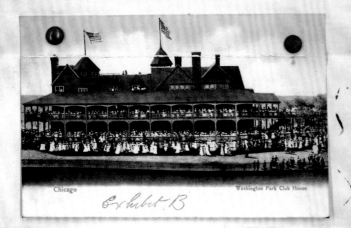

Chicago Washington Park Club House

Exhibit B

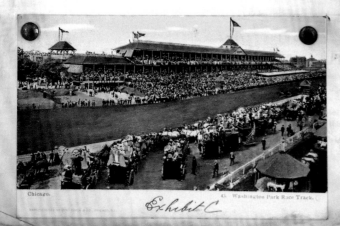

Chicago. 45. Washington Park Race Track.

Exhibit C

Chicago photographer George Lawrence was a pioneer in producing panoramic pictures. He designed his own cameras and would go to any length to create his photographs. He stood on ladders, went up in balloons, and once took a shot inside the Chicago Board of Trade after simultaneously igniting twelve pounds of flash powder placed in 350 spots along the room's balcony rails.

After Lawrence took a sweeping panorama of the Washington Park Race Track on Chicago's South Side, the Curt Teich postcard company produced colorized versions of Lawrence's photo. The two postcards shown here come from sections of the same Lawrence picture.

Lawrence sued Teich in 1906, alleging that the postcards were produced "without the consent in any way of the Plaintiff and against his will." Lawrence demanded that 6,000 of the postcards in Teich's possession be turned over to him.

Lawrence's suit was settled out of court. Eventually Lawrence moved on from photography to concentrate on aviation design.

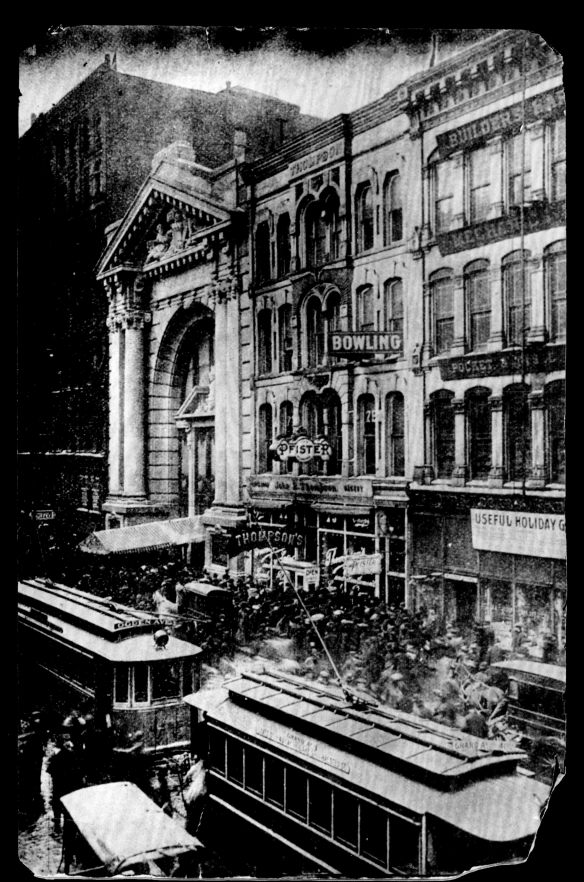

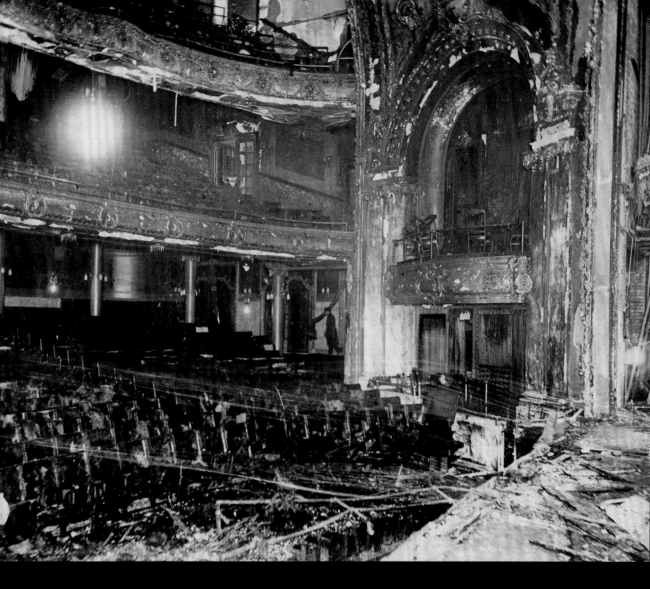

The Iroquois Theatre in Chicago's Loop was "absolutely fireproof," according to advertisements. Yet on December 30, 1903, a week after it opened, the Iroquois was the scene of the deadliest theater fire in U.S. history.

The sold-out matinee of *Mr. Blue Beard* had begun when sparks from an arc light ignited a curtain and the blaze rapidly spread. The design of the exits was inadequate.

Panicked spectators piled up at doors they could not open. At least 602 people died.

A flurry of legal action followed, but little of it was in federal court. A teenage survivor, Edna Hunter, sued the Iroquois Theatre and the construction company, George A. Fuller Co., in U.S. District Court. Edna had attended the show with several friends, two of whom died. Her burns required skin grafts, and

the newspapers wrote about how five friends had donated skin to help reconstruct her badly damaged ear.

District Judge Kenesaw Mountain Landis ruled for the defendants, first severing Fuller from the case and then dismissing the suit because city ordinances cited in the lawsuit were flawed.

Edna ended up getting $750 from Fuller in a local court case.

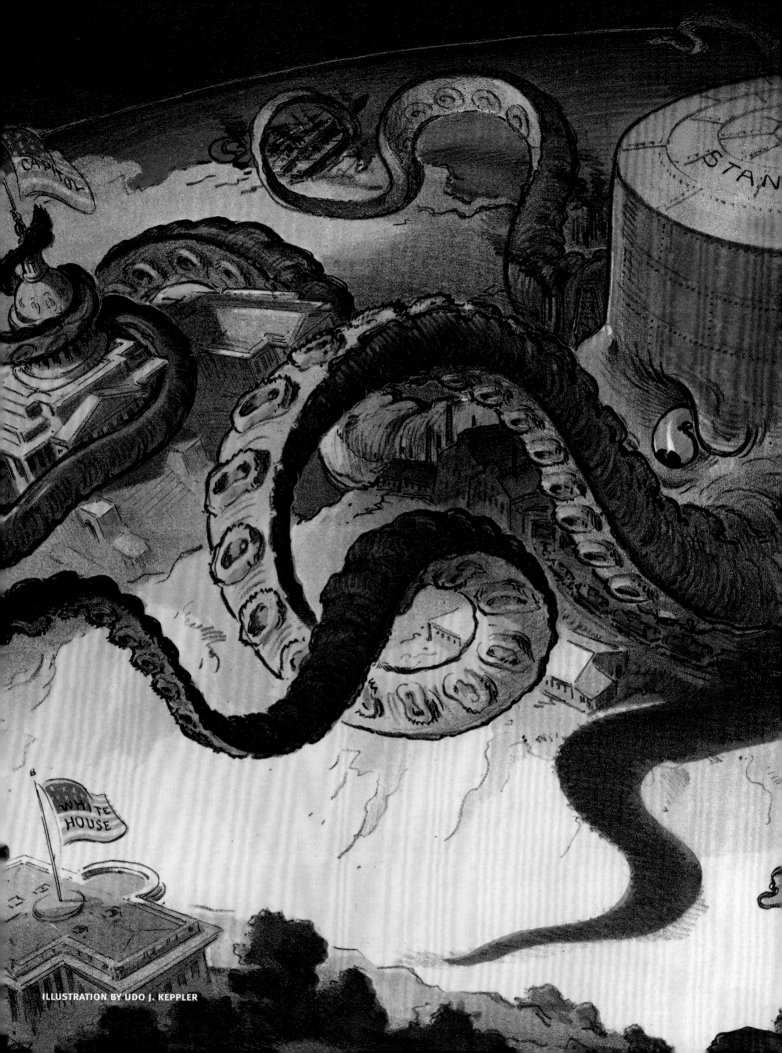

ILLUSTRATION BY UDO J. KEPPLER

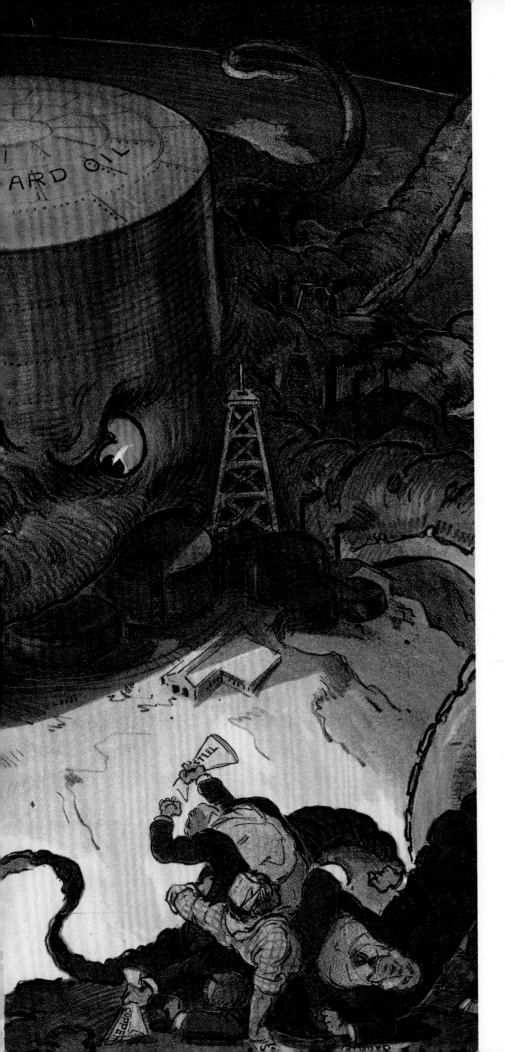

A MONOPOLY WITH MANY TENTACLES

Standard Oil was a behemoth. At one point, John D. Rockefeller's collection of corporations controlled 85 percent of the refined oil in the United States. It was powerful enough to strong-arm railroads into providing lavish rebates and jacking up the rates for competitors.

Rockefeller was often protected by the courts. For example, an attempt to serve him with a subpoena at his Cleveland estate was invalidated when a judge ruled he was in Ohio for personal reasons, not in his role as a businessman.

But in Chicago, District Judge Kenesaw Mountain Landis offered no such protection. He ruled in 1907 that Standard Oil owed the government more than $29 million for violating a federal ban on the railroad rebates. Standard Oil appealed, with a three-judge appeals panel throwing out the fines. The opinion was written by former Chicago District Judge Peter Grosscup, who was often vilified for pro-business decisions.

In 1911, a Supreme Court ruling in a separate case would break up Rockefeller's monopoly.

A fter all the grumbling about the federal court's poorly constructed Chicago home from 1880 to 1896, the government did better with its next permanent building, a Beaux-Arts giant designed by Henry Ives Cobb.

President William McKinley helped lay the cornerstone in 1899, but it was another six years before the building was ready for the courts to move in.

Officially called the Post Office, Custom House and Sub-Treasury, the building at 225 South Clark Street featured a 300-foot-high rotunda with a 100-foot diameter, making it larger than the rotunda of the U.S. Capitol in Washington. Its staircases were marble, and its elevators had open grilles.

The building, perhaps best known as the place where gangster Al Capone was convicted, was indeed a showcase. But it was also a target. A bomb planted by a suspected labor radical killed a postal worker there in 1918. Another explosive was disarmed three years later. In 1957, a disturbed ex-postal worker fired on guards before being subdued.

Though some held the building in high regard, others craved a more efficient place to work. A few years before its demise in 1965, the *Chicago Tribune* described it as a "granite octopus."

Chicago's position at the center of America's meatpacking industry made it a battleground for legal disputes over whether companies operated illegal monopolies.

The federal government had investigated price-fixing in the industry since 1905, the same year Upton Sinclair's exposé of the Chicago Stockyards, *The Jungle,* was first published in serial form. But it took until 1911 for federal prosecutors to bring ten meatpacking executives to trial on charges of price-fixing in violation of the Sherman Anti-Trust Law.

The trial, in the courtroom of District Judge George Carpenter, was so sensitive that jurors were sequestered from the first week in December 1911 until the end of March 1912—with no exception even for Christmas. In the end, all defendants were acquitted, prompting tears from both defendant Edward Swift and prosecutor James H. Wilkerson, who would later become a federal judge. As the trial ended, the meatpackers announced they were dissolving their jointly owned National Packing Company, which the prosecution called a vehicle for abusive practices.

Price-fixing cases often reached Chicago's District Court, including milk cases under judges Wilkerson, William Holly, Charles Woodward, and Phillip Sullivan in 1938. Judge Elwyn Shaw presided over a cheese price-fixing case in 1944, and Judge Winfred Knoch struck down monopoly charges against the Chicago Mortgage Bankers Association in 1954. A later case involving meatpacking resulted in Judge Hubert Will's 1971 oversight of the closing of the Stockyards.

THE UNITED STATES)

5166 vs.)

John Arthur Johnson,)

otherwise known as)

Jack Johnson.)

 We, the jury, find the defendant John Arthur

Johnson, guilty as charged in the indictment.

 James J Bruce Foreman

 W. A. Rek

 Christing

 D. J. Madison

 John McKanara

 Gus Carlson

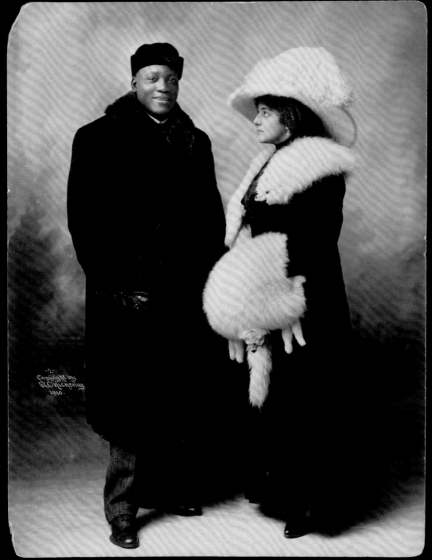

PHOTO BY ELMER CHICKERING

Jack Johnson, the first African American heavyweight boxing champion, refused to bend to the racism and sexual mores of his time. He is shown here with his wife, Etta, who had a tumultuous relationship with Johnson before she committed suicide in 1912.

The next year, Johnson's relations with white women led to federal charges under the White-Slave Traffic Act, also known as the Mann Act. It barred the transportation of a woman or girl across state lines for any "immoral purpose."

Johnson had indeed arranged for a woman to travel from Pittsburgh to Chicago, and they did indeed have sex without benefit of marriage. The woman, Belle Schreiber, was a white prostitute who freely admitted she was a "sporting woman." Johnson set her up in a South Side apartment building known for prostitution. As one of Schreiber's fellow residents put it: "I don't think you could make a mistake by ringing a bell."

When Schreiber took the stand, she faced questioning like this:
Q: Were you in love with him?
A: I don't know.
Q: What?
A: I don't know.
Q: Don't you know now? Did you think you were then?
A: I don't know what love is.

District Judge George Carpenter presided over the case, instructing the all-white jury: "The law does not apply solely to innocent girls. It is quite as much an offense against the Mann Act to transport a hardened, lost prostitute as it would be to transport a young girl, a virgin."

Johnson was convicted and sentenced to a year and a day plus a $1,000 fine. Freed pending appeal, Johnson fled to Canada. Eventually he returned to the United States and did his time.

In 2018, 72 years after his death, the famed boxer was pardoned by President Donald Trump.

Nº 11.

Western Electric Company employees piled onto the steamship *Eastland* on a July morning in 1915 for an excursion across the lake to Michigan City, Indiana. But before the ship had pushed away from the downtown dock on the Chicago River, it suddenly overturned. Within minutes, 844 lives were lost in the deadliest disaster in Chicago history.

Before the dead could even be buried, authorities launched investigations to assess blame. District Judge Kenesaw Mountain Landis wanted those investigations coordinated. He ordered the U.S. Commerce Department to stop interrogating witnesses for its internal investigation of the boat inspection service because he feared the probe would get in the way of a federal grand jury looking into the disaster. Others suspected that Commerce wanted to whitewash its own inspectors' culpability for the disaster.

It was widely expected that the grand jury would lead to charges, since the disaster appeared to be avoidable. The *Chicago Tribune* reported that several federal indictments had been "semi-officially promised," and another *Tribune* story was headlined "Federal Jury to Indict Dozen." But the grand jury ended without recommending any charges.

Even so, lawyers were busy sorting out civil claims, with about 600 lawsuits asking for $8 million in District Court. A dozen years after the disaster, a special master determined that the *Eastland* overturned because the chief engineer had filled water ballast tanks improperly. That conclusion relieved the ship's owner of most of the liability.

WRIGLEY FIELD WAS WEEGHMAN PARK

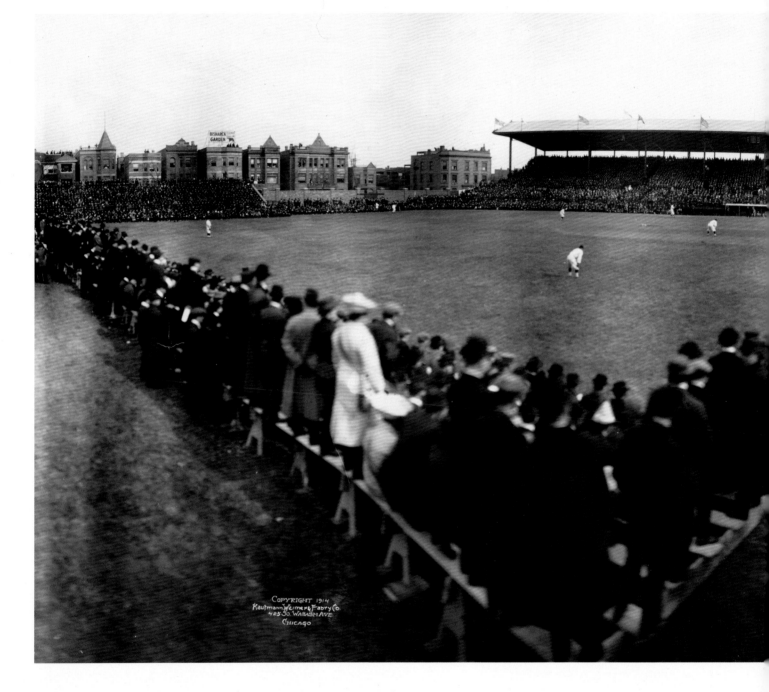

COPYRIGHT 1914
Kaufmann Weimer & Fabry Co.
425 So. Wabash Ave.
Chicago

The first Opening Day for Wrigley Field took place on April 23, 1914. But it wasn't called Wrigley back then; it was Weeghman Park. And the home team wasn't the Cubs; it was the Chicago Federals or Chi-Feds, the city's entry in the new Federal League that sought to rival the American and National leagues. Soon the Chicago team would be renamed the Whales.

The Federal League sued the two older leagues, complaining they were violating anti-trust law by blackballing players who signed with the new league and holding other players to unfair contracts to keep them from jumping. The case went before a baseball fan, District Judge Kenesaw Mountain Landis, who initially moved quickly but

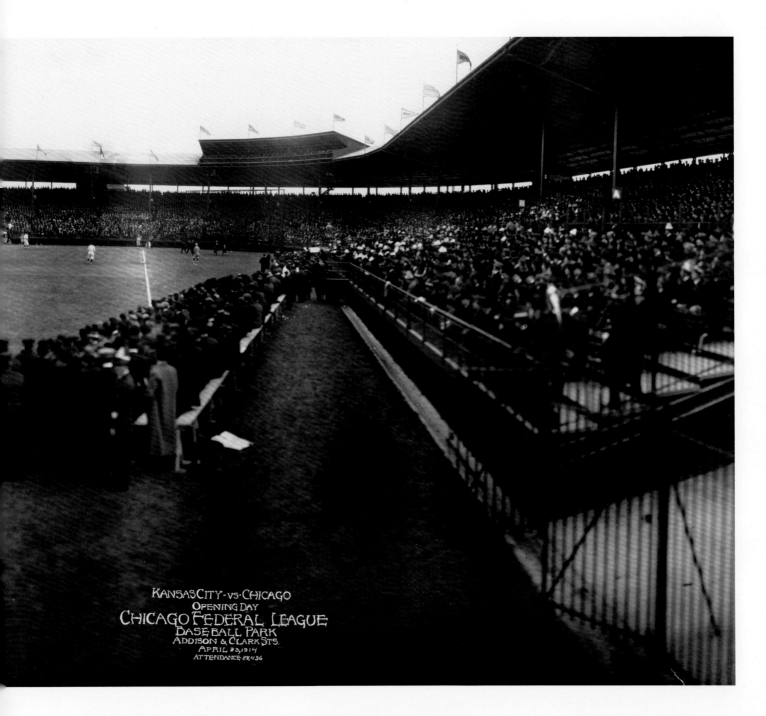

KANSAS CITY·vs·CHICAGO
OPENING DAY
CHICAGO FEDERAL LEAGUE
BASE BALL PARK
ADDISON & CLARK STS.
APRIL 23,1914
ATTENDANCE 28,436

soon became a human rain delay—releasing no ruling for many months. Finally, the cash-strapped Federal League cut a deal, shutting down its operations and allowing two of its owners to buy teams in the older leagues. The league—and the Whales—went belly-up after the 1915 season.

The lawsuit was dropped. The next year, the National League's Chicago Cubs moved from the West Side to the newly available stadium at Clark and Addison streets.

A separate lawsuit by Baltimore's Federal League team led to the U.S. Supreme Court ruling in 1922 that major league baseball was exempt from anti-trust laws. It's a decision that benefits team owners to this day.

ROUNDING UP THE WOBBLIES

The Industrial Workers of the World—the "One Big Union" often known as the "Wobblies"—was founded in Chicago in 1905 and earned a reputation for aggressive confrontation with big business.

In 1917, when the United States entered World War I, federal authorities targeted the IWW as an anti-American organization. Agents raided the Wobblies' national headquarters in Chicago and prosecutors charged more than 100 union leaders with conspiring to harm the war effort.

District Judge Kenesaw Mountain Landis presided over their trial at which all were convicted and sentenced to prison. The judge declared that dissent must be curtailed in wartime: "When the country is at peace, it is a legal right of free speech to oppose going to war ... but when once war is declared, this right ceases."

Among those imprisoned was IWW leader William "Big Bill" Haywood. "We who have been on trial are only a handful; our fellows have kept up the organization

and will continue to do so," Haywood said. "The fight cannot end." In fact, Haywood's fight *had* ended; the crackdown devastated the IWW. It was among the era's series of harsh government actions that sharply limited civil liberties in America.

In case you're wondering, there is no consensus on why IWW members were called

Wobblies. Some based it on criticism that union activists lacked commitment and were "wobblers." Others thought it came from a Chinese immigrant's poor pronunciation of IWW. A third theory involved the Australian phrase "on the wallaby track," which described people wandering around the country looking for work

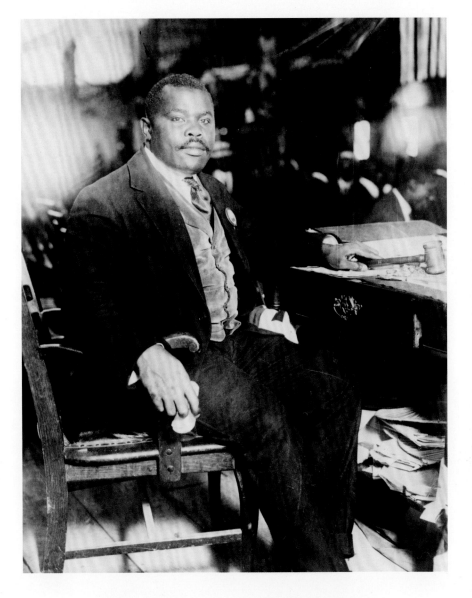

MARCUS GARVEY'S 'BLUE SKY' STRUGGLE

Marcus Garvey was the Jamaican-born stalwart of the "back to Africa" movement. He promoted an economic empowerment effort that called for blacks to establish businesses, organizations, and a unified Africa. But Garvey, founder of the *Negro World* newspaper, found himself in a feud with another black entrepreneur, Robert Abbott, founder of the *Chicago Defender.*

Abbott made an impact on the nation with his Chicago newspaper, which urged Southern blacks to come north for civil rights. Abbott's approach, encouraging African Americans to participate and prosper in white society, conflicted philosophically with Garvey's black-separatist views.

When Garvey tried to start a new steamship company called the Black Star Line, Abbott's *Defender* depicted the enterprise as a scam. And when Garvey came to Chicago in 1919 for fundraising, Abbott arranged for him to be arrested on orders of the Illinois attorney general, Edward Brundage. Garvey was charged with violating "blue-sky laws" designed to curb investment swindles. The incident was played up in the *Defender,* which reported that the steamship line, "instead of sailing the Atlantic Ocean en route to some foreign port, had anchored at the Harrison police station."

Illinois' blue-sky fine was small, and Garvey was soon freed to return to New York. But he wasn't done tussling with Abbott. A *Defender* story headlined "Brundage 'Sinks' Black Star Line" prompted Garvey to sue, complaining that the paper had libeled him and tried to destroy his business. District Judge George Carpenter dismissed the case, with Garvey paying court costs.

The Black Star Line soon failed, and Garvey was later convicted of mail fraud in New York and sent to prison.

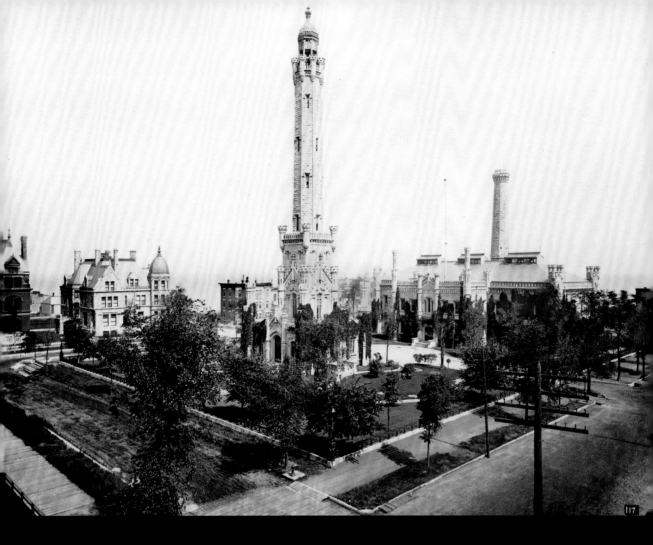

117

Captain George Wellington Streeter found himself in court quite often, but those were state courts, not the U.S. District Court. His widow, on the other hand, made a splash as a federal litigant.

The captain was one of the oddest characters in Chicago history. In 1886, his boat became stuck on sand north of the mouth of the Chicago River. That's the high-rent district now, but back then it was a seedy den of vice and mostly vacant and where builders dumped construction waste.

Streeter's boat became surrounded by such landfill, and he brazenly claimed the area as his "Deestrick of Lake Michigan," a territory separate from the state of Illinois and the city of Chicago. City officials spent years trying to evict Streeter, whose mischief made good copy for newspapers. He finally lost his land claims in court in 1918, and died three years later.

His widow, Elma "Ma" Streeter, filed a federal lawsuit in 1924 against 1,500 lakefront property owners

for $1 billion. District Judge James Wilkerson threw out her claim on the grounds that her marriage to the captain was invalid. The next day, she received another indignity when police charged her with improperly docking her houseboat in the Chicago River, failing to install lights on the boat, or giving the boat a name. She spent a night in jail.

After Ma's lawsuit was tossed, other Streeter heirs filed their own unsuccessful claims, the final claim being evicted from court in 1940

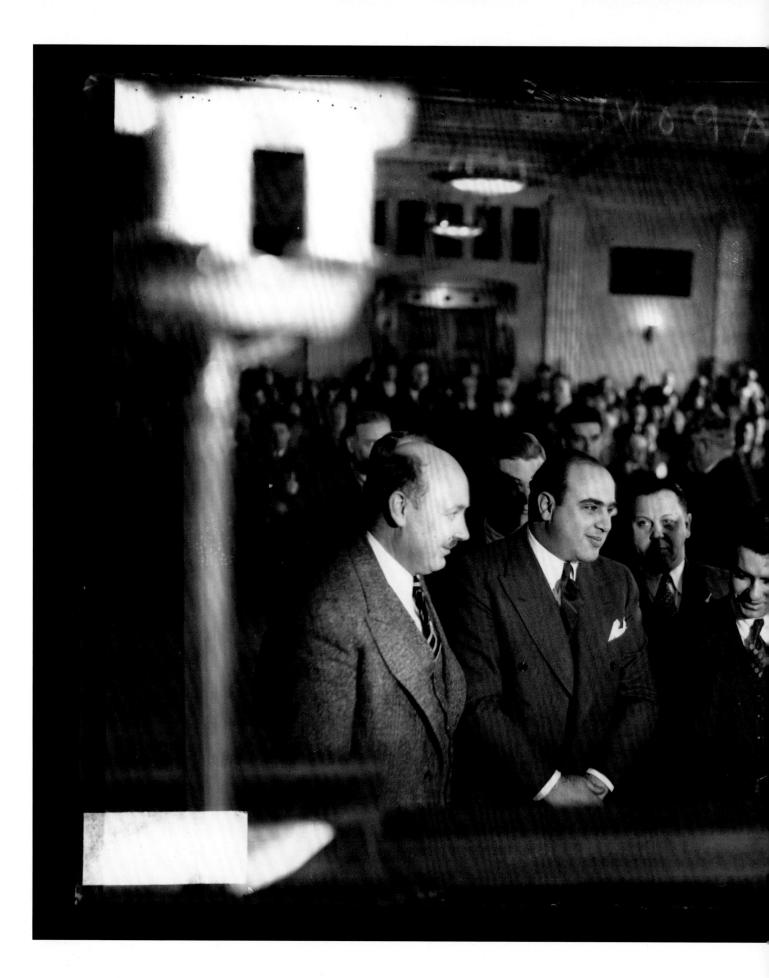

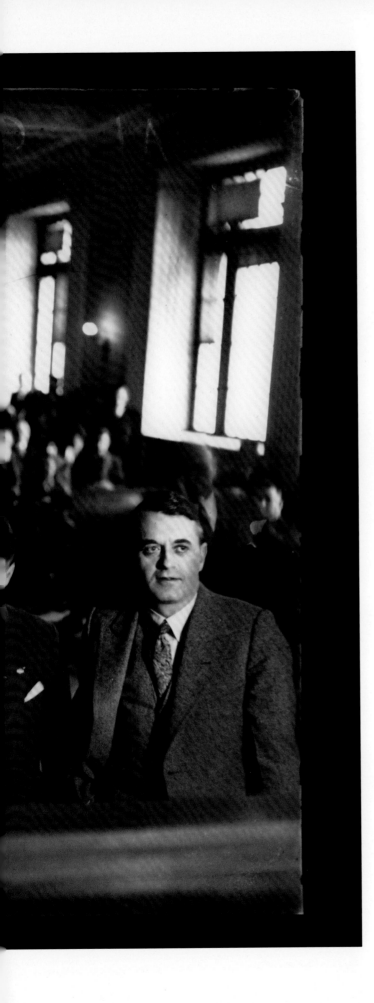

CAPONE AND 'THE ABSOLUTE UNREACHABILITY OF THE FEDERAL COURTS'

Perhaps nowhere in the history of the federal courts has there been a better example of U.S. law enforcement taking on a public danger that local authorities were utterly incapable of addressing. The federal target: Alphonse Capone, top mob boss in a Chicago suffering from unchecked gangsterism and lawlessness.

Capone was suspected of ordering the murder of seven associates of rival mobster Bugs Moran in the 1929 St. Valentine's Day Massacre, and of orchestrating countless other killings. The local police were either on the take or afraid to stand up to Scarface's firepower.

But Capone had a vulnerability that federal investigators exploited: He hadn't paid income tax on his ill-gotten gains. Capone knew he was in trouble and initially planned to take a plea deal for a short prison term. But Capone's showy public appearances at the racetrack and ballpark so infuriated District Judge James Wilkerson that he rejected the deal. The case went to trial.

To guard against jury tampering, Wilkerson brought in a new set of jurors at the last minute. Capone was convicted by three grocers, two painters, a pattern maker, a real estate broker, a stationary engineer, a hardware merchant, an insurance agent, a farmer, and a clerk. Wilkerson sentenced Chicago's most notorious criminal to ten years in prison and one year in the county jail, plus $50,000 in fines and costs.

Prosecutor George E.Q. Johnson credited the outcome to "the absolute unreachability of the federal courts."

CHEERS TO THE BATTLE AGAINST BOOTLEGGING

In 1933, the staff of the Palmer House in downtown Chicago was ready for the end of Prohibition—the 13-year national ban on booze.

The defiance of Prohibition, and the spotty attempts to enforce it, had kept both mobsters and judges—especially James Wilkerson and Adam Cliffe—busy for years.

George E.Q. Johnson, the U.S. attorney who put Al Capone away, served as a judge in the waning days of Prohibition. He joined the court under a recess appointment by President Herbert Hoover. But he was not backed by President Franklin Roosevelt and the Senate, so Johnson left the court after only seven months, the shortest judicial term in the Northern District's history.

But during Johnson's brief time on the bench, he presided over a few noteworthy Prohibition cases. He convicted John Kluczynski, a state representative who quietly faced the music for a two-year-old Prohibition violation and received a suspended six-month sentence. Kluczynski later became a U.S. congressman. The Kluczynski Federal Building was named in his honor after his death in 1975.

Johnson also presided over the case of a bootlegger from the western suburb of Riverside who pleaded for mercy, telling the judge that his pregnant wife needed him. Problem was, the pregnant-looking woman who showed up in court had been hired by the suspect to pose as his wife. The suspect got sixty days in jail for bootlegging and another sixty for contempt of court.

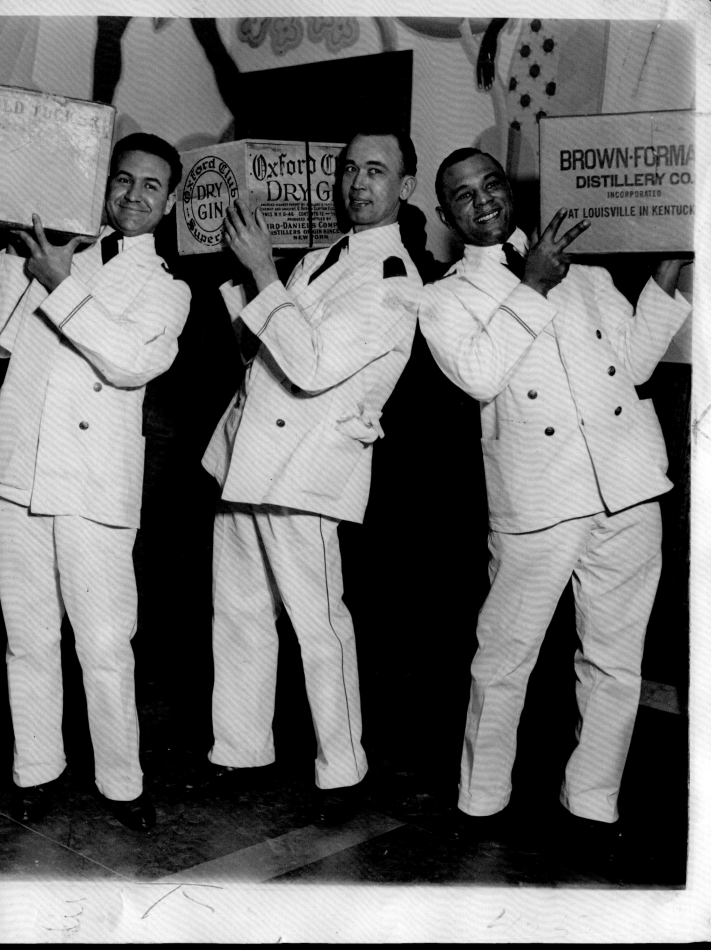

SCRUBBING THOSE FILTHY FILMS

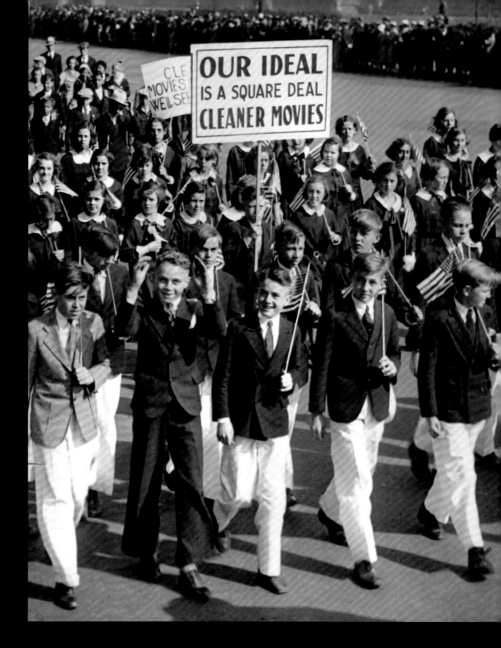

Catholic boys and girls paraded down Michigan Avenue in 1934 as part of the Legion of Decency's campaign for "cleaner movies." The film industry faced major scrutiny in Chicago, which had long employed official censors and even demanded custom edits to guard the morals of its residents.

The battles between Chicago censors and Tinseltown came to a head with two federal rulings in 1959.

District Judge Philip Sullivan struck down a provision of Chicago's city code that allowed the police censor board to label a film as "adults only." Paramount Film Distributing Corporation had filed suit challenging that designation for *Desire Under the Elms* starring Sophia Loren and Anthony Perkins.

That same year, the censor board ruled that the James Stewart movie *Anatomy of a Murder* could not be shown in Chicago unless five pieces of "immoral and obscene" dialogue were removed.

Director Otto Preminger flew into town to lobby city officials. They trimmed their objections to two sections of dialogue, but Columbia Pictures would not compromise and instead filed suit in federal court. District Judge Julius Miner ruled against the censorship.

Chicago's film censorship ordinance was tossed out by the U.S. Supreme Court in 1968, reversing an Illinois Supreme Court finding that city officials acted properly in banning *Rent-a-Girl* and *Body of a Female.* The City Council rewrote and passed a new ordinance addressing the high court's concerns about lack of prompt legal review under the old law. The new ordinance was challenged by seven movie distributors that objected to any censorship at all, but District Judge Alexander Napoli ruled it constitutional.

HOW 'CANNED MUSIC' FOUND AN OPENING

In retrospect, James Caesar Petrillo's struggle seemed doomed to failure, but that wasn't so clear in 1942 when the nation's musicians union boss declared war on "canned music."

Petrillo, shown here at right, stuck up for live entertainment by banning members of his American Federation of Musicians from working on recordings for radio, jukeboxes, or other commercial use except for home enjoyment. The union said it was striking the latest blow in "the ancient struggle between man and machine."

Government attorneys weren't quite as philosophical—or opposed to modern technology. They saw Petrillo's ban as an anti-trust violation and took his union to court, seeking an injunction.

But District Judge John Peter Barnes denied the government's request for an injunction, ruling that the fight over Petrillo's ban was essentially a labor dispute and did not fall under anti-trust laws. That ruling was appealed to the U.S. Supreme Court, which affirmed Barnes' decision.

In 1946, Petrillo was charged with violating a federal ban on unions forcing broadcasters to hire more workers than needed. But District Judge Walter LaBuy found Petrillo not guilty, and the union boss held firm until he reached royalty agreements with recording companies. Only then could technology move forward.

Petrillo's efforts are remembered by the Petrillo Music Shell in Grant Park.

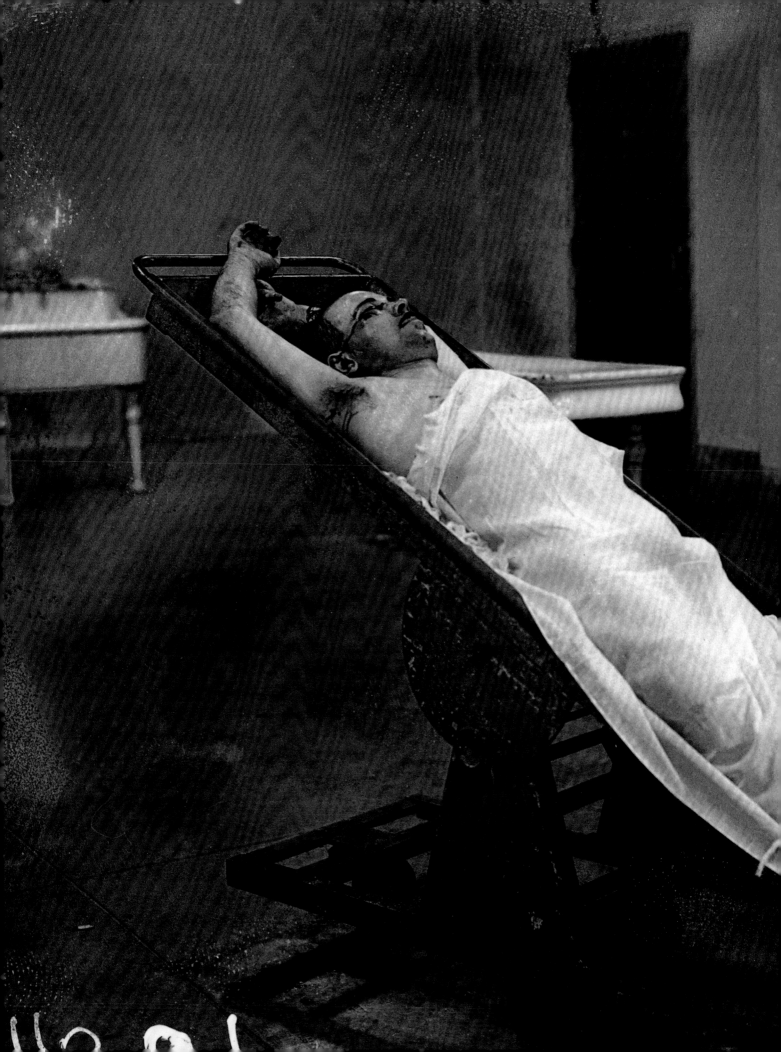

JUSTICE OUTSIDE THE BIOGRAPH THEATER

The public was fascinated with John Dillinger, known for deadly bank robberies and daring escapes from jail. Federal agents, far less enthralled, launched a manhunt for "Public Enemy No. 1." In the summer of 1934, they got a tip from Romanian immigrant Anna Sage, described as a "disorderly resort keeper"—in other words, a prostitute and madam.

Sage had recently met a man she recognized as Dillinger, and she told authorities, hoping they'd help her fight her deportation, ordered because of her morals arrests. Sage told police that Dillinger planned to take her and another lady friend to the movies. So federal agents were armed and ready outside the Biograph Theater on Chicago's North Side when the trio strolled out of the Clark Gable film *Manhattan Melodrama.* Dillinger was shot to death and, with public interest at its peak, his body was put on display at the morgue.

The role of the District Court was a footnote: Sage, known as "the Woman in Red," insisted that federal agents had promised she could stay in the country, but the deportation process continued. Sage lost her appeal to District Judge John Peter Barnes. She received a $5,000 reward for turning in Dillinger, but was denied a place in America. As she prepared to leave in 1936, Sage continued to correct the news media on one key detail: she had been wearing orange that night, not red.

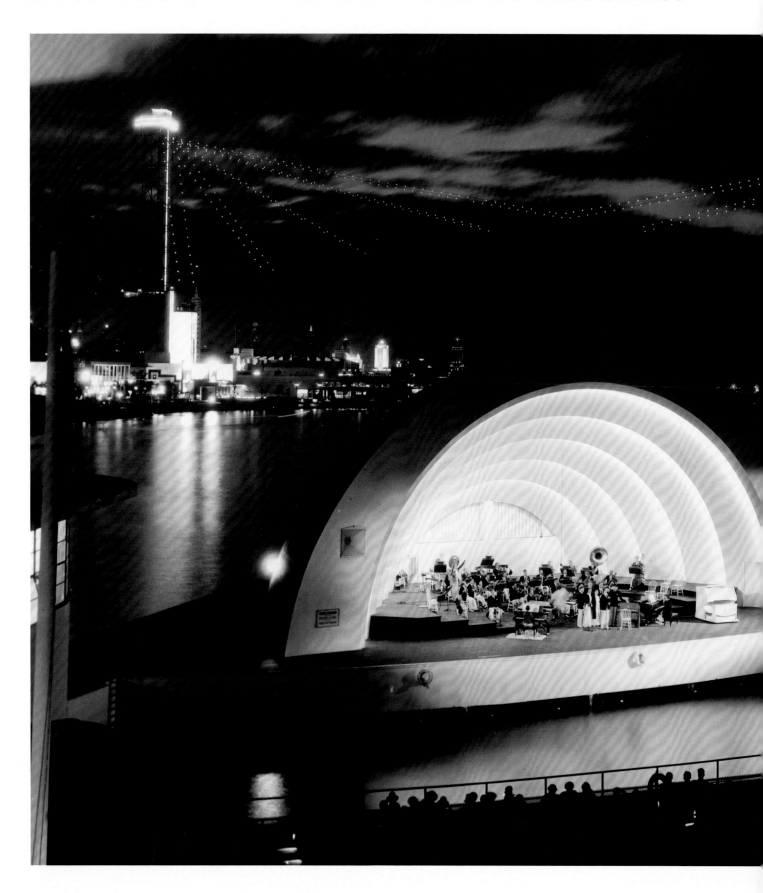

The Century of Progress, Chicago's World's Fair of 1933-34, gained publicity when scantily clad fan dancer Sally Rand was arrested for indecency. But that was just a local hassle. Another fair-related legal case ended up in federal court and involved a different sensation, the Dionne quintuplets.

In May 1934, Elzire Dionne of Ontario, Canada, gave birth to five identical girls. The births made news worldwide, and Chicago promoter Ivan Spear rushed to Canada to arrange for the quints to appear at the Century of Progress. Spear told the family that the quints' birth was "the greatest human interest story since the Armistice" that ended World War I.

Spear said he had a signed deal, but the quints' doctor, Allan Dafoe, refused to approve their travel. Spear filed a $1 million lawsuit against Dafoe and others involved with their publicity. District Judge John Peter Barnes allowed jurors to hear testimony, but then dismissed the case.

Dr. Dafoe told Chicago reporters he was pleased but not shocked by the decision: "I have never been surprised at anything since the night the five babies were born."

The doctor ended up having a major role in the quints' upbringing. The kids lived under his supervision in a government-built nursery across from the family farmhouse. While the Dionnes were never displayed in Chicago, they still ended up as exhibits. In their first nine years at the nursery, they received about 3 million visitors.

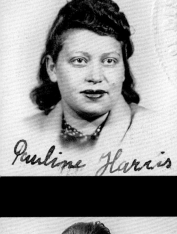

Pauline Harris

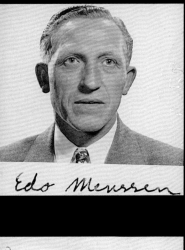

Edo Meurren

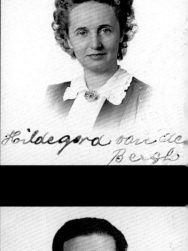

Hildegard van de Bergh

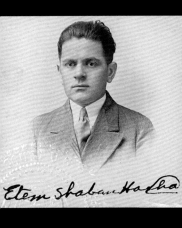

Etem Shaban Hodha

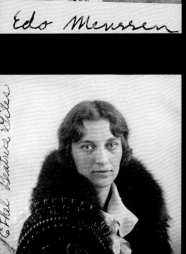

Ethel Beatrice Stiles

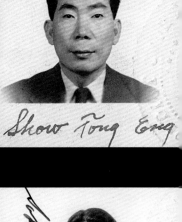

Show Tong Eng

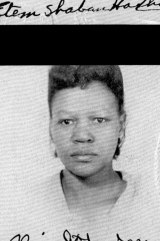

Eloise Johnson

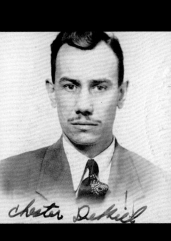

Chester DeKiel

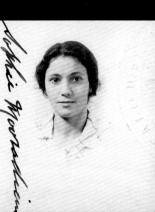

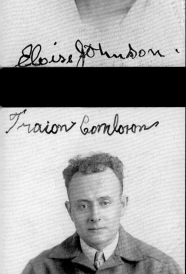

Traion Comloron

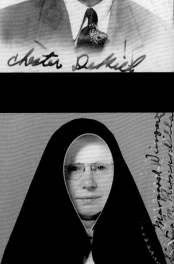

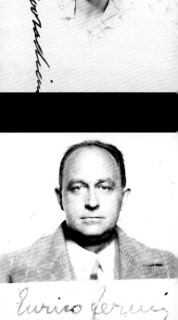

Enrico Fermi

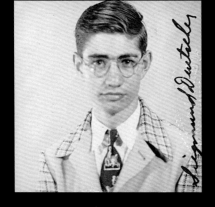
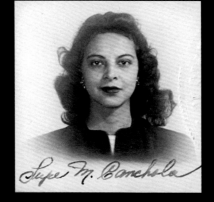
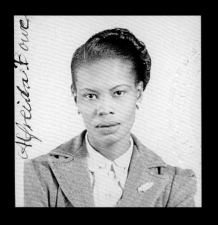
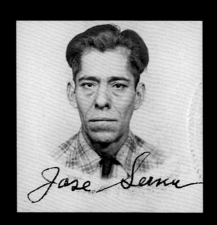
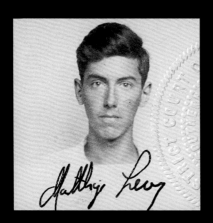
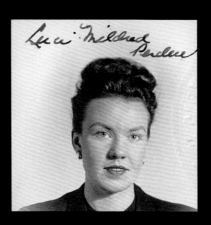
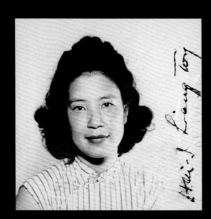
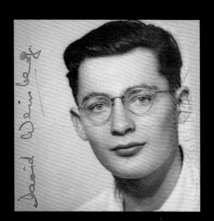

Close to a million Chicago-area immigrants have achieved U.S. citizenship though the District Court of Northern Illinois. To become citizens, immigrants generally need to live in the United States for five years and must show they can speak, write, and read in English. Applicants undergo an FBI background check and take English and civics tests. It is not an easy process and can take over a year.

Naturalization ceremonies, held in the Ceremonial Courtroom, are glorious moments. "You can still revere your country's traditions, its food, its language, its culture, and its customs," District Judge Sara Ellis told a group of new citizens whom she swore in during 2017. "Everything that you love and hold dear about your country, you can continue to love and hold dear. What you are doing today is opening yourself up to loving another country, different traditions and customs, maybe even a different language, but this now is your home."

Ellis knew. She was born in Canada and became a naturalized citizen when she was 15 years old.

The photos shown here were attached to prospective citizens' Declaration of Intention filed with the court over several decades.

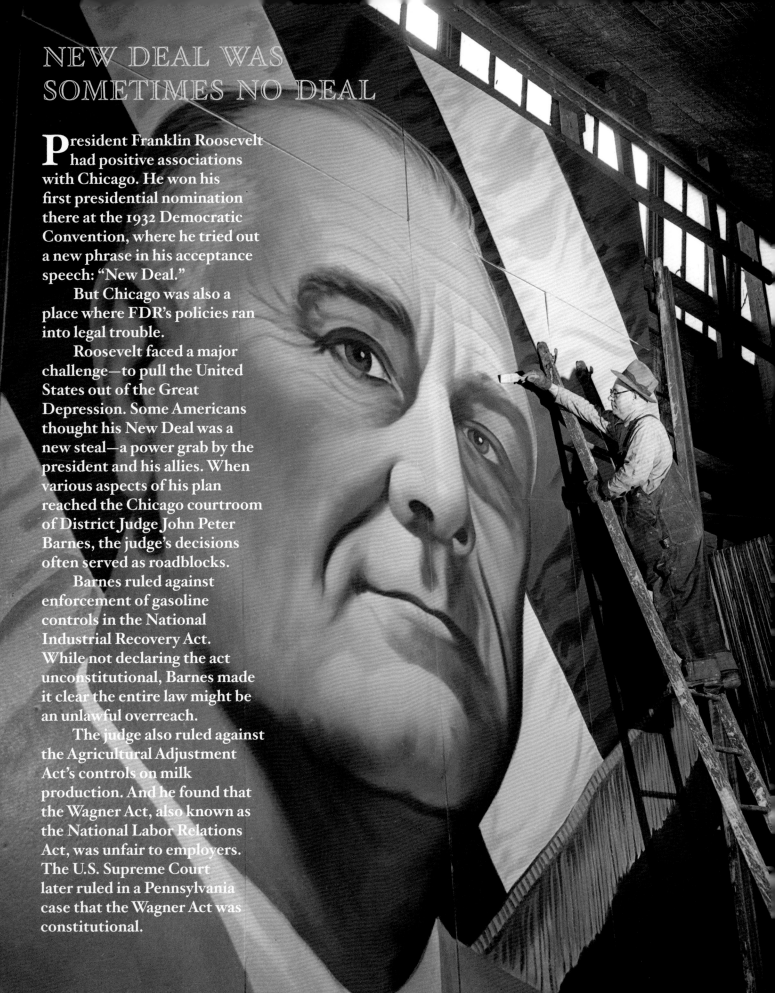

NEW DEAL WAS SOMETIMES NO DEAL

President Franklin Roosevelt had positive associations with Chicago. He won his first presidential nomination there at the 1932 Democratic Convention, where he tried out a new phrase in his acceptance speech: "New Deal."

But Chicago was also a place where FDR's policies ran into legal trouble.

Roosevelt faced a major challenge—to pull the United States out of the Great Depression. Some Americans thought his New Deal was a new steal—a power grab by the president and his allies. When various aspects of his plan reached the Chicago courtroom of District Judge John Peter Barnes, the judge's decisions often served as roadblocks.

Barnes ruled against enforcement of gasoline controls in the National Industrial Recovery Act. While not declaring the act unconstitutional, Barnes made it clear the entire law might be an unlawful overreach.

The judge also ruled against the Agricultural Adjustment Act's controls on milk production. And he found that the Wagner Act, also known as the National Labor Relations Act, was unfair to employers. The U.S. Supreme Court later ruled in a Pennsylvania case that the Wagner Act was constitutional.

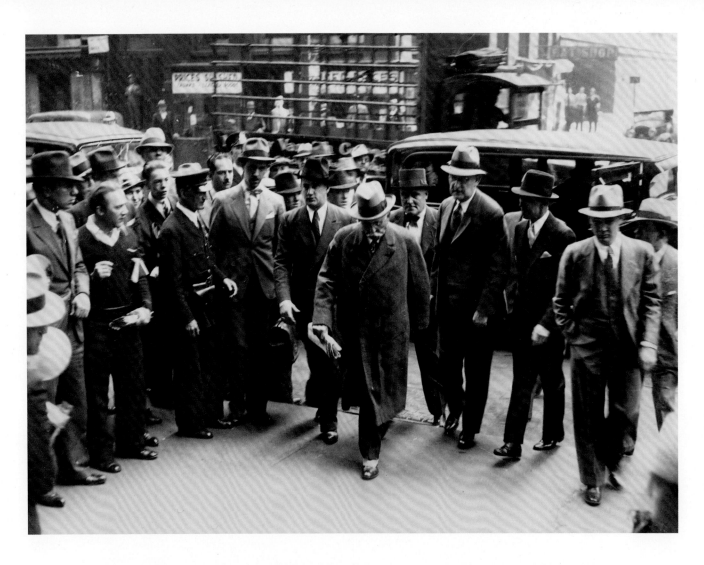

ELECTRICITY BOSS LOST POWER

British-born Samuel Insull rose to business prominence as inventor Thomas Edison's personal secretary and then as president of the Chicago Edison Company, later known as Commonwealth Edison. His company offered reasonable rates on electricity to encourage consumption and build revenue.

But while prosperity made Insull powerful, a lack of prosperity made him vulnerable. He had sold bonds to everyday Americans to finance his business expansion, and the Great Depression made those investments worthless. It also made Insull a scapegoat, and he was charged with fraud.

"What I did, when I did it, was honest; now, through changed conditions, what I did may or may not be called honest," Insull said. "Politics demand, therefore, that I be brought to trial."

Insull withstood two federal trials and one in a Cook County court. He was acquitted each time. The federal trials were presided over by District Judge James Wilkerson in 1934 and John Knox, a visiting New York federal judge in 1935

Despite the not-guilty verdicts, Insull's reputation was ruined, and he left for France. When he died of a heart attack in a Paris subway station a few years later, the former head of a $4 billion empire had the equivalent of 84 cents in his pocket.

Herbert Haupt was born in Germany, immigrated with his parents to Chicago, and became a U.S. citizen. At age 21, he took a trip with a friend to Mexico, Japan, and finally Germany. Haupt was there when his native country and his adopted homeland went to war in 1941. The German government, recognizing Haupt's knowledge of the United States, trained him as a saboteur and dropped him off in Florida by submarine. Haupt traveled to Chicago and stayed with his parents. He was arrested there by FBI agents who tracked him down through another would-be saboteur.

Haupt faced a military tribunal in Washington, D.C., was convicted, and was executed by electric chair.

His parents, Hans and Erna, were tried in District Judge William Campbell's Chicago courtroom on charges of assisting in their son's treason. Both were convicted, with Hans sentenced to death and Erna to 25 years in prison. On appeal, the Seventh Circuit sent the case back for retrial. Erna was deported, while the government retried Hans in District Judge John Peter Barnes' courtroom. The jury convicted him, but sent Barnes a note urging mercy. Hans received a life sentence. Ultimately, he too was deported to Germany.

Chicago, Illinois
June 7, 1944

GOVERNMENT EXHIBITS INTRODUCED AND RECEIVED IN EVIDENCE:

NO.	DESCRIPTION	IDENTIFIED BY:	ENTERED
1	Photograph of Lieutenant WALTER KAPPE	ERNEST PETER BURGER, 5/25/44	5/25/44
2	Photo of GEORGE JOHN DASCH	ERNEST PETER BURGER, 5/25/44	5/25/44
3	Photo of HERBERT HAUPT	ERNEST PETER BURGER, 5/25/44	5/25/44
4	Photo of HEINRICH HEINCK	ERNEST PETER BURGER, 5/25/44	5/25/44
5	Photo of EDWARD KERLING	ERNEST PETER BURGER, 5/25/44	5/25/44
6	Photo of HERMAN NEUBAUER	ERNEST PETER BURGER, 5/25/44	5/25/44
7	Photo of RICHARD QUIRIN	ERNEST PETER BURGER, 5/25/44	5/25/44
8	Photo of WERNER THIEL	ERNEST PETER BURGER, 5/25/44	5/25/44
10	Money Belt	ERNEST PETER BURGER, 5/25/44	5/25/44
11	Trench Shovel with rope	ERNEST PETER BURGER, 5/25/44	5/25/44
12 & 13	Two Trench Shovels	ERNEST PETER BURGER, 5/25/44	5/26/44
14	#1 Wooden Box with Tin Container	ERNEST PETER BURGER, 5/25/44	5/26/44
15, 16, 17 & 18	Four German Marine Caps	ERNEST PETER BURGER, 5/25/44	5/26/44
19	Ring of HERBERT HAUPT	ERNEST PETER BURGER, 5/25/44	6/2/44
20	Blank Draft Registration Card	ERNEST PETER BURGER, 5/25/44	(not entered)
21	Social Security Card of HERBERT HAUPT	ERNEST PETER BURGER, 5/25/44	6/2/44
22	Time Delay Clock (14 days)	ERNEST PETER BURGER, 5/25/44	5/26/44
23	Fountain Pen & Pencil Set (physical)	ERNEST PETER BURGER, 5/25/44	5/26/44
24	Cardboard paper & metal detonators (70 mins)	ERNEST PETER BURGER, 5/25/44	5/26/44
25	Photo of coal explosives	ERNEST PETER BURGER, 5/25/44	5/26/44
26	Photo of 4 wooden boxes in garage	ERNEST PETER BURGER, 5/25/44	5/26/44
27	Photo of Ponte Vedra Beach	EARL J. CONNELLEY, 5/25/44	5/26/44
28	Photo of 2 boxes in sand pit at Ponte Vedra	EARL J. CONNELLEY, 5/25/44	5/26/44
29	Photo of 4 boxes in sand pit at Ponte Vedra	EARL J. CONNELLEY, 5/25/44	5/26/44
30	Box #4 Open & contents (detonators & fuses & time clocks)	EARL J. CONNELLEY, 5/25/44	5/26/44
31	Box #3 - Open & contents (10 TNT block-like coal - coils of safety fuse)	EARL J. CONNELLEY, 5/25/44	5/26/44
32	Box #2 - Open & Contents (18 TNT Block Demo)	EARL J. CONNELLEY, 5/25/44	5/26/44

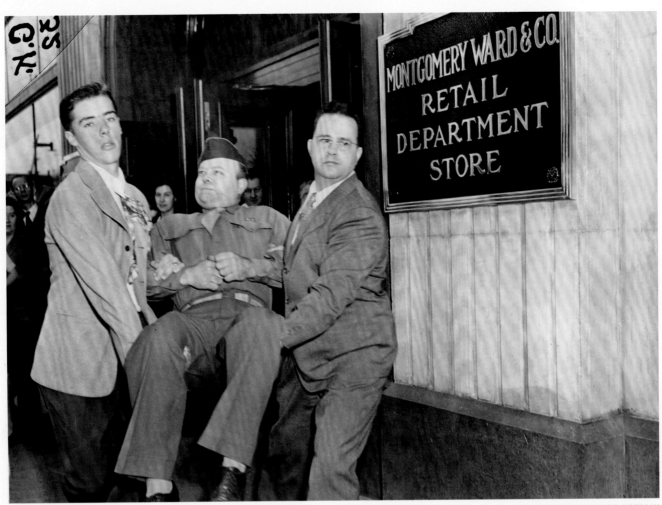

PHOTO BY GEORGE KOTALIK

MANAGEMENT'S SIT-DOWN STRIKE

Sewell Avery, a business executive who rescued the Montgomery Ward catalog company from desperate straits during the Depression, did not welcome union activism and was no admirer of Franklin Roosevelt. When Avery refused to settle a strike in 1944, Roosevelt invoked wartime powers and seized control of Montgomery Ward. Attorney General Francis Biddle showed up at Avery's office with a military escort.

Avery recalled Biddle telling the soldiers to throw him out.

"A colonel—a courteous soldier—came over and asked me to stand up," said Avery. "I told him I wouldn't budge an inch."

At that point, two national guardsmen lifted Avery from his office chair and hauled him away—creating a memorable wartime image from America's home front.

Roosevelt declared that Avery's company "has waged a bitter fight against the bona fide unions of its employees throughout the war, in reckless disregard of the government's efforts to maintain harmony between management and labor."

A month later, District Judge Phillip Sullivan ruled that the government's action had been illegal, but the feds prevailed on appeal. The military presence remained at Montgomery Ward until October 1945, when a photographer captured two workers ceremoniously removing Corporal Joseph Tobys from the premises.

Nation of Islam leader Elijah Muhammad was indicted on a sedition charge in 1942 for telling his followers not to register for the draft or serve in the armed forces during World War II.

The government charged Muhammad, born Elijah Poole in 1897, with resisting the war effort in a series of statements to followers at the Allah Temple of Islam on Chicago's South Side. FBI agents told a federal grand jury that Muhammad said Muslims are not citizens of the United States.

He allegedly declared: "The black man owes no respect to the American flag because under the American flag the negro is oppressed, beaten and lynched; that the only allegiance a Moslem owes is to the flag of Islam." He was also accused of saying the Japanese were "the brothers of the negro" and were fighting to free blacks in the United States.

According to court documents, the case was dismissed in 1943 before Judge John Peter Barnes, but Muhammad was imprisoned until 1946 for failure to register for the draft.

"When the call was made for all males between 18 and 44, I refused (not evading) on the grounds that, first, I was a Muslim and would not take part in war and especially not on the side with the infidels," he wrote in his 1965 book *Message to the Blackman in America.* "Second, I was 45 years of age and was not, according to the law, required to register."

Actually, Selective Service law at the time required men between the ages of 18 to 64 to register

FOR THE HANSBERRYS, A DREAM DEFERRED

Laws and rules that prop up racial discrimination are major themes in the Lorraine Hansberry play *A Raisin in the Sun.* They also formed the backdrop of Hansberry's life growing up on Chicago's South Side.

Lorraine's father, Carl Hansberry, brought cases to state and federal courts challenging racial bias in Chicago. Hansberry, a former Northern District Court deputy marshal who owned a successful real estate business, filed a federal lawsuit in 1938 against two railroad companies for discriminating against him on a trip from Chicago to Ardmore, Oklahoma. Hansberry paid for a first-class ticket, but was sent to the second-class "day coach" after the train left Kansas City, Missouri, and to a "filthy, unsanitary" third-class compartment after leaving Arkansas City, Kansas. He asked for $50,000, but did not win.

Hansberry later challenged Chicago's restrictive covenants designed to keep blacks from moving into white neighborhoods, when the family relocated into the nearly all-white Woodlawn neighborhood. The state courts enforced the restrictive covenants and dismissed the complaint, but Hansberry took his case to the U.S. Supreme Court and won.

Victory came at a cost: Wrote Lorraine Hansberry in *To Be Young, Gifted and Black,* "Twenty-five years ago, [my father] spent a small personal fortune, his considerable talents, and many years of his life fighting, in association with NAACP attorneys, Chicago's 'restrictive covenants' in one of this nation's ugliest ghettos. That fight also required our family to occupy disputed property in a hellishly hostile 'white neighborhood' in which literally howling mobs surrounded our house. . . . My memories of this 'correct' way of fighting white supremacy in America include being spat at, cursed and pummeled in the daily trek to and from school."

Shown here is *A Raisin in the Sun* on Broadway, starring Glynn Turman *(from left),* Sidney Poitier and John Fiedler.

DECEMBER

A Merry Christmas to you all!
I'm off to join the WAACs,
And serve the country that I love
Until the Axis cracks!

S	M	T	W	T	F	S
		1	2	3	4	
5	6	7	8	9	10	11
12	13	14		16	17	18
19	20	21	22	23	24	25
26	27	28	29	30	31	

WAAC

COMPROMISING POSITION ON VARGA GIRLS

Peruvian-born artist Alberto Vargas was famous for illustrations of phantasmagoric women wearing scanty clothing. The drawings were morale boosters during World War II. Novelist Kurt Vonnegut, a war veteran, wrote that GIs' "capacity to make do with imaginary women gave our military forces a logistical advantage." Unlike foreign armies that arranged for female companionship, "American soldiers and sailors simply brought their own undemanding and nearly weightless dolls along."

Back home, however, postal inspectors pointed out the Varga Girl when they challenged *Esquire* magazine on obscenity grounds. *Esquire* prevailed. After the war, Vargas sued *Esquire* in an attempt to get out of his exclusive contract. *Esquire* prevailed again.

A few years later, *Esquire* sued Vargas over outside sales of Varga Girl artwork in violation of his contract, and the case was heard in Chicago. District Judge William Campbell said the clothing in Vargas' work was as "concealing as the ordinary window pane." He took judicial note of "the exaggerated torso and the subtly curved but unduly long leg." In a Solomonic decision, Campbell found a middle ground, ruling that Vargas could draw sexy women for other publications, but that only in *Esquire* could they be labeled Varga Girls.

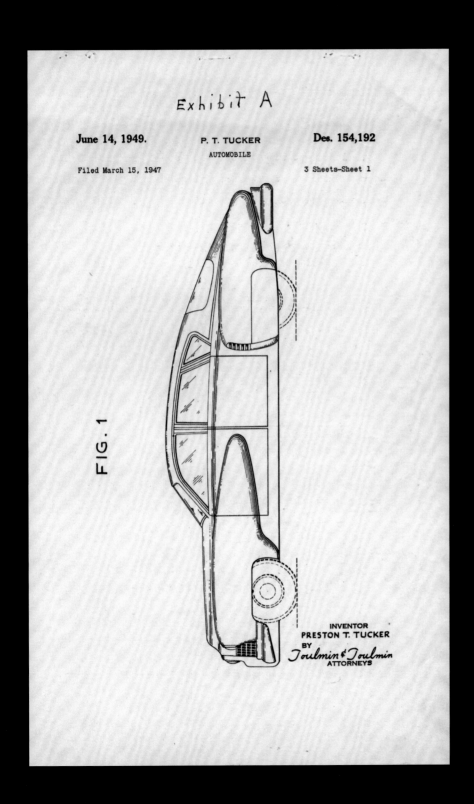

Exhibit A

June 14, 1949. P. T. TUCKER Des. 154,192
AUTOMOBILE

Filed March 15, 1947 3 Sheets—Sheet 1

FIG. 1

INVENTOR
PRESTON T. TUCKER
BY
Toulmin & Toulmin
ATTORNEYS

Preston Tucker was a visionary who got poked in the eye.

His innovative auto was initially called the Tucker Torpedo, but renamed the Tucker '48 to downplay the military imagery in postwar America. Built with cutting-edge disc brakes and a pop-out windshield, the sedan also featured a center headlight known as the "Cyclops Eye" that turned along with the car's wheels.

But just as Tucker was getting started, he collided with the government.

The Securities and Exchange Commission investigated Tucker's stock practices, which put a chill on investor interest. Tucker and seven associates faced criminal charges of mail fraud and securities violations, although they were acquitted. But it was too late for the car company.

The Tucker controversy kept Chicago's judicial talent busy, with cases handled by District Judges John Peter Barnes, William Campbell, Michael Igoe, Walter LaBuy, and Philip Sullivan.

Only 52 Tuckers were built. In 2011, one was found in a garage in Auburn, Washington, where it had sat for 54 years. Unrestored, it sold for nearly $800,000. Restored Tuckers can sell for

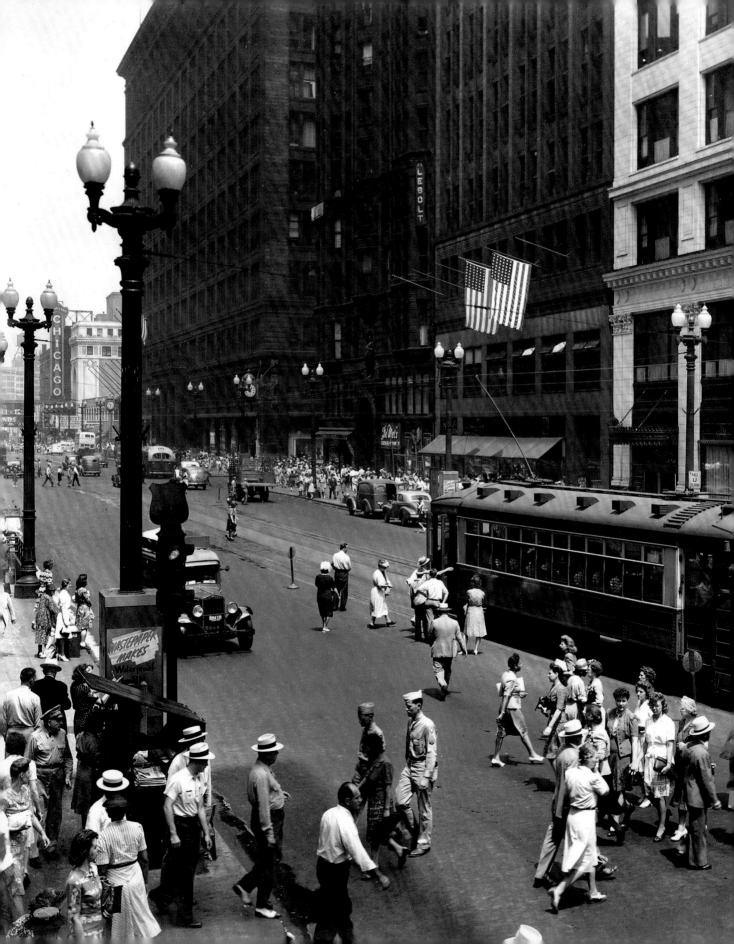

A STREETCAR NAMED DEFUNCT

For decades, Chicago's public transit system was a disorganized assortment of private buses, streetcars, and trains. Various lines were privately owned, and all were battered by the Great Depression.

In 1942, with surface and elevated lines in receivership, District Judge Michael Igoe approved a plan for Chicago to buy them and fold them into a new agency that would include the privately owned bus system and the city-owned subway. It would be called the Chicago Transit Authority.

Igoe had a headache of an assignment, sorting out how much should be paid to transit investors. The judge oversaw the valuation of the unified system down to the last dollar, with the total coming to $179,348,468.

Even after his initial approval, bureaucratic hurdles remained. In early 1945, he prodded public officials to cooperate on "traction," a common word back then to describe public transit. "I am convinced that unless the state and city do get together on a traction program there will never be a solution," Igoe said. "As it is, I think we may expect speedy progress."

Well, "speedy" was a matter of opinion. The state approved the CTA later that year, but the consolidated transit agency wasn't officially launched until 1947. Two years later, Igoe was still sorting out attorneys' fees.

The street scene shown in this photo, at State and Madison streets, would soon be but a memory. The CTA said goodbye to streetcars in 1958.

ROGER TOUHY'S 'STOLEN YEARS'

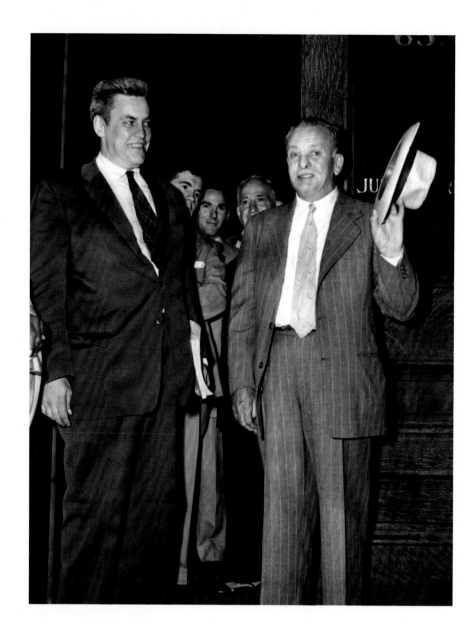

Roger Touhy, at right, was the mobster son of a Chicago police officer. In the last days of Prohibition, he was a bootlegging rival of Al Capone. Not fond of any competition, Capone framed Touhy for the 1933 faked kidnapping of John "Jake the Barber" Factor, the brother of cosmetics czar Max Factor Sr. Touhy was convicted and sent to Stateville Prison, but in 1942 he was part of a gang that used smuggled handguns to break out. The FBI captured him two months later.

In 1948, Touhy's attorney filed a writ of *habeas corpus* with the U.S. District Court, citing the shady nature of his prosecution. It took six years for District Judge John Peter Barnes to take testimony and rule that there was perjury in Touhy's original trial and prosecutors knew it.

Shown here with lawyer Robert Johnstone after Barnes' ruling set him free, Touhy said he held no grudge against those responsible for his long prison hitch. "They have their consciences to live with," he said.

Touhy said he might go into the manufacturing business, and reporters asked him whether he'd ever manufactured anything before. "Beer," he replied.

Two days later, a federal appeals court put Touhy back in custody. He wrote a book in prison called *The Stolen Years.* Governor William Stratton ultimately commuted Touhy's sentence, and he was paroled in 1959, telling reporters: "The first thing I'm going to do is to visit my parole officer, as it says here in the rules."

Within a month, Touhy was ambushed and killed by shotgun-wielding hit men on the steps of his sister's Chicago home. His dying words: "I've been expecting it. The bastards never forget."

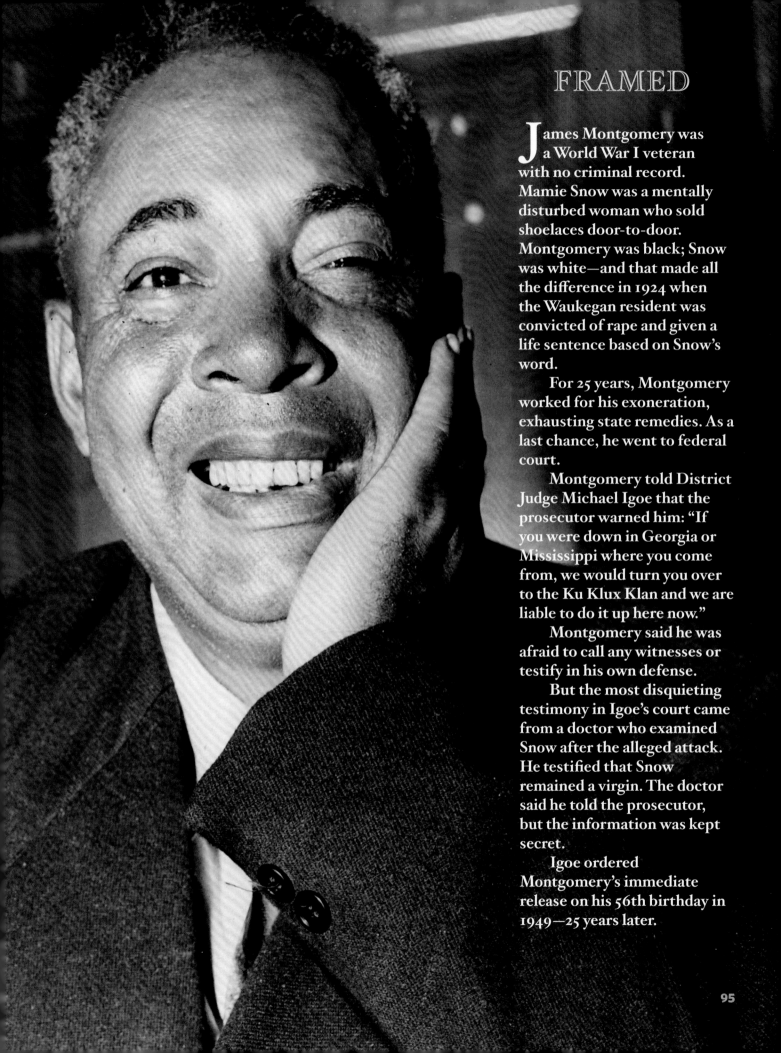

FRAMED

James Montgomery was a World War I veteran with no criminal record. Mamie Snow was a mentally disturbed woman who sold shoelaces door-to-door. Montgomery was black; Snow was white—and that made all the difference in 1924 when the Waukegan resident was convicted of rape and given a life sentence based on Snow's word.

For 25 years, Montgomery worked for his exoneration, exhausting state remedies. As a last chance, he went to federal court.

Montgomery told District Judge Michael Igoe that the prosecutor warned him: "If you were down in Georgia or Mississippi where you come from, we would turn you over to the Ku Klux Klan and we are liable to do it up here now."

Montgomery said he was afraid to call any witnesses or testify in his own defense.

But the most disquieting testimony in Igoe's court came from a doctor who examined Snow after the alleged attack. He testified that Snow remained a virgin. The doctor said he told the prosecutor, but the information was kept secret.

Igoe ordered Montgomery's immediate release on his 56th birthday in 1949—25 years later.

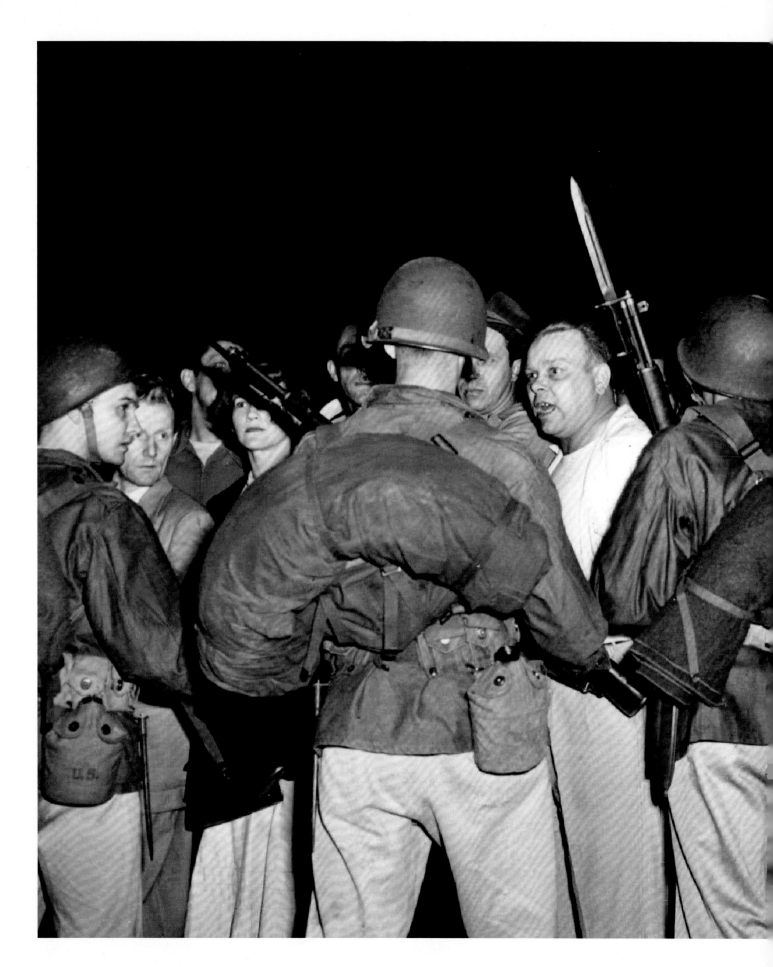

RACE RIOT IN CICERO

Harvey and Johnetta Clark tried to move their family into an apartment in the near west suburb of Cicero in 1951. Because they were black, some Cicero whites were outraged.

The Clarks filed a federal lawsuit accusing the Cicero police of beating and harassing them. District Judge John Peter Barnes issued a temporary injunction, and declared: "You are going to treat these folks just like white people. See to it that they are not molested."

But after the family moved furniture into the home and left, a crowd of whites threw rocks through the windows. The next night, vandals destroyed the furniture. That led to deployment of the Illinois National Guard. About 3,000 people gathered the next day and rioted. Three officers and three guardsmen were hurt. Two police cars were overturned and one set on fire.

A federal grand jury indicted Cicero's town president, police chief, and five other officials on charges of violating the family's civil rights. Four defendants were convicted and one acquitted. Charges were dismissed against two others. District Judge Walter LaBuy called it a "sordid chapter in the history of our metropolitan community." But in the end, justice wasn't served. LaBuy set aside one verdict, and the other three defendants won a retrial. Then District Judge Joseph Sam Perry dismissed the charges.

The Clark family left the state. According to *Jet* magazine, Harvey Clark died in his North Carolina home in 1998.

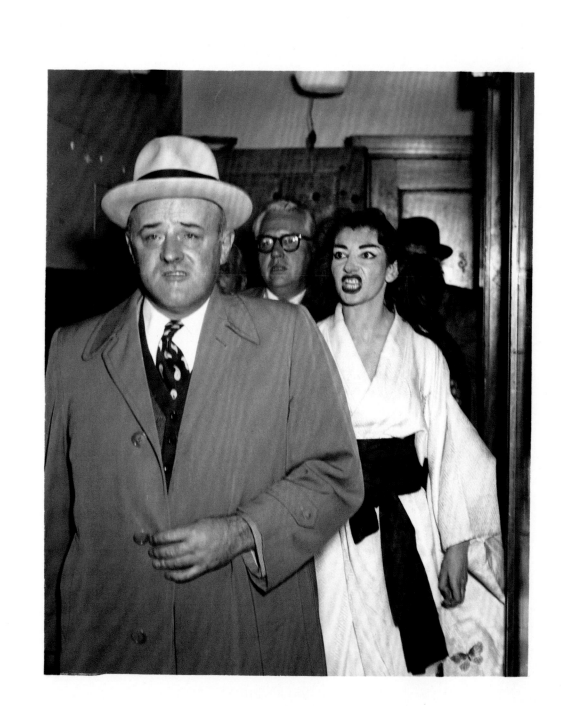

DON'T MESS WITH THE DIVA

A defendant in a 1955 lawsuit was Maria Kalogeropoulos Meneghini, also known as Sophie Cecilia (Kalos) Meneghini, also known as Maria Callas.

The opera star was accused of failing to pay her agent's fees. U.S. Deputy Marshal Stanley Pringle (in foreground) was assigned to serve her with a court summons when she was in town. The Lyric Opera of Chicago arranged for Pringle to wait until Callas had performed before delivering the document. Opera officials figured that if Callas was served beforehand, she might refuse to sing.

This photo, taken by Bud Daley of the *Chicago Sun-Times,* was printed with tape to show how it would be cropped for the newspaper. It captures Callas, still wearing her kimono from *Madame Butterfly,* expressing her fury at Pringle.

Attorney Harvey Levinson later testified: "At the time that Mr. Pringle served her, she appeared to take it gracefully, until someone shouted about touching the Madam, and whereupon the Madam made some reference to the fact she had the voice of an angel and no man could serve her; and those who were in her party commenced to attempt to assault the marshal. She went to her dressing room, shouting in various and sundry languages. It was my opinion she gave a much better performance off-stage that evening than she did on-stage."

Two years after the famous summons incident with Callas, District Judge Walter LaBuy dismissed the case, with "each party to bear his own costs."

COMMUNISM ON TRIAL

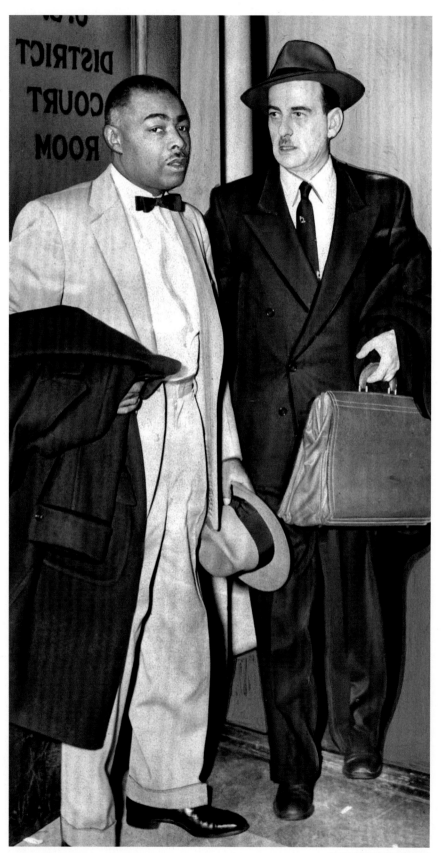

Communist activism felt empowering to Claude Lightfoot, an African American living amid racial prejudice in Chicago.

"After having gotten up on the soapbox and cursing the police and then marching away triumphantly with the workers, well, from that day on I was a man," Lightfoot said.

But in 1954, Lightfoot became a criminal defendant, too. His role as Illinois executive secretary for the Communist Party led to federal charges under the Smith Act, which banned advocacy of the overthrow of the government.

Decidedly unfriendly District Judge Joseph Sam Perry set a high bond and denounced Lightfoot's testimony at a pretrial hearing as "an insult to the intelligence of the court." The case was taken over by District Judge Phillip Sullivan, and a jury convicted Lightfoot. He was sentenced to five years in prison and handed a $10,000 fine, but the U.S. Supreme Court threw out that verdict because Lightfoot's lawyers were denied access to FBI files. Just before a retrial under District Judge William Campbell in 1961, the government dropped the charge. Lightfoot proudly continued his activism until his death in 1991.

Literary types who were upset about censorship at the University of Chicago's *Chicago Review* started their own magazine. The first issue featured the work of such beat icons as Jack Kerouac and William S. Burroughs. The magazine was called *Big Table,* based on a note Kerouac wrote to himself: "Get a bigger table."

The editors put the issue in the mail. Two months later, the Post Office sent a notice that the magazine would not be mailed because of its "obscenity and filthy contents."

Big Table indeed contained what one court document called "certain words, phrases and sentences which mention and describe acts of sexual intercourse, including certain acts which constitute incest, sodomy and the practice of homosexuality." In addition, the magazine "frequently mentions the private parts of the human body."

The court file included testimony by Paul Carroll, publisher and editor of *Big Table,* in which he told a hearing examiner: "Mr. Burroughs writes about the ravages of the human soul much the same way the Bible does."

District Judge Julius Hoffman ultimately ruled in favor of *Big Table.*

A CANCER CURE
THAT WASN'T

The battle against cancer has been a series of steady medical advances and isolated, bogus claims of quick-cure breakthroughs. Krebiozen was one of the latter.

The mysterious drug was a cancer treatment promoted in the 1960s by prominent Illinoisans, including Senator Paul Douglas and Andrew C. Ivy, a physician and University of Illinois vice president.

It was introduced by a Yugoslavian physician named Stevan Durovic, who approached Ivy with claims of success. But Durovic would not reveal what was in it.

"It is unusual in medical research for doctors to experiment with secret drugs," Ivy said, "but the promise of this one seemed to me more important than the method of its manufacture."

Douglas accused the National Cancer Institute and the Food and Drug Administration of being "pawns for organized medicine" because of their doubts about Krebiozen.

Federal authorities banned interstate shipments of the unproven substance in 1963. A year later, they charged Durovic, Ivy, and two others with violating that ban.

The trial in District Judge Julius Hoffman's court lasted about eight months. Despite damning evidence, the defendants were acquitted.

Jury foreman Adolph Baranek, a printer, said the issue was better settled by scientists than a jury: "This trial, I understand, cost over $1 million. I think the money could have been put to a better use, such as a laboratory test of the drug."

The state of Illinois banned the sale of Krebiozen in 1973, and now there's firm consensus on its worthlessness.

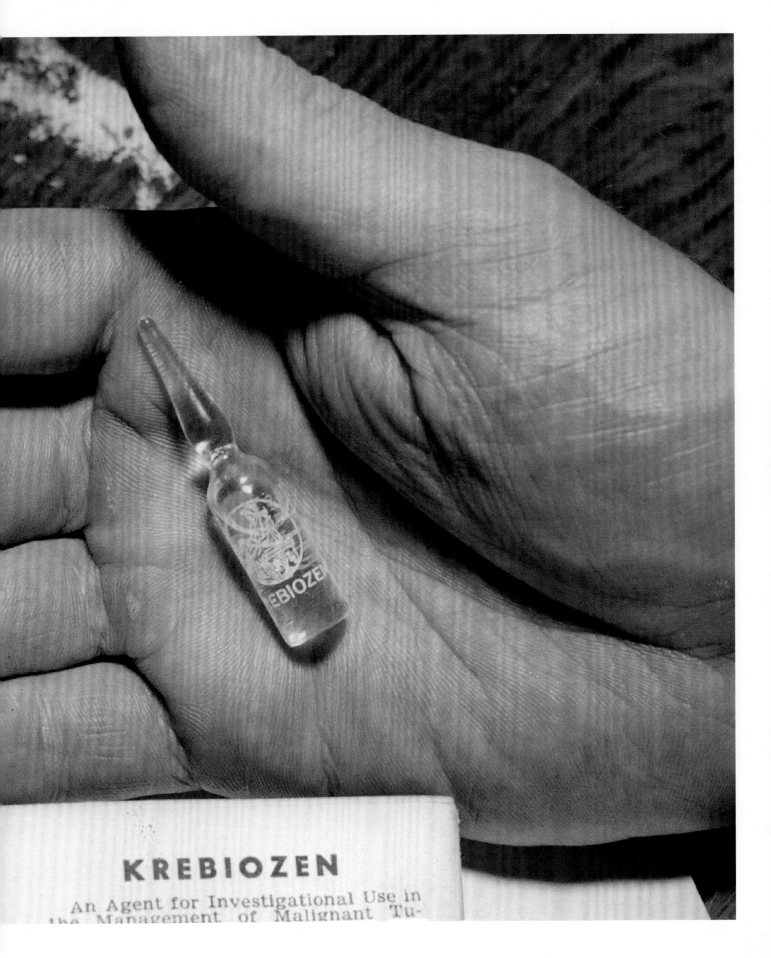

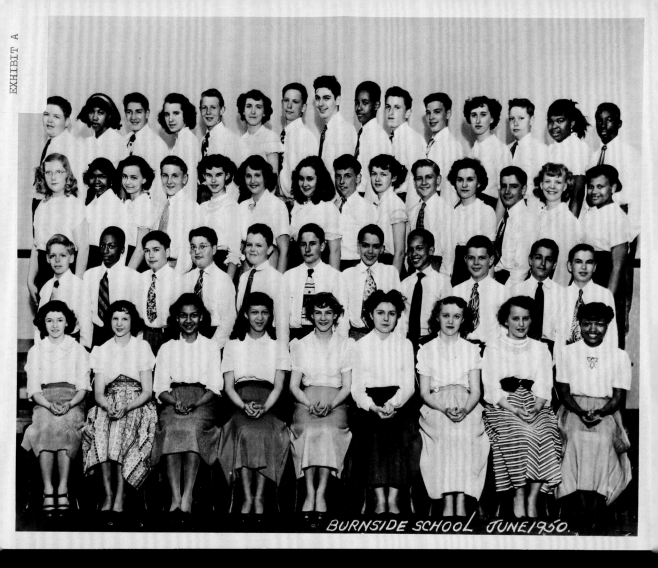

BURNSIDE SCHOOL JUNE 1950.

SCHOOL COLORS IN SEGREGATED CHICAGO

Dramatic racial change in Chicago neighborhoods led to fierce battles over school assignments. Some took place at Chicago Board of Education meetings, some in federal court.

The photos here, showing eighth graders at the South Side's Burnside

School in 1950 and 1962, were offered as evidence of both racial change and overcrowding at the school. According to a federal lawsuit against the school board, the school at 95th Street and Langley Avenue became severely overcrowded as more African Americans moved

into the neighborhood. Built for 900 students, it had 1,700. There were 75 students in some kindergarten classes.

When the school board tried to move students to other schools, they skipped over the nearest school, Perry, which was predominantly white, in favor of Gillespie, which was farther away. African American parents sued in 1962, saying students were "assigned so as to retain

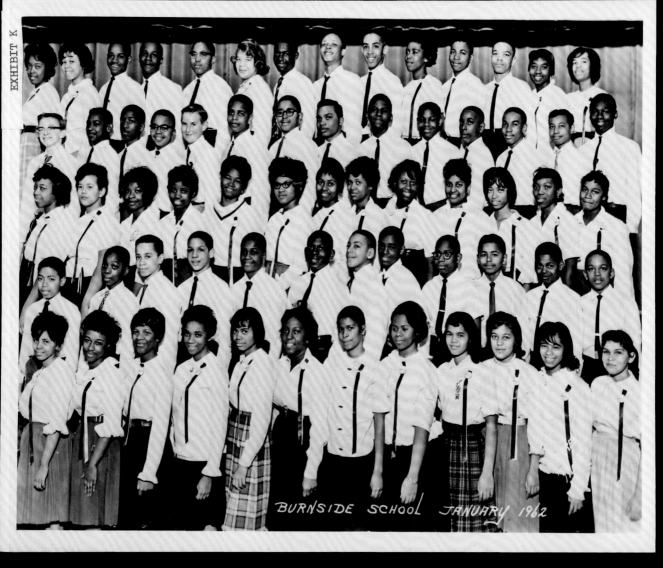

BURNSIDE SCHOOL JANUARY 1962

Perry Elementary School as a school to which members of the Caucasian race alone can attend."

A lightning rod in the segregation battles of the '60s was School Superintendent Benjamin Willis, who attempted to address the problem of overcrowded schools by placing mobile classrooms—which came to be called "Willis Wagons" —on school grounds.

Challenges to the school board's school boundaries came in multiple lawsuits handled by District Judges Richard Austin, Julius Hoffman, Alfred Kirkland, and Abraham Lincoln Marovitz. A future federal judge, George Leighton, was one of the attorneys for black parents.

The activists attacking school segregation were often frustrated by court rulings. For example, Hoffman refused to set aside a Cook County Circuit Court judge's injunction barring civil rights groups from organizing a school boycott in 1965.

African American dissatisfaction over school resources continues to this day.

While there is a system of school assignments that gives students more choice, segregation remains a reality in many Chicago schools.

TRAILBLAZERS WHO WON AND LOST

The Northern District of Illinois boasted the nation's first African American life-tenured federal judge, but it was also the place where an early opportunity for gender equity was missed.

The black pioneer, James Benton Parsons *(left)*, was asleep on an August day in 1961 when he got a phone call. Thinking it was his wife, he picked up the phone and chewed her out for waking him. "When I paused, this voice came on the phone and said, 'But this is President Kennedy,'" Parsons recalled. The president asked him if he was willing to become a federal judge. Parsons answered: "As a former naval officer, aye-aye, sir."

Parsons, born in Kansas City and raised in downstate Decatur, taught music before becoming a lawyer and working in private practice and in the U.S. attorney's office. He was a state court judge for a year before he was appointed for life as a judge under Article III of the U.S. Constitution.

It would be two decades later when the Northern District got its first female district judge, Susan Getzendanner. Much earlier, a spirited but unsuccessful campaign was waged to put a woman on the bench. Judge Kenesaw Mountain Landis had stepped down in 1922, and highly respected Chicago patent attorney Florence King *(above)* was identified as a worthy successor.

King, who grew up in Michigan, worked as a stenographer in a law office and then as a court reporter before becoming a lawyer herself. In 1920, with the 19th Amendment giving women the right to vote, the time for a female federal judge seemed ripe.

But neither U.S. senator from Illinois supported her bid. Senator William B. McKinley urged President Warren G. Harding to give her a consolation prize: a federal judgeship in the Panama Canal Zone that would not be a lifetime appointment. King said she wasn't interested. The first woman wasn't named to the federal judiciary until 1934.

Getzendanner joined the federal bench in Chicago in 1980. Like Florence King, she became interested in law when she took a law office clerical job. She recalled thinking: "Hey, I'm as smart as they are, but they're making all the money. There's no reason why I can't be a lawyer too."

Solomon Bethea was considered the District Court's first senior judge. The first Hispanic district judge in Chicago was Rubén Castillo, and he became its first Hispanic chief judge. Rebecca R. Pallmeyer was the first female chief district judge. The first Asian-Pacific district judge was Edmond Chang.

NOTORIOUS CHICAGOANS— TOKYO ROSE AND NATHAN LEOPOLD

Iva Toguri D'Aquino had plenty of experience dealing with federal authorities, but only a small portion of it was in federal court in Chicago.

D'Aquino, born in Los Angeles to Japanese immigrant parents, was in Japan when the Pearl Harbor attack thrust the United States into World War II. She took a job as a radio host broadcasting propaganda to U.S. soldiers. D'Aquino was one of several radio personalities known collectively as "Tokyo Rose."

After the Japanese surrender, D'Aquino talked to American reporters about her wartime work, and soon became the face of Tokyo Rose. American authorities detained her for a year before deciding not to prosecute her. But prominent Americans such as FBI Director J. Edgar Hoover and radio personality Walter Winchell kept pushing for charges. Even though D'Aquino insisted she had never considered her actions disloyal, she was indicted for treason in 1948.

The San Francisco district court trial was the longest and most expensive in a treason case up to that

time, lasting twelve weeks with 46 witnesses called for the prosecution and 25 for the defense. The jury convicted D'Aquino, and she served more than six years in a women's reformatory in West Virginia. Afterward, she moved to Chicago and assumed a quiet life, running the J. Toguri Mercantile grocery store and gift shop on the North Side.

But the feds weren't

done. D'Aquino hadn't paid the fine included in her sentence, and District Judge William Lynch ordered her to turn over $4,745 from the cash value of two insurance policies.

When President Gerald Ford pardoned her in 1977, D'Aquino said, "It is hard to believe. But I have always maintained my innocence— this pardon is a measure of vindication." She died in 2006.

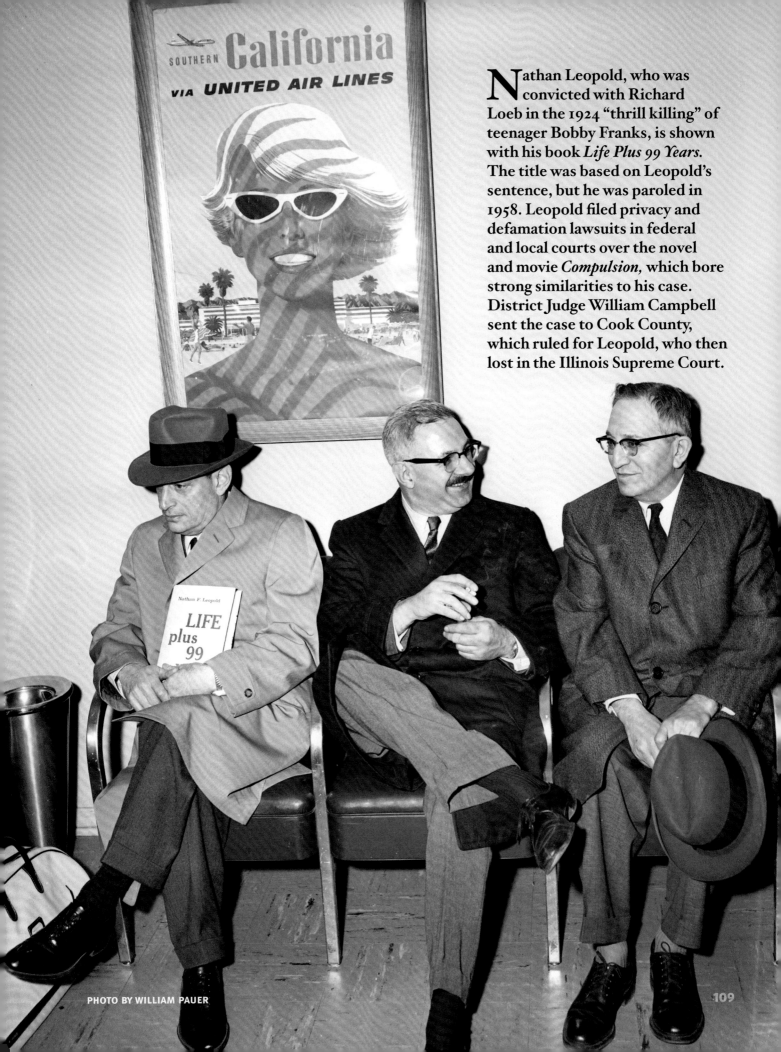

Nathan Leopold, who was convicted with Richard Loeb in the 1924 "thrill killing" of teenager Bobby Franks, is shown with his book *Life Plus 99 Years.* The title was based on Leopold's sentence, but he was paroled in 1958. Leopold filed privacy and defamation lawsuits in federal and local courts over the novel and movie *Compulsion,* which bore strong similarities to his case. District Judge William Campbell sent the case to Cook County, which ruled for Leopold, who then lost in the Illinois Supreme Court.

PHOTO BY WILLIAM PAUER

236

WITNESS R

WHAT HAPPENED TO JIMMY HOFFA?

J immy Hoffa was a crook. Of that, there is no doubt.

Even before the Teamsters union boss went on trial in Chicago in 1965, he had been convicted of jury tampering in a Tennessee case. This prompted District Judge Richard Austin to conduct jury selection quite carefully. When the court in Chicago had exhausted its first list of 350 prospective jurors, only four had been chosen. Eventually a jury was seated—and sequestered—for a three-month trial. This photo shows the outside of the witness room during the trial.

Hoffa and associates were charged with fraudulently obtaining at least $20 million in loans from the union's pension fund, including $100,000 linked to Hoffa's investment in Florida retirement homes.

Of the 28 counts against him, Hoffa was convicted of four, for which he was sentenced to five years in prison and fined $10,000. That sentence was tossed out when the U.S. Supreme Court ordered Austin to determine whether government wiretaps had tainted the

THE LAW OF MODERNISM

By the 1960s, it was time for a new courthouse, and a modernist design by architect Ludwig Mies van der Rohe was chosen. Construction began in 1961 and the court was completed in 1964 at a cost of $40 million. The demolition of the old building, next to the new one, was mourned by some who considered it a Loop landmark.

While the new structure made a simple impression on the outside, its interior was more complex and showy. Chief District Judge William Campbell wanted it that way to impress those who came inside. "The administration of justice must be more than pure justice," he said. "It must appear to be justice, and it can't appear to be justice in cracker-box surroundings."

When the new courthouse was dedicated, one of the speakers was Governor Otto Kerner Jr., who would later be tried and convicted in the building.

ALI'S BOUT IN FEDERAL COURT

Muhammad Ali called himself "The Greatest," and he didn't appreciate a radio show pretending that he wasn't. His annoyance was aimed at Murray Woroner, who produced radio broadcasts in 1967 featuring an imaginary tournament of history's best boxers.

When the fictional Ali was matched against the fictional Jim Jeffries and lost, the real Ali filed a federal lawsuit in Chicago claiming defamation of character. The lawsuit stipulated that "plaintiff is the world's most famous professional boxer; he is the greatest."

Ali settled the suit and accepted at least $9,999 for his involvement in another fake bout, this time against Rocky Marciano in a film. Ali's agreement stated: "I hereby acknowledge that I may lose the said fight." And he did, sort of. At the time, Ali was unpopular in the United States because of his resistance to the military draft, so the American version gave the win to Marciano. A version in Europe, where Ali was popular, showed a victory by The Greatest.

PHOTO BY RALPH WALTERS

GIFT TO CHICAGO

In 1967, a Chicago landmark arrived: a 50-foot-tall, 162-ton steel sculpture by world-acclaimed artist Pablo Picasso.

Because of Picasso's fame, Mayor Richard J. Daley and others boasted that the artwork boosted Chicago's status. But no one seemed sure of what the sculpture in Daley Plaza depicted. Was it a woman's head? A Viking ship? A bird?

Chicago alderman John Hoellen wanted the artwork removed and replaced with a statue of Cubs star Ernie Banks. But the Picasso stayed, and the Ernie Banks statue settled for a spot outside Wrigley Field.

The Spanish artist gave the city the sculpture as a gift, but he didn't assign copyright. That led to a legal fight as the city's Public Building Commission sought to claim the right to charge fees for souvenirs and items featuring the image. A publisher called The Letter Edged in Black Press filed suit, and District Judge Alexander Napoli ruled in its favor.

And if you're wondering what the sculpture's title is, sorry, it doesn't have one.

DECADES OF STRUGGLE OVER PUBLIC HOUSING

Public housing in Chicago wasn't exactly the idyllic urban experience presented in this Chicago Housing Authority archives photo. There were some safe and well-tended homes, and there were many that were not.

Gautreaux et al. v. Chicago Housing Authority, a federal lawsuit filed in 1966, dominated public housing policy in the city for half a century. Dorothy Gautreaux was a resident of the all-black Altgeld Gardens housing project on the Far South Side. She and others charged in her class-action lawsuit that the CHA's concentration of public housing in black neighborhoods fostered segregation and violated both the Constitution's requirement of equal protection under the law and the 1964 Civil Rights Act, which banned federally funded programs from discriminating based on race.

Three years later, District Judge Richard Austin ruled in favor of Gautreaux, banning the CHA from building any new public housing in black areas unless housing was also built in white areas. Mayor Richard J. Daley's response was to call a halt on virtually all new construction.

Gautreaux led to a Supreme Court ruling that the entire Chicago area could be used to remedy past public housing bias in the city. More than 25,000 people participated in the resulting mobility program in a 22-year period. The ruling also ushered in the CHA's scattered-site program, an attempt to make public housing fit better into neighborhoods rather than operate in isolation as high-rise "warehousing."

Chicago's struggles with public housing kept the *Gautreaux* case alive. District Judge John Powers Crowley inherited *Gautreaux,* and District Judge Marvin Aspen approved a final settlement in 2019.

PAY DIRT FOR PRO FOOTBALL

The National Football League was more than forty years old when it merged with the upstart American Football League in 1966, ushering in one of America's most popular traditions—the Super Bowl.

But three Chicago businessmen hated the idea. They sought an AFL team in Chicago, and the merger scotched those plans. So the three sued for $12 million.

One of the businessmen, stockbroker Robert Nussbaum, said the AFL had told him there would be no second Chicago team after the merger. (The Bears had Chicago to themselves when the Cardinals left for St. Louis before the 1960 season.) "I don't think the merger is fair to the players or fans or good for football," said Nussbaum. "It's a monopoly."

The case, presided over by District Judge Alexander Napoli, failed to stop the merger or give the businessmen a team.

Shown here is the Bears playing the San Diego Chargers in 1970 in the Bears' first regular-season game against an AFL team. It was the Bears' last season in Wrigley Field.

THE 'ILL-CONCEIVED' BLACK PANTHER RAID

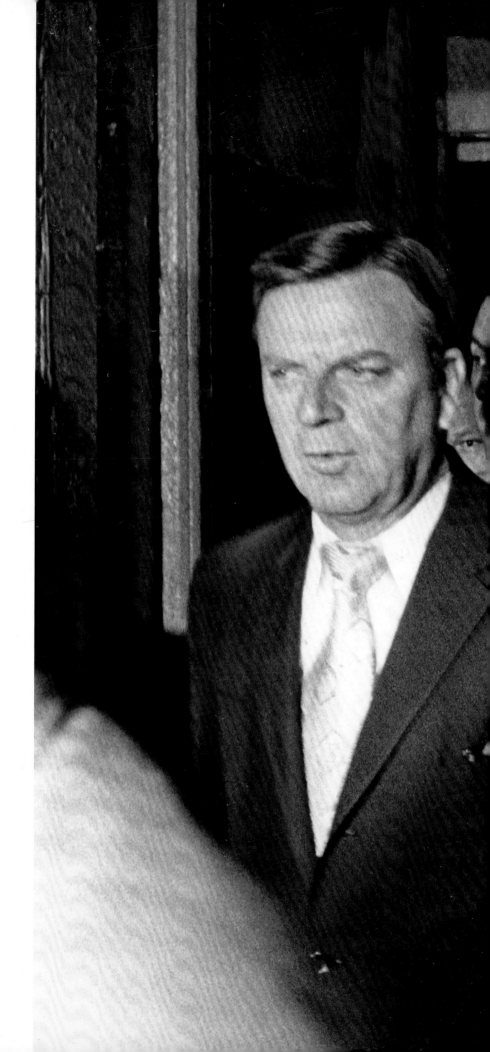

Cook County State's Attorney Edward Hanrahan launched an early-morning police raid on the Black Panthers' West Side headquarters in 1969. Two leaders of the black militant group, Fred Hampton and Mark Clark, were shot to death. Hanrahan, shown here at the scene of the raid, depicted the assault as a gunfight. But evidence demonstrated that the Panthers shot just once while the police fired as many as 99 times.

A federal grand jury called the raid "ill-conceived," but no indictments were returned. State charges accusing Hanrahan and others of conspiracy to obstruct justice were dismissed.

The survivors and families of Hampton and Clark filed suit in 1970 against nearly thirty defendants, including Hanrahan. District Judge Joseph Sam Perry eventually dismissed charges against Hanrahan and twenty others, and let the rest off when a jury deadlocked. But the U.S. Supreme Court sent the case back to the District Court for retrial, and it was reassigned to District Judge John Grady. The parties reached a $1.8 million settlement in 1983.

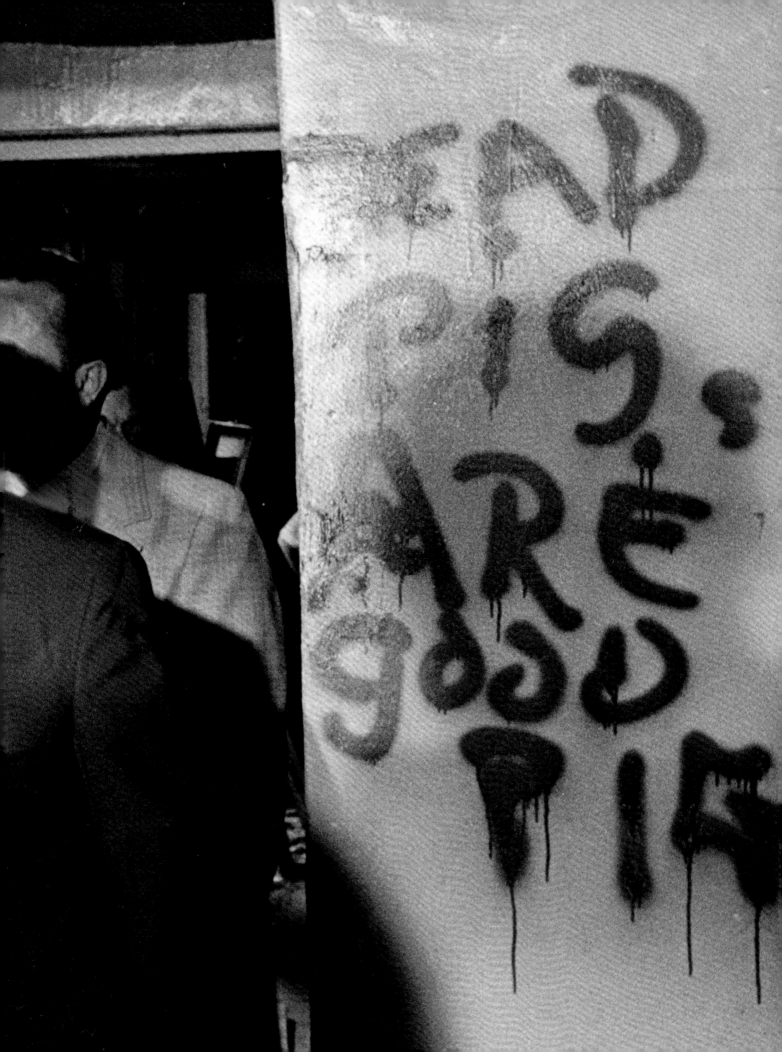

Take a divisive overseas war, add a political convention, mix thousands of anti-war demonstrators with a police force hostile to hippies, and you have all the elements for havoc on the streets of Chicago. And later in a federal courtroom.

The 1968 Democratic National Convention will be remembered for police attacks against protesters, and for charges against eight anti-war activists for alleged conspiracy to riot.

The most famous defendant was Abbie Hoffman (bottom right), a provocateur who disrupted the New York Stock Exchange by tossing dollar bills onto the trading floor. He was one reason the Chicago conspiracy trial, presided over by District Judge Julius Hoffman, turned into a circus.

The only African American defendant, Bobby Seale, called Judge Hoffman a "fascist dog." He was gagged and strapped to a courtroom chair. Eventually his case was detached from the others'—and the Chicago Eight became the Chicago Seven.

The defendants brought marijuana into court, and spread out a Viet Cong flag on the defense table. Judy Collins sang "Where Have All the Flowers Gone" from the witness stand, stopping only when a bailiff covered her mouth.

As soon as jurors began deliberating, Hoffman sentenced all the defendants and their lawyers to jail for contempt of court. The jury acquitted all seven defendants of conspiracy, but found five guilty of crossing state lines to incite a riot. The Seventh Circuit reversed those convictions and ordered a new trial, but the government decided not to continue. In the end, none of the contempt and riot charges stuck against Seale or the Chicago Seven.

122

PHOTO BY GARY SETTLE

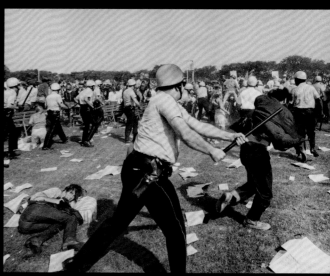

PHOTO BY JOHN TWEEDLE

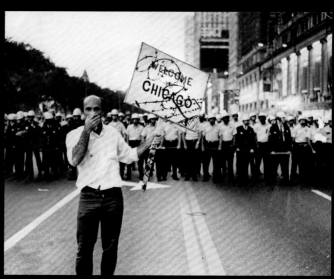

PHOTO BY DUANE HALL

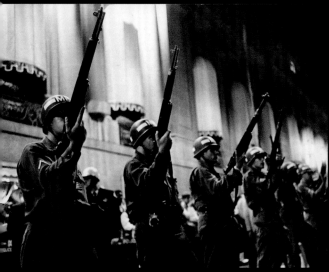

PHOTO BY CHARLES KREJCSI

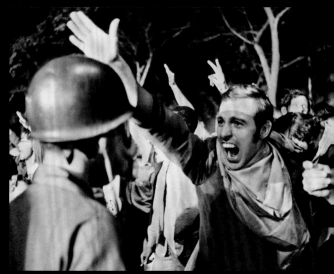

PHOTO BY PERRY C. RIDDLE

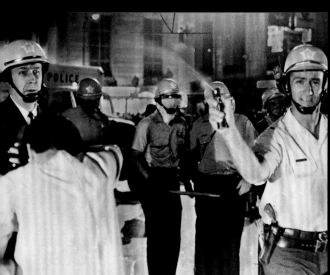

PHOTO BY PAUL SEQUEIRA

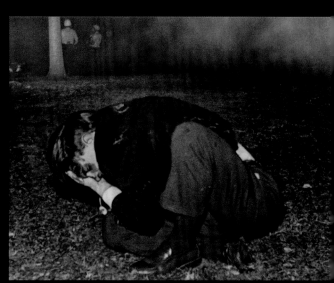

PHOTO BY CHARLES KREJCS

WHEN BOBBY HULL SKATED AWAY

The Golden Jet became a Winnipeg Jet. And the Chicago Blackhawks became very, very angry.

Hull, a beloved Blackhawks star and two-time National Hockey League most valuable player, was dissatisfied with his salary and signed with Winnipeg of the new World Hockey Association. The Blackhawks sued in Cook County Circuit Court, saying the reserve clause in NHL contracts prohibited Hull's move, which would cause "irreparable damage."

Hull sued in federal court, seeking to move the case there. District Judge James Parsons issued a temporary restraining order that prevented Hull from promoting his new team. But then District Judge William Lynch determined that state courts should handle the matter. Soon, another federal court in Philadelphia settled the issue for NHL players, including Hull, by prohibiting the league from enforcing its reserve clause.

PHOTO BY RALPH WALTERS

A RULING THAT DELIVERED FOR DADS

Today it's normal—even expected—for fathers to accompany expectant mothers into the delivery room. But until 1970, a Chicago rule banned it.

District Judge Alexander Napoli struck down that Board of Health regulation, instituted in 1933 to allay health concerns that the father would bring in germs.

Merle Gross testified in court that the presence of her husband, Barry, in the delivery room would be "reassuring and crucial" for the birth of their second child, expected within weeks. Gross said she and Barry had been taking Lamaze classes so that he could participate in the delivery process.

Napoli ruled that the Board of Health regulation was "overly broad and goes beyond that which is reasonable and necessary in the exercise of police powers and the protection of the public safety and welfare." The judge said fathers could attend their child's birth if both the mother and the physician approved.

The ruling applied only to the city of Chicago. The state of Illinois had changed its rules to allow fathers in the delivery room three years earlier.

The photo shown here depicts the bad old days— Fred Silver peeking through a window into the maternity ward at Mount Sinai hospital in 1955. He was standing in the hospital's official "fathers' room."

In another noteworthy federal case related to pregnancy and sex bias, District Judge Richard McLaren voided a Chicago Board of Education rule in 1972 that required teachers to take leave after the fifth month of pregnancy and stay on leave for six months.

WOMEN BEHIND THE BAR

Until 1970, women in Chicago were banned from working as bartenders unless they were the mother, daughter, wife, or sister of the licensee. Why? Because, as an attorney for the city put it, female bartenders might stupefy male customers and induce them into drinking too much.

"Your honor," said city attorney Benjamin Novoselsky, "they can sweet-talk them, and they can convince them, and they can mesmerize them, some of them hypnotize in some way. A poor fellow would not know what he was drinking."

District Judge James Parsons didn't push back on that assertion, but thought it would be addressed if his temporary restraining order barring enforcement of the ban included a dress code. He suggested a requirement that female bartenders wear "britches" or "trousers."

The city attorney wasn't convinced.

Novoselsky: "I can see a woman in a pair of trousers who would be more tantalizing to me than a woman in a mini-skirt, your honor. I mean, after all—"

Parsons: "Do you mean they excite you when they –"

Novoselsky: "Nothing excites me at my age, your honor. Really, I am ashamed to say that."

After all the sophomoric talk (including a discussion of Novoselsky's favorite scotch, Chivas Regal), Parsons declared that the ordinance was a violation of the 14th Amendment to the Constitution.

And that was that. Parsons' ruling in favor of a group of women and tavern owners meant that female bartenders were legal.

"Being a bartender would be a good job for a woman," lead plaintiff Carolyn McCrimmon said before the favorable ruling, explaining that it was better than a factory job for women with children because they could be contacted by phone immediately.

SHAKMAN'S ATTACK ON PATRONAGE

The word "clout" has a special meaning in Chicago, describing a system of patronage in which politicians place supporters in public jobs. In return, the workers make campaign contributions and do political work. Patronage sometimes places unqualified workers in do-nothing jobs. The photo at left is from a *Chicago Daily News* investigation of city employees.

Reformer Michael Shakman (above) sued Mayor Richard J. Daley and other politicians in 1969, challenging the Chicago system. His lawsuit went before District Judge Abraham Lincoln Marovitz, who was later described by Daley's son, Richard M., as "my dad's best friend." Marovitz dismissed the suit, but it was reinstated on appeal. Public sentiment was clear, and Marovitz approved a consent decree in 1972 banning most patronage hiring and firing. Later, District Judge Nicholas Bua further cracked down on patronage.

Court fights over the *Shakman* decrees went on for decades—involving District Judges Wayne Andersen, David Coar, Bernard Decker, Brian Duff, Susan Getzendanner, and Harry Leinenweber. *Shakman* oversight was lifted for Chicago in 2014 and for Cook County in 2018.

OTTO KERNER'S TERRIBLE FALL

Otto Kerner Jr., shown at right, served two terms as Illinois governor, chaired the National Advisory Commission on Civil Disorders, and was sitting as a judge on the Seventh U.S. Circuit Court of Appeals when his public image took a sudden and disgraceful hit.

Federal prosecutors charged that as governor, Kerner had arranged for state-regulated horseracing dates to be changed in a secret deal that let him buy racetrack stock at a cut-rate price and then sell it for a windfall profit. That, prosecutors said, was a felony.

Kerner was indicted in 1971 on charges of bribery, mail fraud, perjury, and tax evasion. Because of Kerner's prominent role in Chicago's federal courts, U.S. Chief Justice Warren Burger was asked to name an outside judge to preside over the case. District Judge Robert Taylor of Tennessee got the assignment.

Kerner's position as a judge on his home turf created complications. Prosecutor (and future governor) James R. Thompson complained about Kerner talking to prospective jurors: "He told them where they could get a cheap lunch real fast and they wouldn't have to leave a tip. It's not fair to have one of the defendants exposed to social chats with prospective jurors."

Kerner was found guilty and sentenced to three years in prison. He became the first U.S. appellate judge convicted while in office. Kerner spent less than a year in prison before being released in 1975 because of his declining health. He died of cancer the next year.

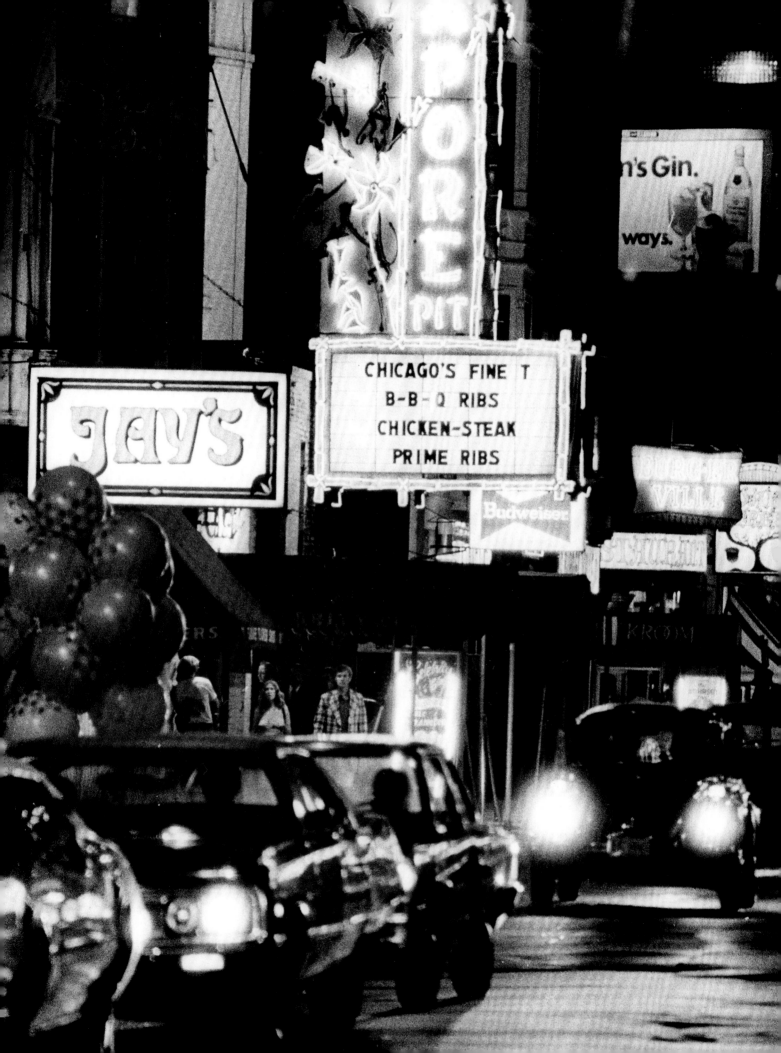

CORRUPT COPS ON RUSH STREET

In 1972, Chicago Police Commander Clarence Braasch and 23 other police officers from Braasch's East Chicago Avenue District were indicted on charges of conspiracy, extortion, and perjury in connection with a scheme to extort tavern owners, including those in the famous Rush Street nightclub area. After more than two months of trial in 1973 before District Judge William Bauer, a jury found Braasch and eighteen officers guilty.

Meanwhile, more than a dozen Austin District officers were charged with shaking down business people, from tavern owners to fortune-tellers. And in 1996, seven Austin officers were accused of protecting some drug dealers and shaking down others. Among the district judges presiding over cases were Richard Austin, Bernard Decker, Abraham Lincoln Marovitz, Thomas McMillen, Philip Tone, Hubert Will, and Ann Claire Williams.

Some other police cases:

In 2016, District Judge Sara Ellis threw out a jury verdict in favor of a woman who said an off-duty officer attacked her in a road rage incident. Ellis also blocked a deposition of Mayor Rahm Emanuel on the police "code of silence."

In 2018, Chicago settled lawsuits involving police officers after disclosures that the city withheld evidence. Judge Rebecca Pallmeyer handled a lawsuit over the shooting of teenager Jaquise Evans. District Judge Virginia Kendall presided over the case of former Detective Joseph Frugoli after his drunken-driving accident led to code-of-silence allegations.

In 2019, District Judge Robert Dow Jr. named former District Judge David Coar as a special master to oversee a consent decree on police reform.

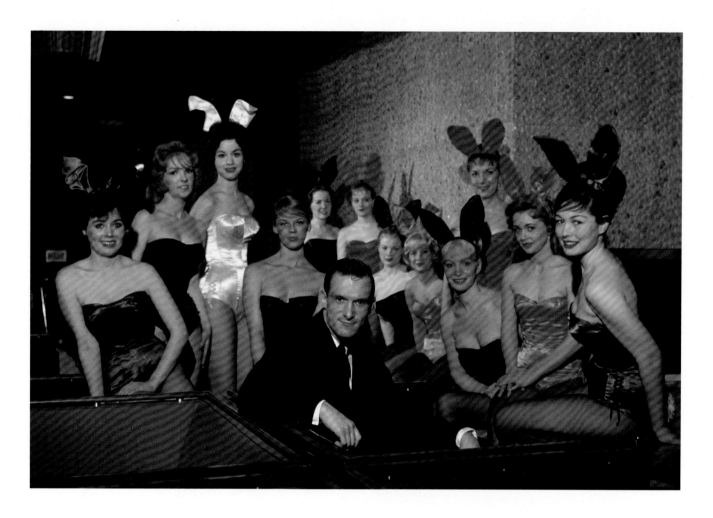

PLAYBOY UNDER SIEGE

Playboy magazine, founded by Hugh Hefner in Chicago's Hyde Park neighborhood, created a myth of American hedonism and sexual freedom that drew both fawning admirers and angry detractors. Chicago's downtown Playboy Club was a Midwest mecca for the hip set.

In 1963, Hefner was arrested on a local charge of publishing obscenity, but the jury could not reach a verdict. Eleven years later, another legal case shook Hefner's organization to its core.

Hefner's executive assistant, Bobbie Arnstein, was convicted of cocaine smuggling and sentenced to fifteen years in prison in a case presided over by District Judge Bernard Decker. The next year, Arnstein killed herself with a drug overdose, leaving a note saying she had been framed.

Hefner publicly blamed U.S. Attorney James Thompson and the Drug Enforcement Administration for Arnstein's death, saying the government pressured her to provide evidence against Hefner. The *Chicago Tribune* reported that Hefner was the target of a federal probe, but nothing came of it.

Thompson denied pressuring Arnstein, but did concede that his office warned her that they had heard about a plot to kill her. Said Thompson: "I felt it was our obligation to advise her of this." Later, he said, "Suppose something had happened and we had not forewarned her."

Flight attendants—or "stewardesses" as they were once known—took on a curious role in mid-twentieth century culture. Featured in "Fly Me" TV commercials, they were expected to be young, cute, and available. And if they worked at United Airlines, they had to be single. If they got married, they had to quit.

The rationale for the rule was not explicit—but many suspected it was an attempt to attract male business travelers.

Challenges to United's rule began with a complaint to the Equal Employment Opportunity Commission in 1966. United dropped the rule two years later, but the

legal fight over back pay, seniority, and other issues continued for nearly two decades. Along the way, the case made two visits to the Supreme Court.

Finally, in 1986, District Judge James Moran approved a settlement that provided about $33 million in back pay. Nearly 500 flight attendants were reinstated.

PUROLATOR HEIST: AN INSIDE JOB

The life of a security guard can be quiet and boring. Not so for Ralph Marrera.

In 1974, Marrera was the "inside man" in a $4.3-million cash theft, the largest in U.S. history at the time.

After guard Marrera let thieves into the Purolator armored car money warehouse on the Near North Side, they grabbed cash, set fires to mask the heist, and fled.

Within days, six suspects were rounded up, including Marrera. Most of the money was tracked down, including $1.5 million deposited in a Grand Cayman Islands bank and $1.4 million found under newly poured concrete in a vacant home on the Northwest Side owned by Marrera's grandmother.

Five defendants were put on trial. Four were convicted and given prison terms in cases presided over by District Judge William Bauer. The sixth suspect, Marrera, attempted suicide twice. He was taken to a hospital and lapsed into a mysterious coma for three days. He's shown here going to a fitness hearing with his wife. Ultimately, a court-appointed physician found him unfit, reporting that "all intellectual functions are grossly impaired." It

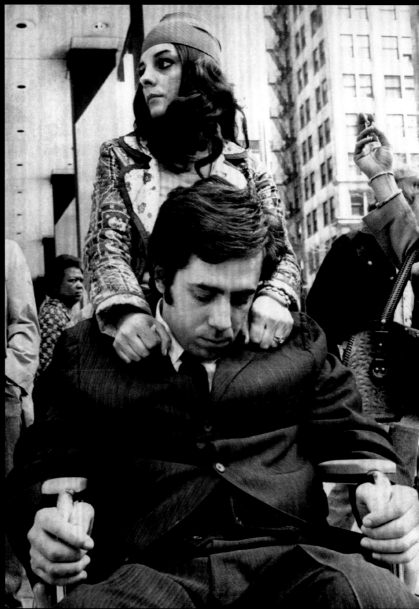

was "highly probable," the doctor found, that Marrera's condition was permanent.

The former security guard disappeared from a nursing home in 1980, and was arrested in a TV store burglary outside Chicago in 1982. Authorities took another look at his fitness, and he was put on trial in

1983, nine years after the heist. Convicted and sentenced to twenty years in prison, he served six.

But the story wasn't over. In 1990, Marrera won a lawsuit against Cook County over his coma at the hospital. He collected $650,000 from taxpayers.

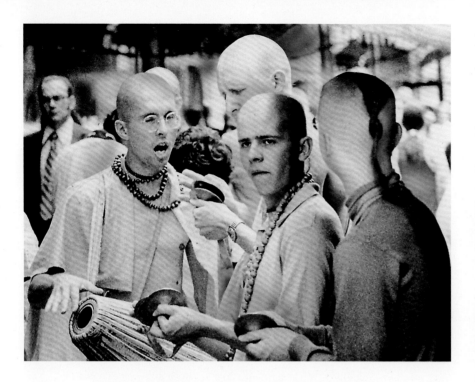

HARE KRISHNAS AT O'HARE

The Hare Krishna sect, which was quite unpopular with travelers at O'Hare International Airport, benefitted from federal rulings in 1973 and 1977 against Chicago's attempts to keep its followers from distributing literature and soliciting funds at the airport.

In his 1977 ruling, District Judge George Leighton wrote that "as a form of religious activity" the Krishnas' proselytizing "occupies the same estate under the First Amendment as do worship in churches and preaching from pulpits."

Chicago Commissioner of Aviation J.P. Dunne was frustrated by the court's rulings. "We'll put up signs at O'Hare to let people know these solicitors do not have any official permission for what they do," Dunne said. "We don't want anyone to think we're in favor of them."

The Krishna dispute was among many religious cases that reached federal court:

•District Judge Joel Flaum ruled that the Chicago Board of Education acted properly in 1979 by firing kindergarten teacher Joethella Palmer, who cited her Jehovah's Witness beliefs in refusing to teach her students the Pledge of Allegiance. The Seventh Circuit Court of Appeals affirmed the ruling, and the U.S. Supreme Court declined to take up the case.

•District Judge James Holderman ruled in 1985 that the city of St. Charles, Illinois, must take down the lighted cross displayed above the city's firehouse during the Christmas season. The case went to the Supreme Court, which let Holderman's ruling stand.

•District Judge Frank McGarr ruled in 1986 that Chicago could keep its Christmas crèche in the City Hall lobby, but his ruling was reversed when the American Jewish Congress appealed.

•District Judge Milton Shadur prohibited Ottawa, Illinois, from displaying sixteen paintings of Jesus Christ in a public park as a Christmas tradition. His 1989 decision was reversed on appeal when the Seventh Circuit declared that religious messages have as much right as any others to be displayed in public places as long as there is no official government endorsement.

•In 2009, District Judge Robert Gettleman overturned an Illinois law requiring public school students to observe a moment of silence at the start of each day. He declared the law was an attempt to introduce prayer in public schools, which has been ruled unconstitutional. Gettleman was reversed on appeal.

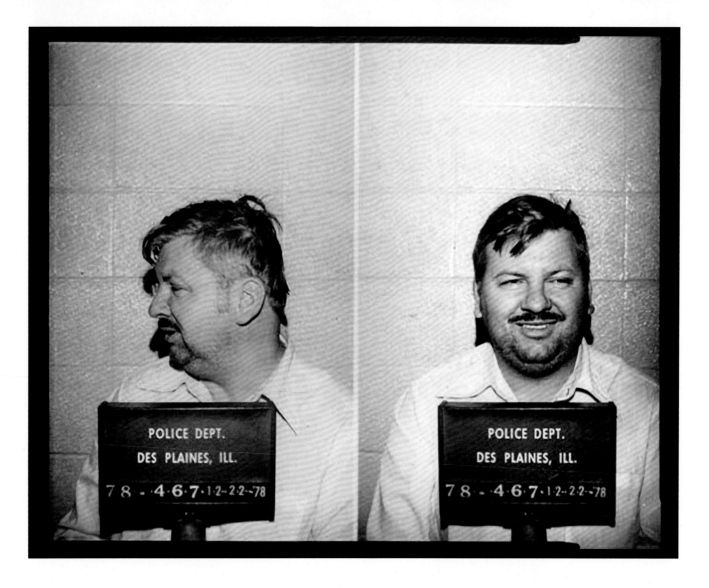

THE HORROR IN GACY'S CRAWLSPACE

Just before Christmas in 1978, authorities began pulling bodies out of the crawlspace of John Wayne Gacy's ranch house in Norwood Park near Chicago. Ultimately, the construction contractor would be convicted of killing 33 men and boys.

Gacy's criminal charges were handled in Cook County Circuit Court, but the case reached federal court in 1992 when he argued that he deserved a new trial because his lawyers had done an inadequate job. Gacy questioned his lawyers' strategy of an insanity defense, and he also accused the county judge of not properly exploring whether publicity had prejudiced the jury.

In a 144-page ruling, District Judge John Grady wrote that Gacy's arguments "have not persuaded this court that there is any constitutional defect in his conviction or sentence."

The Seventh Circuit backed Grady, noting that the evidence was overwhelming. "As Judge Grady remarked, Gacy's only real choice was between an insanity defense and a guilty plea," the appeals court wrote. As for the insanity defense, Seventh Circuit judges noted that Gacy never instructed his lawyers not to pursue it.

Out of appeals, the notorious serial killer was executed by lethal injection in 1994.

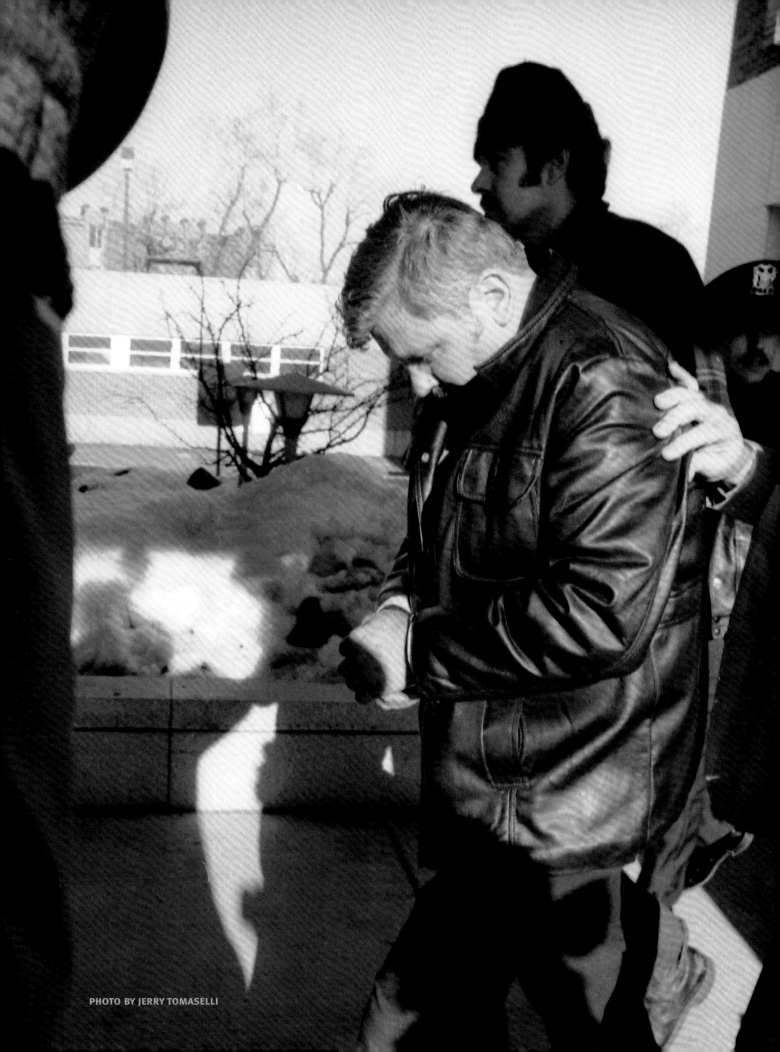

The abortion issue has been a pitched battle in Chicago's federal courts.

In 1978, District Judge Prentice Marshall struck down a state law requiring unmarried girls under age 18 to secure parental or court permission for an abortion. Marshall wrote that the law violated the minors' right to privacy.

The next year, District Judge John Grady ruled against the Hyde Amendment, named for U.S. Representative Henry Hyde, whose legislation banned federal funding for abortion in most cases. The Supreme Court reversed Grady's ruling.

A 1991 ruling dismissed allegations that anti-abortion groups violated antitrust and racketeering laws by protesting outside abortion clinics. But the Supreme Court found on appeal that the racketeering law could apply to such cases. District Judge David Coar took the reinstated case, and a jury decided that anti-abortion activists had used violence or threats of violence to keep women from abortion clinics.

In 2017, District Judge Frederick Kapala blocked a state law requiring medical professionals to inform pregnant women of all options, including abortion. Christian health professionals had challenged the law.

ABORTION: THE NEVER-ENDING ISSUE

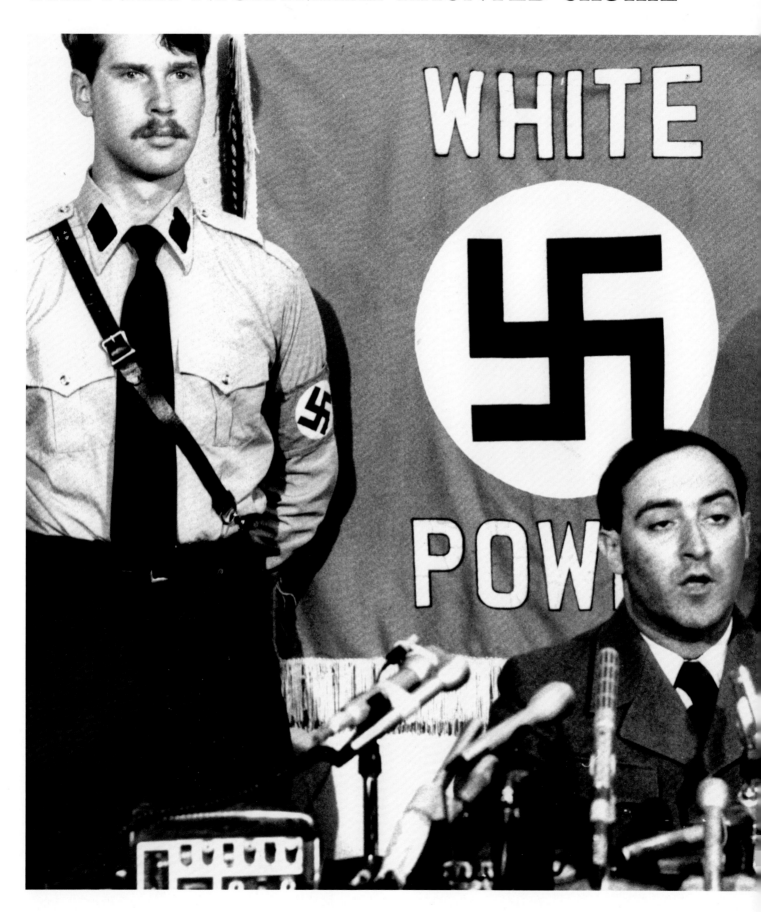

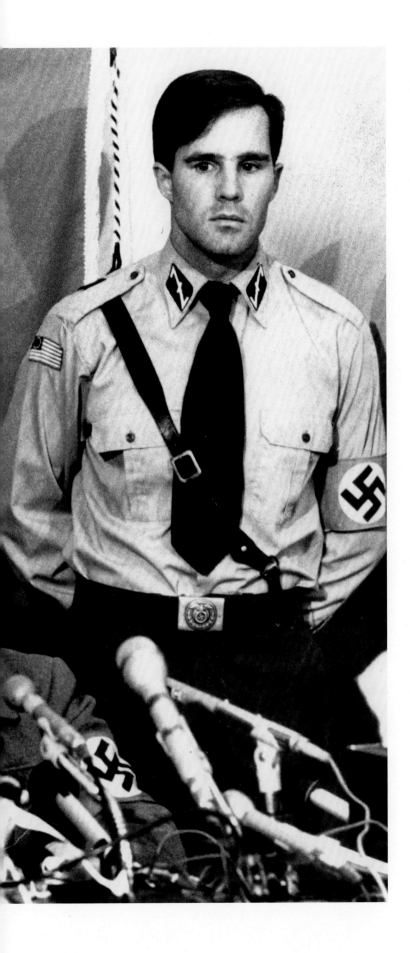

The suburb of Skokie, just north of Chicago, was a destination for Jewish survivors of the Holocaust who resettled in the United States after World War II. It was not unusual to see someone in line at a Skokie grocery store with a tattooed number on his or her arm.

So it was disturbing in 1977 when Illinois Nazi leader Frank Collin, center, announced plans to hold a march in Skokie. The Skokie Village Board passed ordinances banning demonstrators from wearing military-style uniforms and passing out literature that incited hatred. Demonstrators were also required to post a $350,000 bond to hold a rally. The American Civil Liberties Union, which believed that First Amendment rights should be protected even if benefiting groups like the Nazis, declared that Skokie's new laws were "appallingly unconstitutional."

The ACLU lawyer representing the Nazis was David Goldberger, who was Jewish and withstood considerable pressure as he argued the case. Goldberger won a ruling against the Skokie ordinances from District Judge Bernard Decker, whose ruling was affirmed on appeal.

The Nazis fought a separate legal battle against the city of Chicago, which had passed an ordinance requiring insurance for any group holding a protest of more than 75 people. District Judge George Leighton ruled in the Nazis' favor. They chose to rally in Marquette Park on Chicago's Southwest Side and canceled their Skokie march.

"The whole Skokie issue which began in March 1977 was pure agitation on our part to force the system to restore our rights to free speech," Collin said.

The Marquette Park rally was attended by about fifteen Nazis, protected by more than a thousand Chicago police officers.

CLEARING A DISASTER'S DEBRIS

The only intelligible word found on the flight recorder of American Airlines Flight 191 was "Damn."

An engine had fallen off the left wing of the DC-10 jetliner as it was taking off on May 25, 1979. The plane was doomed, crashing in a fireball just outside O'Hare International Airport.

"As soon as it went down, it went up in flame, swish, just like napalm," said witness Michael Delany, a Chicago police officer.

All 271 people aboard and two people on the ground were killed in the worst disaster in U.S. aviation history up to that time.

The litigation afterward was a thicket of complex issues, overseen by District Judges Edwin Robson and Hubert Will.

Kevin Forde, a lawyer who served as "liaison counsel" for more than 150 lawsuits, said: "We are dealing with the laws of fifteen or sixteen states and Puerto Rico." States had different rules for how damages could be assessed. For example, California let the spouse of a victim receive compensation for loss of companionship. Illinois did not.

The two Chicago district court judges decided that the issue of punitive damages should be based on the law in the state where the defendant was based. That meant someone suing Missouri-based aircraft manufacturer McDonnell Douglas could seek such damages, while someone suing New York-based American Airlines could not. That view was overruled by an appeals court, which ruled that lawsuits should follow the law in Illinois, which did not permit punitive damages in such cases.

Robson and Will took an extraordinary step in the settlement talks. Annoyed because they thought a key negotiator for American's insurer was lowballing settlement offers, the judges banned him from the talks.

Five years after the crash, settlements in the case had totaled about $80 million.

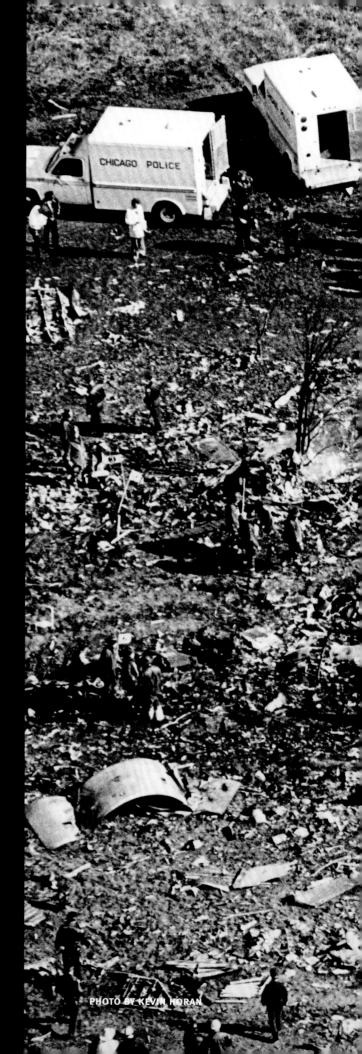

PHOTO BY KEVIN HORAN

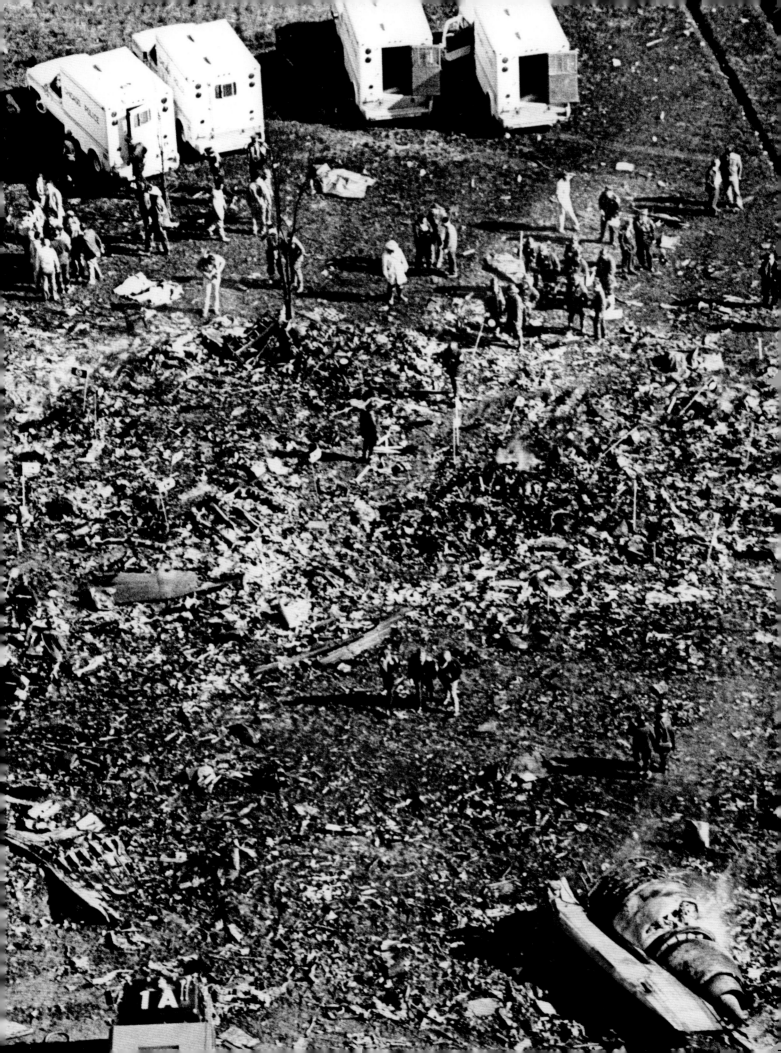

TRAFFIC JAM AT O'HARE

A contract dispute between the Federal Aviation Administration and the Professional Air Traffic Controllers Organization in 1980 and 1981 snarled not only air travel but also auto traffic around O'Hare International Airport, as people picked up passengers stranded by delayed and cancelled flights.

Members of PATCO first tried a series of work slowdowns, but the FAA persuaded District Judge Nicholas Bua to issue a temporary restraining order to stop the job action. Four months later, however, District Judge Milton Shadur dismissed the FAA's lawsuit over the slowdown scheme, saying the dispute was best handled by the U.S. Federal Labor Relations Authority.

Contract talks broke down and air traffic controllers walked out in August 1981 in violation of a ban on federal employees striking. That presented a challenge to Ronald Reagan, who was less than a year into his presidency. A Washington, D.C.-based district judge ordered large fines for every day PATCO was out, but the union did not return to work. Reagan fired all 11,345 strikers. The union was decertified and went out of operation.

It was a huge blow to organized labor, in general, and a boost to Reagan's stand-your-ground image. Ironically, PATCO had endorsed Reagan over Jimmy Carter in the 1980 election.

PUERTO RICAN TERROR BOMBINGS

Activists for Puerto Rican independence launched a series of bombings in New York and Chicago in the 1970s, and a crackdown led to several Chicago federal trials and demonstrations outside the courthouse.

In 1981, ten members of FALN (Fuerzas Armadas de Liberación) were convicted of seditious conspiracy and other charges, receiving terms of 55 to 90 years. District Judge Thomas McMillen told several defendants he wished he could sentence them to death. FALN leader Oscar Lopez Rivera was convicted later, getting 55 years.

In 1984, District Judge George Leighton threw out hidden camera evidence against four more suspects. But the Seventh Circuit ruled, "there is no right to be let alone while assembling bombs in safe houses." The four were convicted, with three getting 35-year sentences and the fourth probation.

In 1988, Lopez Rivera and three others were convicted of plotting to break him out of prison using a helicopter. District Judge William Hart sentenced them to up to fifteen years. But Lopez Rivera was released in 2017 after President Barack Obama commuted his sentence.

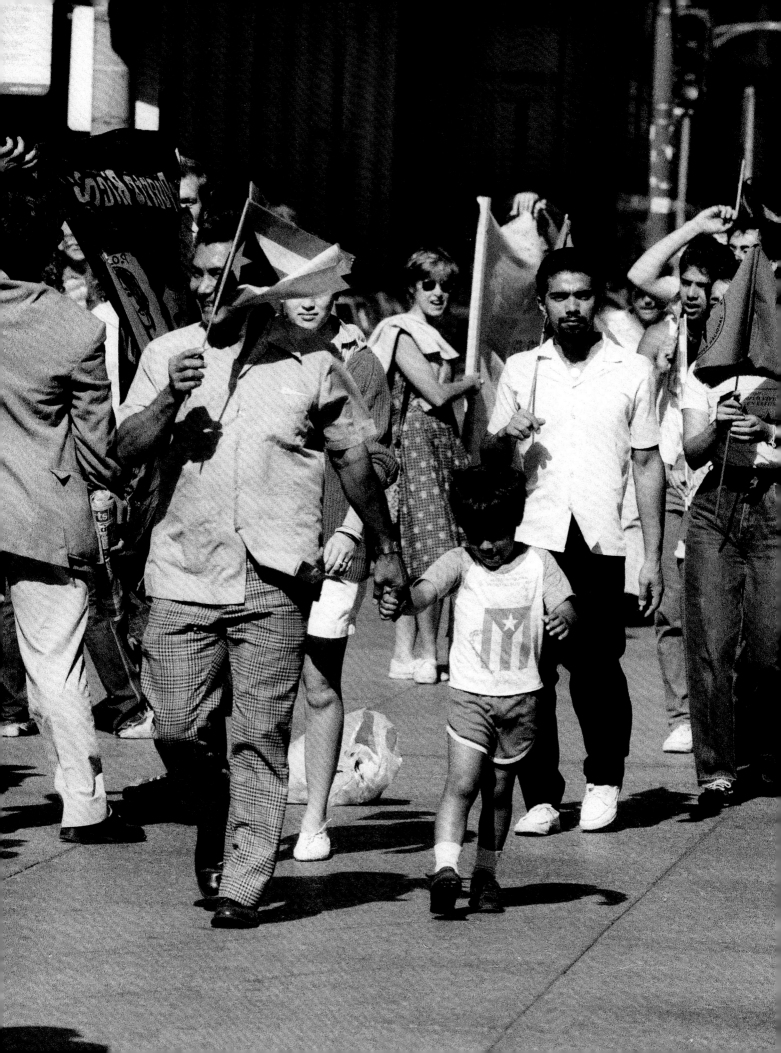

THE TYLENOL MYSTERY

In 1982, seven people in the Chicago area died over the course of several days from taking Extra-Strength Tylenol laced with cyanide. Americans were shocked by the randomness of the crime—and by the idea that anyone could have been a victim. For one family, the tragedy came in waves. A 27-year-old postal worker died, and the stress led his brother and sister-in-law to take medication from the same bottle. They both died.

When the medication's manufacturer, Johnson & Johnson, received an extortion note demanding $1 million, police identified James Lewis (*right*) and his wife, LeAnn, as suspects. He had twice been committed to mental health facilities, and was once indicted in the death of an elderly neighbor in Kansas City, Missouri, but charges were dropped.

The Lewises went on the lam, but were captured after a two-month manhunt. District Judge Frank McGarr presided over the trial in which James Lewis was convicted of extortion and sentenced to ten years in prison.

Despite suspicions that Lewis was involved in the poisonings, he was never charged, nor has any other credible suspect been identified.

PHOTO BY GENE PESEK

HOW PAC-MAN GOBBLED UP LEGAL FEES

The Japanese-designed video game Pac-Man was originally called Puckman because the game's main character was shaped like a hockey puck. But when the game came to America, there were fears that vandals would change the P to an F, so Puckman became Pac-Man.

The maze-chase game was a big hit, and lawyers in Chicago's federal courts started gobbling up legal fees to protect it from illegal imitation. In a much-watched decision, District Judge George Leighton ruled that a game called K.C. Munchkin was not so similar to Pac-Man that it constituted a copyright violation. But that decision was overturned in the Seventh Circuit.

After a company called Strohon created a kit to modify Pac-Man, District Judge Hubert Will ruled in 1983 that the kit violated the Pac-Man copyright (because a computer chip was removed and new chips were added) but did not violate the game's audiovisual copyright (because the gobbler looked different from the original).

In a video game case two decades later, District Judge Matthew Kennelly struck down a law pushed by Illinois Governor Rod Blagojevich to ban sales of violent and sexually explicit games to minors. Kennelly said the state failed to make its case that the ban would prevent violence by children.

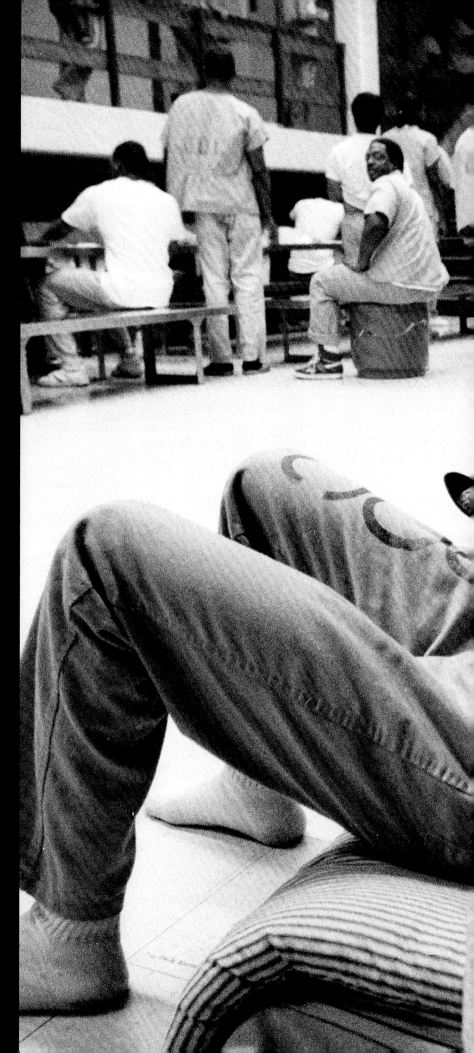

A JUDGE'S BATTLE TO BAN SLEEPING ON THE FLOOR

Overcrowded conditions at Cook County Jail led to an inmate lawsuit in 1974, and a consent decree was approved in 1982 to address the problem. For years afterward, District Judge Milton Shadur made demands and scolded jail officials.

Shadur ordered the county not to put two inmates in the same cell, and he banned sleeping on the floor. Richard M. Daley, then state's attorney and later mayor, complained that felony suspects were being released because "the federal order has become a way to beat the criminal justice system."

By 1988, sleeping on the floor had become routine, with up to one thousand inmates not having beds. Shadur imposed a $1,000-a-day fine for about a year. Some thought Shadur's sympathies were misapplied. Said Chicago Police Superintendent LeRoy Martin: "I say put the two bums in the same cell. Put four in there. Sleep in shifts."

Shadur turned over the jail case in 1992 when he reached senior status. District Judge George Marovich picked it up, and then District Judge Virginia Kendall continued the work. Court oversight ended in 2018 after substantial reforms.

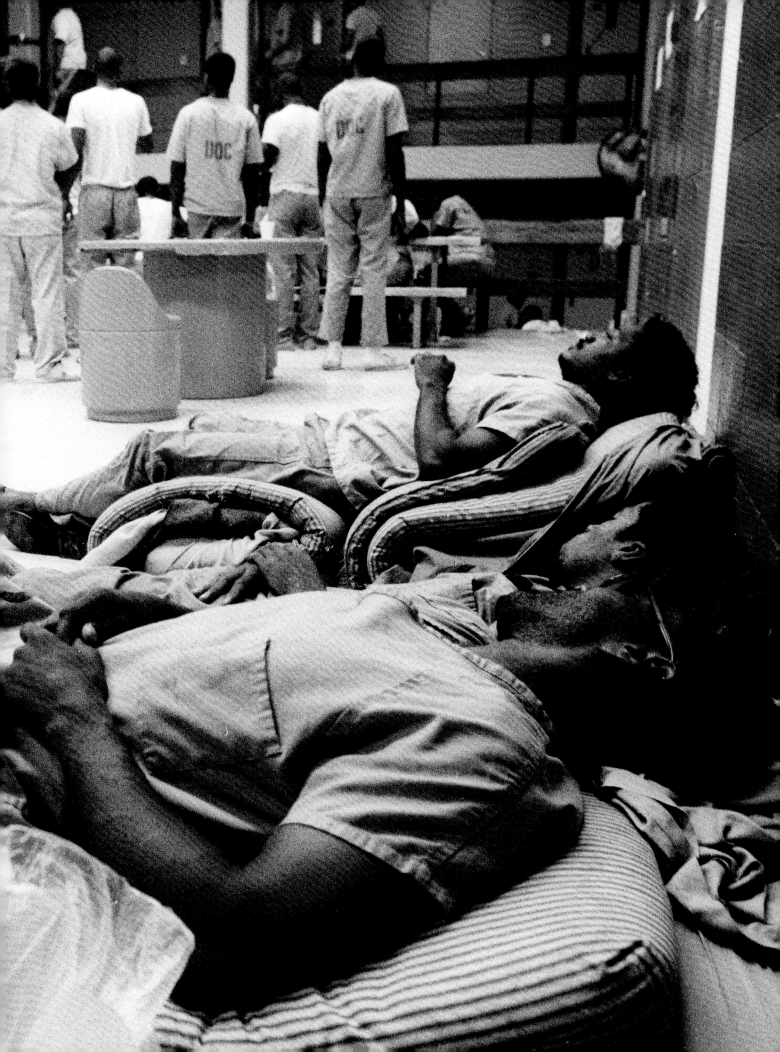

THE OIL SPILL THAT REACHED CHICAGO

The oil tanker *Amoco Cadiz* experienced equipment failure that caused it to slam into rocks off the coast of Brittany, France. The ship broke apart, dumping more than 1.6 million barrels of crude oil in a 1978 spill that was the worst up to that time.

Miles of the French coast were blackened; some of the world's most valued oyster beds were ruined.

Because the ship's owner, Amoco, was based in Chicago, litigation over damages occurred there. Six years after the spill, District Judge Frank McGarr ruled that the oil company had put off maintenance and was liable.

He ordered Amoco to pay $85 million plus legal costs. Both sides expressed dissatisfaction and vowed to appeal—a reaction that McGarr cited as a sign that his decision was fair. McGarr retired after the ruling, but stayed on as a special master. Reassessing the amount, he recommended an increase to more than $158 million, and District Judge Charles Norgle approved that. Fourteen years after the accident, when the Seventh Circuit got its say, the amount soared to $200 million.

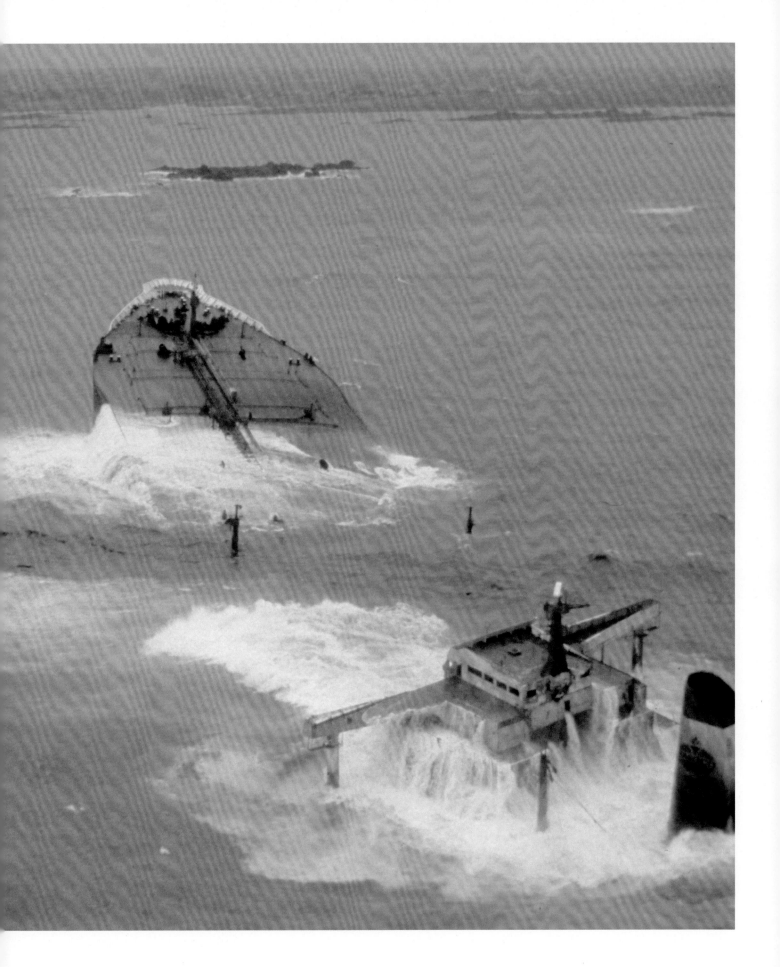

MICHAEL JACKSON'S COURTHOUSE CONCERT

A young man worth about $70 million took the stand in District Judge Marvin Aspen's courtroom. Over four hours, he sang and mimicked musical instruments. And won.

"Songs create themselves, as if you are not doing it, as if it is there already," Michael Jackson testified in 1984.

But Fred Sanford, a songwriter from Schaumburg, claimed that the music for Jackson's "The Girl Is Mine" was originally his own tune, "Please Love Me Now."

Sanford's lawsuit against CBS Records, not Jackson, said he gave CBS a demo tape of the song. Soon afterward, Jackson and Paul McCartney recorded "The Girl Is Mine" for CBS, with Jackson credited as the composer. Jackson said he came up with the song in his sleep, woke up, and sang it into a tape recorder. The jury accepted that explanation.

In another song-rights trial a year earlier, a jury ruled that another suburban man wrote the music for the Bee Gees' "How Deep Is Your Love." But District Judge George Leighton rejected that verdict and ruled for the Bee Gees.

HOW A TRANSSEXUAL
PILOT WAS GROUNDED

Kenneth Ulane flew combat missions as an army pilot in Vietnam, earning the Air Medal of Honor. He went on to work as a pilot with Eastern Airlines for twelve years, becoming a first officer and flight instructor. In 1979, Ulane took a six-month leave to receive sex reassignment surgery, then reported back to work as Karen Ulane, ready to fly.

Eastern Airlines *wasn't* ready, however.

Ulane cleared her medical fitness exam, but Eastern raised a number of concerns, including objections from some fellow pilots and "unresolved psychological problems" that the airline thought might compromise safety. The airline offered her a medical disability retirement or a job on the ground, but she declined both.

Eastern fired her, and she sued.

District Judge John Grady ruled that Ulane was legally a woman and that she was the victim of illegal sex discrimination. He found that Eastern had displayed "a prejudiced, close-minded pre-determination" of the issue, and he ordered the airline to reinstate her and give her $158,590 in back salary.

But Eastern appealed, and the Seventh Circuit reversed Grady with a strikingly harsh declaration that Ulane's self-identification as a woman was "pathetic" and "delusional." It found that Ulane was not a victim of sex discrimination under federal law. The U.S. Supreme Court affirmed the ruling without comment.

Ulane was killed in the crash of a twin-propeller DC-3 charter plane near DeKalb, Illinois, in 1989. It was unclear whether Ulane was the pilot.

GREYLORD: CRACKDOWN ON CROOKED LOCAL COURTS

John M. Murphy was among the first judges charged in 1983 in a sweeping and shocking crackdown on Cook County Circuit Court corruption. The FBI called the investigation Operation Greylord after the wigs worn by British judges.

The three-year undercover phase of the investigation featured former prosecutor Terrence Hake posing as a crooked defense attorney and gathering evidence while secretly on the FBI payroll. Investigators went so far as to plant a listening device in the chambers of one crooked judge.

More than ninety suspects were charged, including 17 judges, 48 lawyers, ten deputy sheriffs, eight other police officers, and a state legislator. Three suicides were linked to Greylord, including the death of a police officer assigned to Murphy's courtroom who killed himself on the day of the judge's indictment.

Some of the fixed cases involved drunken driving; one involved a mob contract killing. The hit man was acquitted, but after bribery was revealed, he was retried and found guilty. By the end, fifteen county judges and about 50 in total were convicted. Greylord helped spur other public corruption probes, including Operations Silver Shovel and Incubator.

Among the U.S. district judges handling Greylord cases were James Alesia, Marvin Aspen, Susan Getzendanner, John Grady, William Hart, James Holderman, Charles Kocoras, Prentice Marshall, Frank McGarr, Thomas McMillen, James Moran, John Nordberg, Charles Norgle, James Parsons, Stanley Roszkowski, Ilana Rovner, Milton Shadur, and James Zagel.

PHOTO BY RICHARD DERK

'THE LITTLEST DEFECTOR'

In 1980, a dispute over a 12-year-old boy further chilled the Cold War between the Soviet Union and the United States.

Walter Polovchak's family moved from Ukraine to Chicago, but then his parents decided to go back. Walter decided otherwise, and sought political asylum. When the U.S. government said yes, the Soviets protested the action as a "kidnapping" and accused officials of bribing the boy with a bicycle. The media called him "the littlest defector."

Walter's parents sued, and the case moved slowly. It was 1985 before District Judge Thomas McMillen gave Walter's parents the ruling they wanted—that the U.S. Immigration and Naturalization Service had violated their rights by not giving them a hearing on the asylum request. McMillen said they could come back from the Soviet Union to pick up their son. But a quick appellate order blocked McMillen's ruling, and the case was sent back to him for further hearings. Less than a month later, Walter turned eighteen, making the issue moot. Walter could now decide for himself.

When a reporter caught up to him a quarter century later, Walter was a U.S. citizen living in the Chicago suburb of Des Plaines with his wife and two sons. "I would do it all over again," he said.

CLOWN ON
THE RUN

Mobster Joey Lombardo was nicknamed "The Clown" because of his jocular nature, as evidenced by this 1981 incident where he cut a hole in a copy of the *Chicago Sun-Times* and used the newspaper to shield himself from the media outside court.

But Lombardo's victims didn't find him very amusing.

Organized crime figures were regular visitors to Chicago's federal courts, but perhaps the most momentous legal action didn't occur until the Family Secrets charges in 2005. Federal prosecutors accused twelve organized crime figures and two former police officers of gangland murders that spanned decades. One of those mob hits was the murder of the Spilotro brothers, which was well known because it inspired the pivotal cornfield killing scene in the 1995 film *Casino*.

While most of the suspects were arrested before charges were announced, the FBI was still hunting for a key one: Lombardo. The Clown went into hiding and was arrested after a nine-month manhunt.

At Lombardo's 2007 trial, his attorney, Joseph "The Shark" Lopez, told the jury that his client may have done bad things in the past but was now harmless. "See the man sitting there in a powder-blue suit?" Lopez said. "He could be a cheese salesman from Wisconsin."

Lombardo was tried with four other defendants, and all were convicted. District Judge James Zagel sentenced The Clown to life in prison. Zagel noted that Lombardo charmed some people, but said people should be judged on actions, not on "our wits and our smiles."

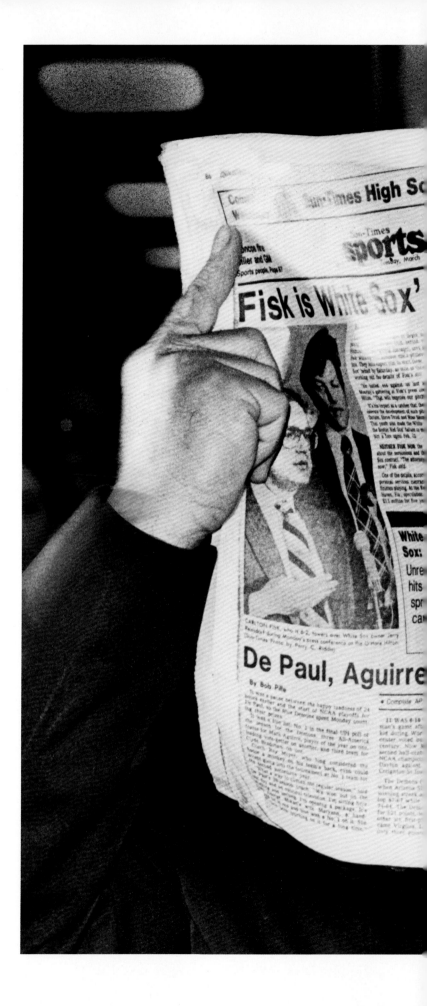

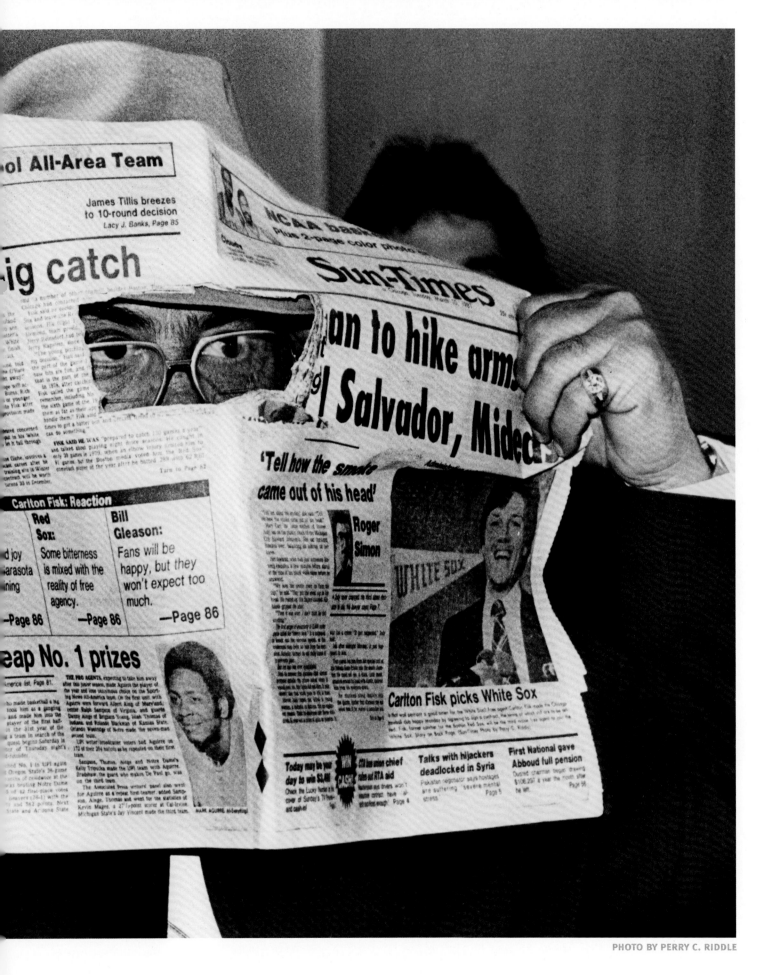

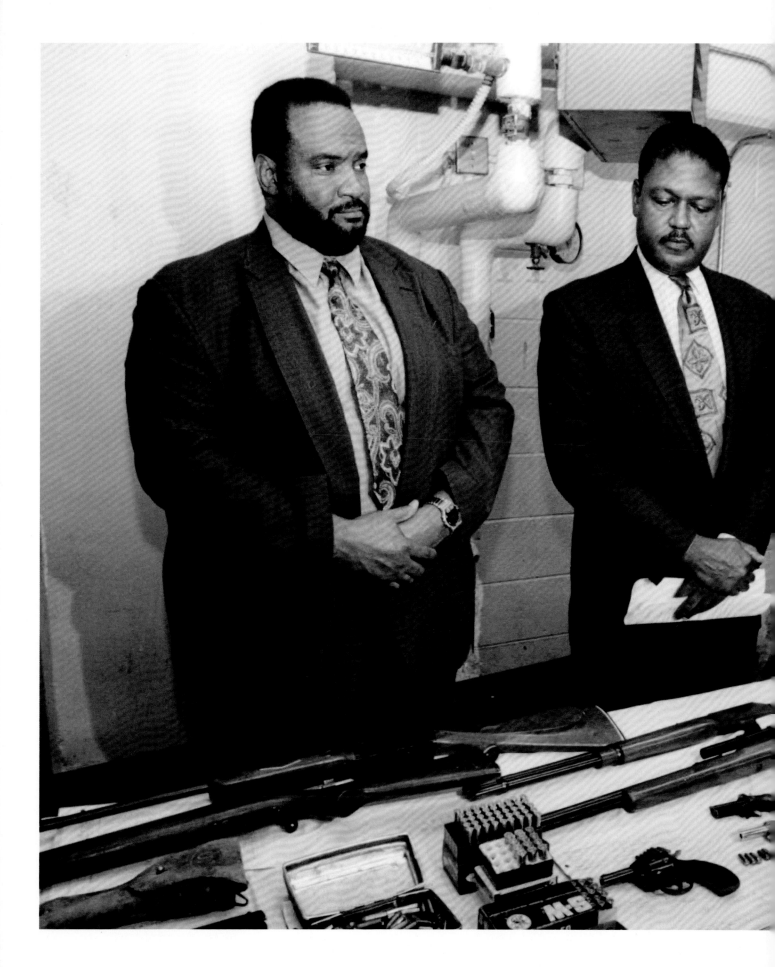

HIGH COURT DISARMED CHICAGO'S HANDGUN BAN

Chicago, long plagued by gun violence, developed strict laws regulating firearms, including a handgun ban in 1982. Chief Hosea Crossly of the Chicago Housing Authority Police is shown at left with CHA Chairman Vincent Lane after a gun sweep at the Robert Taylor public housing development in 1993.

While the city's handgun ban was popular with many residents, it was open to challenge on Second Amendment grounds. Pro-gun-rights groups sued, with elderly South Side resident Otis McDonald as lead plaintiff.

District Judge Milton Shadur ruled in favor of Chicago's ban, and so did the Seventh Circuit. The case went to the Supreme Court, which reversed those rulings and held that Americans have a constitutional right to keep guns in their home for lawful purposes, such as self-defense.

"I was fed up with drug dealers and gang-bangers messing with my home, my property and eventually threatening my life, and somebody saying that all we needed was to get guns out of the houses," said McDonald after his legal victory.

SEIZING A PAINTING AT THE ART INSTITUTE

Harold Washington, Chicago's first black mayor, had been dead just six months when art student David K. Nelson created a painting showing Washington in women's underwear and displayed it at an art show. Three aldermen—Bobby Rush, Dorothy Tillman, and Allan Streeter—marched into the Art Institute accompanied by police officers and took an outrageous action in a free country: They seized the painting.

Shown here are activist Harold Hall, left, and art student Cherie Granger arguing over the artwork in 1987. Such passion was cited by the aldermen, who said they were defusing a "powder keg."

The American Civil Liberties Union, representing Nelson, sued in federal court, seeking $100,000 from each of the three lawmakers. ACLU Legal Director Harvey Grossman said that if the painting was causing unrest, it was up to police to control the people's reaction, not censor the artwork.

In court, the defendants put forth a novel argument: The painting's seizure had actually helped Nelson by making him famous.

District Judge George Lindberg ruled that the lawmakers had violated Nelson's civil rights, and the Seventh Circuit affirmed that, calling the action "lawless." But ultimately, the aldermen avoided forking over $100,000 each. The city settled the case by paying $95,000 for Nelson's legal fees. Nelson himself got nothing. But the aldermen agreed to accept the ruling that they had violated his rights.

TV'S WALTER JACOBSON GOT SMOKED

Tobacco companies are rarely cast as victims. But skillful lawyers managed to convince a jury in 1985 after Brown & Williamson, manufacturer of Viceroy cigarettes, sued newscaster Walter Jacobson and CBS over commentaries on WBBM-Channel 2.

Jacobson accused the company of enticing young people to take up the cigarette habit by using advertising that depicted smoking as a rite of passage, like "pot, wine, beer, sex and wearing a bra." Brown & Williamson's attorneys said an outside marketing company had suggested such an ad campaign but that the company was outraged by the idea and never adopted it. The tobacco company said Jacobson's accusation was libelous, and the jury agreed.

Jurors awarded Brown & Williamson $3 million in actual damages against Jacobson and CBS, and the TV company was required to pay $2 million more in punitive damages. Jacobson was assessed $50,000 in punitive damages that he had to pay out of his own pocket.

"I feel some outrage, some fury as well as disappointment," said Jacobson after the decision. "I am outraged at the cigarette industry for trying to intimidate the press. I don't feel intimidated."

District Judge William Hart later threw out the $3 million in actual damages, saying there was no proof that the cigarette maker had lost any sales. But he did award a single dollar in actual damages. Hart left the punitive awards as the jury had decided them, including the stinging price tag to Jacobson. The Seventh Circuit restored $1 million of the actual damages award. The Supreme Court let that stand.

DAN WALKER'S 'FALL FROM GRACE'

Dan Walker became famous—and became Illinois' governor—as the red-bandanna-wearing candidate who hiked 1,197 miles all over Illinois. He served one term as the state's chief executive, left office in 1977, and then struggled in business. His chain of law offices and a hunting and fishing club were failures. He tried the savings and loan business, and also owned a chain of quick oil-change garages. And he got himself into serious trouble.

Walker pleaded guilty in 1987 to bank fraud and perjury after obtaining nearly $1.4 million in loans, some of it to finance his oil-change business—and some to pay for an 80-foot yacht, *Governor's Lady*.

District Judge Ann Williams sentenced Walker to seven years in prison, declaring he had "placed himself above the law" and used the savings and loan as "a personal piggy bank, a personal kitty." She said Walker was responsible for his own "fall from grace, loss of stature, embarrassment and humiliation."

But Williams later reduced the sentence to slightly less than eighteen months and freed Walker after his lawyer told her about his client's deteriorating health.

LOYOLA'S BID TO TURN LAKE INTO LAND

Loyola University Chicago wanted to add recreational space to its North Side campus along Lake Michigan, including a 35-foot-wide path for biking and hiking. It also sought to protect its lakefront from erosion. How? By turning 18 acres of the lake into 18 acres of new land. This kind of lakefill was a tried-and-true tactic in Chicago—as demonstrated by how today's downtown lakefront looks far different from the one that existed two centuries ago.

An advocacy group called the Lake Michigan Federation was unimpressed by Loyola's plan. It filed a lawsuit in 1990 complaining that the state had improperly sold the stretch to a private interest.

State Senator Art Berman, who sponsored the Illinois legislation selling the lake land for $10,000, argued that the sale didn't violate the state's public trust doctrine because the walkway would be accessible to community members. Without the lakefill, he argued, the acres in question were "currently accessible only to the fish."

District Judge Marvin Aspen issued an injunction to block the project, and Loyola prepared to appeal it. But the Catholic school decided against continuing the battle.

Said Reverend Raymond Baumhart, Loyola's president: "We found ourselves running a marathon where the requirements changed, the length of the race became indeterminate and those capable of erecting obstacles multiplied."

171

UMPIRES

PLATE 1ST 2ND 3RD
 2 15 10 5

GS BATTER

CINCINNA

LOS ANGEL

PHILADELPHI

ST. LOUI

AMERI

II

District Judge Suzanne Conlon insisted she was "not acting like an umpire" in a 1992 court case. But she called the Chicago Cubs safe at home anyway.

Major League Baseball decided to realign the divisions, moving the Cubs and the St. Louis Cardinals to the National League West and shifting the Cincinnati Reds and Atlanta Braves to the NL East. The Cubs sued, arguing that the move violated the Major League Agreement because they had not approved it. Commissioner Fay Vincent said he was legitimately acting "in the best interests of baseball."

Conlon issued a temporary restraining order, and before an appeal could be heard, Vincent resigned. MLB dropped its plan, and the Cubs dropped their suit. Ultimately, a different realignment happened, with the Cubs moving to a newly created NL Central Division.

The Cubs also spent considerable time in federal court fighting with owners of the rooftops ringing the outfield at Wrigley Field. But now, the Cubs' majority owner, the Ricketts family, owns most of the rooftops.

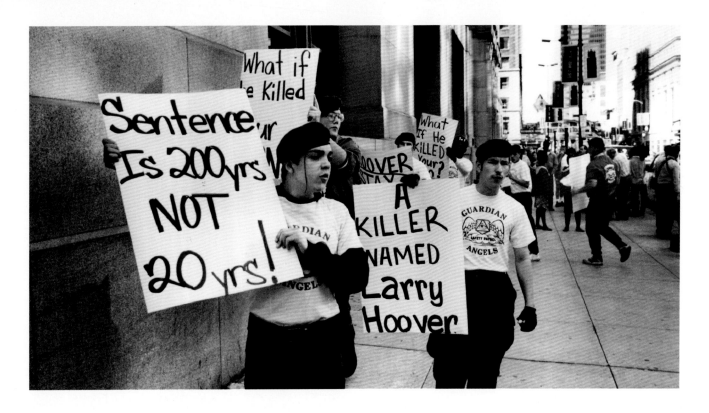

CHICAGO'S WAR ON GANGS

Larry Hoover had served 20 years of his 150-to-200-year sentence for murder when he sought parole in 1993. Hoover, the "chairman" of the Gangster Disciples street gang, told the Illinois Prisoner Review Board that he advised young prisoners on "the need to go to school," then claimed that "GD" now stood for Growth and Development.

Hoover had politicians such as former Chicago Mayor Eugene Sawyer in his corner, but was opposed by the anti-gang activists shown here, members of the Guardian Angels. The review board voted to keep Hoover behind bars.

Two years later, Hoover was among dozens of suspected Gangster Disciples members charged in a conspiracy to sell illicit drugs. Using a transmitter hidden in a prison visitor's badge, investigators recorded Hoover discussing drug deals. District Judges Brian Duff and George Lindberg handled issues related to the Hoover tapes, but Hoover's trial went to District Judge Harry Leinenweber. Hoover was convicted, and Leinenweber ordered him to serve six life sentences, seven twenty-year sentences, and three four-year sentences. All were concurrent, with a five-year sentence to run consecutively after the others were complete. Other district judges handling GD cases included James Alesia, Suzanne Conlon, William Hibbler, Charles Kocoras, Joan Lefkow, George Marovich, Paul Plunkett, and Amy St. Eve.

Prosecutors cracked down on another gang, the El Rukns, in the 1990s. But the U.S. Attorney's Office faced its own scandal when District Judge James Holderman noted that Rukn informants got benefits while in custody—including sexual liaisons and drugs. A memorable *Chicago Sun-Times* headline read: "Sex, Drugs and Rukn Role."

In the 2010s, District Judge John Tharp oversaw trials involving another fearsome gang, the Hobos.

JEFFREY ERICKSON'S FAILED ESCAPE

No one who was at the Dirksen Federal Building on July 20, 1992, will forget what happened that day.

Bank robbery defendant Jeffrey Erickson was being escorted from District Judge James Alesia's courtroom to the Metropolitan Correctional Center when Erickson unlocked his handcuffs, grabbed a handgun, and fatally shot U.S. Deputy Marshal Roy "Bill" Frakes (*left*). Erickson then exchanged fire with Court Security Officer Harry

Belluomini (*right*), fatally shooting him. Erickson, shot in the back by Belluomini, ran from the underground Dirksen garage and was about a third of the way up a ramp when he saw security guards at the top. He was cornered.

Erickson turned the gun toward his own face and fired, killing himself.

The shocking incident ended a saga in which Erickson and his wife, Jill, became infamous as a Bonnie and Clyde-style robbery team. The previous December, Jill shot herself to

death during a police chase.

These handcuffs are similar to those worn by Erickson. A fellow prisoner was found guilty in 2002 of slipping him a handcuff key.

Officers Frakes and Belluomini are honored for their bravery with a plaque in the lobby of the Dirksen Building.

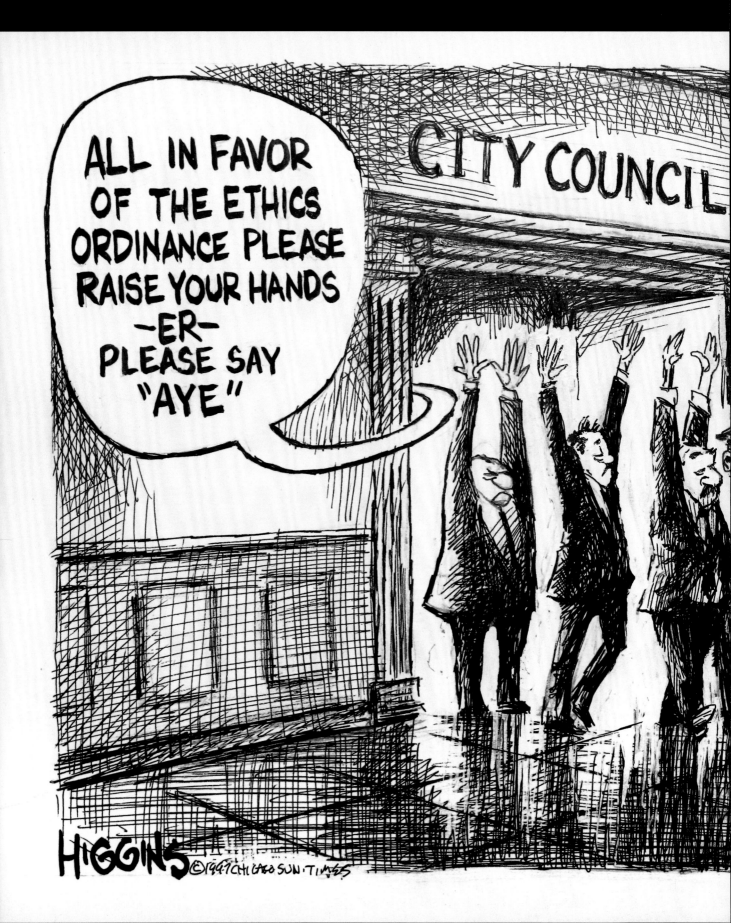

A history of corruption scandals has sullied the reputation of Chicago's City Council.

When Willie Cochran pleaded guilty to a felony charge of wire fraud in March 2019, he became the 30th alderman convicted since 1972, according to a *Chicago Tribune* tally.

District judges who have handled cases of aldermanic corruption include Jorge Alonso, Marvin Aspen, Elaine Bucklo, Rubén Castillo, David Coar, Robert Dow, Brian Duff, Susan Getzendanner, Joan Gottschall, John Grady, James Holderman, Charles Kocoras, George Lindberg, John Nordberg, Charles Norgle, Ilana Rovner, Milton Shadur, Ann Williams, and James Zagel.

No Chicago mayor has ever gone to jail, but one of Richard J. Daley's trusted aides did. He was Earl Bush, the former Daley press secretary most famous for telling the press: "Don't print what he said. Print what he meant." Bush was convicted for the cover-up of a contract he had at O'Hare International Airport. Sentenced to probation by District Judge Philip Tone, Bush got the conviction overturned more than a decade later.

YOU GET A PHOTO! AND YOU GET A PHOTO!

Television host Oprah Winfrey's biggest federal case was in Texas, where her on-air comments questioning the safety of beef inspired the cattle industry to sue her for $10 million. She won that trial, memorably declaring outside court: "Free speech not only lives—it rocks!"

Winfrey had a different kind of battle in a Chicago federal courtroom over a separate issue of free expression.

Freelance photographers Paul Natkin and Stephen Green had taken tens of thousands of pictures of Winfrey's shows, and Winfrey claimed she was a joint owner of the images. Charles Babcock, her attorney, said the photographers wanted to take possession of the photos—which were then stored at Winfrey's Harpo Studios—because "they want to be free to sell them to some kind of rumormonger."

But Natkin testified at the 2000 trial: "I would never sell a photo to a tabloid for any purpose."

PHOTO BY ROBERT A. DAVIS

District Judge Rubén Castillo ruled that the pictures and their copyrights were the sole property of the photographers.

But as Castillo prepared to rule on the photographers' separate allegation that Winfrey used their photos in a book without their permission, the two sides reached a confidential settlement.

They agreed to "share the use of the photographs just like they always have," Babcock said.

Winfrey's attorney also backed off on his claim that the photographers wanted to sell the photos to scandal sheets. "We never really thought they were intending to do that," he said, "but if we had lost they could have had the right to do that."

STUDS HATED STATE SECRETS

Louis "Studs" Terkel, Chicago's leftist warrior and champion of the common man, waged quixotic battles in federal court with a mega-corporation and the U.S. intelligence community.

In 1975, the author and radio host asked the FBI for its file on him, and sued after receiving no answer by the statutory deadline. The file later arrived, but Terkel pressed his suit because many of the 146 pages had "portions deleted." Other documents were withheld in their entirety. (Outside court, Terkel joked that he was annoyed because his wife, Ida, had a larger FBI file than he did.)

District Judge Frank McGarr ruled in favor of the FBI.

In 2006, Terkel was a celebrity plaintiff in a lawsuit against AT&T by the American Civil Liberties Union of Illinois, which said the company violated customers' privacy by giving phone records to the U.S. government without a court order.

The government halted that lawsuit by invoking its "state secrets" privilege, saying any disclosure about its dealings with AT&T would endanger national security. District Judge Matthew Kennelly determined that the government's position meant the plaintiffs would not be able to make a case—so Kennelly dismissed the suit.

26. The human waste is a contaminant as defined by 415 ILCS 5/3.165.

27. Defendants' discharge of the human waste into the Chicago River and onto the *Chicago's Little Lady*, its passengers, and its crew, violated state laws, including 720 ILCS 5/12-5, 415 ILCS 5/12(a) and 415 ILCS 5/12(f).

28. Defendants discharged the human waste into the Chicago River while aware of a substantial probability that the discharge violated Illinois law.

29. The human waste hit the *Chicago's Little Lady* and dozens of its passengers, drenching them with the foul-smelling, brownish-yellow liquid and getting into passengers' eyes, mouths and hair. It soaked the vessel and passengers' clothing and personal belongings. Many passengers experienced nausea and vomiting from their direct exposure or close proximity to the human waste. Passengers hit by the human waste included children, senior citizens, persons with disabilities, and a pregnant woman.

THE DAVE MATTHEWS BAND AND THE CHICAGO RIVER

Architecture sightseeing cruises on the Chicago River are a popular tourist activity. But that was a bad choice on the afternoon of August 8, 2004, when the Dave Matthews Band's bus drove over the Kinzie Street Bridge and dumped its load of human waste through the bridge grates onto *Chicago's First Lady,* a boat below.

About two-thirds of the passengers on the boat's upper deck were drenched by the liquid poop. The band didn't own up to the mess until days later when a video confirmed that its bus was the culprit.

Bus driver Stefan Wohl pleaded guilty in Cook County Circuit Court and got probation, community service, and a $10,000 fine. Illinois Attorney General Lisa Madigan reached a settlement with the band for $200,000 more to fund environmental education. A separate lawsuit, filed by the cruise line against the band and Wohl, was moved from Cook County to federal court. District Judge Mark Filip threw out portions of that suit, and the sides reached a settlement a few months later.

But the incident has lingered. Five years later, WMAQ-Channel 5 in Chicago wrote an online story headlined: "Dave Matthews Still Apologizing for 'Poopgate.'" Said Matthews: "I regret that enormously, and I know some people there accept my apology and other people don't." Later, he said, "If Snoop Dogg had done it, it probably would have raised his record sales, but it applies differently to everybody."

MAXWELL STREET'S SECONDHAND HISTORY

There was a lot of history on Chicago's Maxwell Street. It wasn't an elegant history, but it was history. The Maxwell Street Market on the Near West Side was the place where you could buy all types of used items, or new merchandise that had fallen off a delivery truck. One merchant boasted: "We cheat you fair." Immigrant Jews pushed repair wagons there. African-Americans played blues there.

In 2000, the University of Illinois at Chicago planned to knock down Maxwell's historic buildings to expand its campus. The Maxwell Street Historic Preservation Coalition sued.

Preservationists asked District Judge Ronald Guzman to order a halt while they tried to get Maxwell Street on the National Register of Historic Places, but Guzman saw the chances as "less than negligible" after the area was rejected by the National Register in 1994. The buildings came down.

THIS AIRPORT IS CLOSED

Critics of Mayor Richard M. Daley called it one of the most undemocratic actions in Chicago's recent history. But in the end, Daley prevailed.

As midnight approached on March 30, 2003, city work crews showed up at Chicago's small lakefront airport, Meigs Field, and carved X's in the runways using backhoes. Daley wanted to close the airport because he thought small planes flying near downtown were a terrorism threat in the wake of the attacks on New York's World Trade Center and the Pentagon on September 11, 2001.

Daley didn't inform state or federal authorities about his plans for Meigs. He didn't convene public hearings. He simply ordered it, and it was done.

Many people were furious. "Mayor Daley bulldozed his way into aviation history this morning by destroying a national treasure," declared John Carr, head of the National Air Traffic Controllers Association.

Pilots and the state of Illinois filed suit to prevent Daley from closing Meigs permanently and turning it into a park. But they lost in District Judge Joan Gottschall's court, and the area is now called Northerly Island Park.

THE BAD SEEDS IN AGRIBUSINESS

Archer Daniels Midland, a major agribusiness based in downstate Decatur, made an impact internationally—and not in a good way.

ADM Vice Chairman Michael Andreas, shown here leaving court, helped his company engage in a global conspiracy to fix the price of an animal feed additive called lysine. Andreas had been expected to succeed his father, Wayne Andreas, as head of ADM, but instead was sentenced to two years in prison and fined $350,000 after a 1999 trial

conducted by District Judge Blanche Manning.

The trial followed a long undercover investigation in which ADM division chief Mark Whitacre revealed company secrets and worked as a mole for the FBI for more than two years, recording discussions between ADM and its competitors. Complicating the government's case was the revelation that Whitacre had embezzled money from ADM while working for the FBI.

For the embezzlement, Whitacre was sentenced

to nine years in prison and ordered to pay $11.4 million. For the price-fixing plot, he got 30 months, with most of it to run after the first sentence.

In an antitrust case, ADM pleaded guilty and paid a $100 million fine, a record at that time.

In a prison interview with the *Chicago Tribune*, Whitacre said: "There is a lot of corruption going on in big business. I think a lot of corners are being cut, and they will continue to be cut. Everything's a bottom-line evaluation. It's almost like it's a positive thing to be greedy."

The case was the subject of the 2009 movie *The Informant!*

TRAGIC ATTACK ON A JUDGE'S FAMILY

One of the saddest days in the history of Chicago's federal court was February 28, 2005, when District Judge Joan Humphrey Lekfow arrived home in her North Side neighborhood to find her mother and husband shot to death.

Suspicion initially fell on the radical right because white supremacist Matthew Hale had been convicted of plotting to kill Lefkow, who had held him in contempt of court.

But then an out-of-work electrician named Bart Ross shot himself to death during a traffic stop near Milwaukee, and DNA linked him to the crime. Ross, whose face was disfigured by cancer surgery, had sued over his treatment, and Lefkow dismissed his case. Police suspected that Ross went to the house to kill her.

The murders of Lefkow's husband, Michael, and mother, Donna Grace Humphrey, prompted upgrades in court security. Months later, Lefkow said, "There is no court of appeal that can reverse what has happened. . . . I pray that one day joy will return to our lives, and I believe that will happen." She soon returned to the court.

GET THOSE HOUSES OFF THE RUNWAY!

Houses on Green Lawn Avenue in the suburb of Bensenville were acquired by the City of Chicago as it prepared to build a new runway for O'Hare International Airport. But the quiet scene shown here didn't reflect the loud dispute as suburbanites sought to keep their communities from being gobbled up.

Targeted by the city were hundreds of homes, a couple hundred businesses, and about 1,300 graves at St. Johannes Cemetery, which was established in 1849.

The major case in Chicago's federal court pitted the suburbs of Bensenville and Elk Grove Village, along with St. John's United Church of Christ, against the city. The church argued that the cemetery plan would violate federal law protecting religious freedom.

District Judge David Coar ruled against the suburbs in 2005, acknowledging the "adverse effect" on their communities but deciding that the city's eminent domain efforts were justified.

Later rulings in federal appellate courts in Chicago and Washington, D.C., supported the city's efforts, and the Supreme Court declined to take up the issue.

186

PHOTO BY JOHN H. WHITE

PHOTO BY JEAN LACHAT

WHEN GEORGE RYAN TOOK LICENSE

He was nominated for the Nobel Peace Prize for closing Illinois' Death Row, but there was a side of George Ryan that had nothing to do with justice.

Illinois' ex-governor was charged in 2003 with corruption from his time as secretary of state and in the governor's mansion. Suspicions had swirled around Ryan since the revelation that truck drivers bribed his employees to get licenses after one such driver was involved in an accident that killed six children.

The charges against Ryan did not tie him directly to the licensing scheme, though it did accuse him of trying to sabotage the investigation into it. What was remarkable was the pervasive nature of Ryan's alleged corruption, with Ryan and his relatives getting vacation freebies and cash in exchange for state contracts and other favors.

Ryan was convicted of racketeering and fraud. District Judge Rebecca Pallmeyer sentenced him to more than six years in prison.

Declared Ryan: "I have said since the beginning of this ten-year ordeal that I am innocent. And I intend to prove that."

But he never did.

PHOTO BY ASHLEE REZIN

THE BEAN SCULPTOR VS. THE NRA

The Bean—well, its official name is *Cloud Gate*—became an instant Chicago hit when it was installed in Millennium Park in 2004.

British sculptor Anish Kapoor, shown here taking a selfie with his $10 million, 110-ton creation, said even he was surprised by how well it reflected the image of Chicago's skyline. "I always knew we'd have views of the city, but I didn't know how powerful it would be," he said.

The sculptor was far less pleased when the National Rifle Association included the Bean in its 2017 video called "The Clenched Fist of Truth." Kapoor said he was "disgusted" that his art was incorporated into the video without his consent to promote the gun rights group's "vile message."

Kapoor sued in the Northern District of Illinois, but the case was moved to Virginia, where the National Rifle Association is based. The NRA settled the case by removing The Bean from the video but paying no money. Both sides claimed victory.

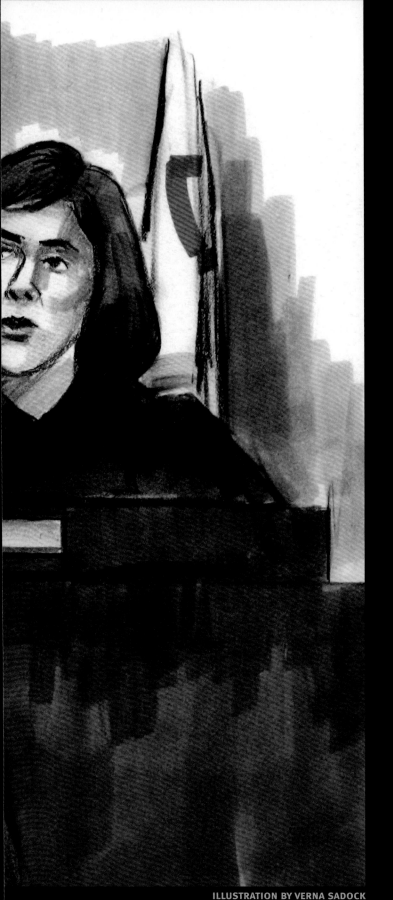

LORD BLACK AND THE LAW

Conrad Black, owner of a global media empire, renounced his Canadian citizenship so he could gain British life peerage as Lord Black of Crossharbour. But, lord, did he get in trouble in a third country, the United States.

Black, shown here with District Judge Amy St. Eve in a courtroom sketch by Verna Sadock, was charged in 2005 with ripping off stockholders of his parent company, Hollinger, whose holdings included the *Chicago Sun-Times*. Prosecutors said Black and his associates arranged sham transactions to collect millions of dollars. Black was also charged with more overt indulgences, such as billing the company for his wife's lavish birthday party and using the company jet for a private vacation to Bora Bora.

A Chicago jury found him guilty of some of the charges, including obstruction of justice and three counts of mail fraud. St. Eve sentenced him to more than six years in prison.

Black appealed, and benefitted from a Supreme Court ruling that federal prosecutors were too broadly applying "honest services" law—the concept that the public has the right to honest services from politicians and business executives. Two of Black's convictions were overturned, but two others were affirmed. St. Eve resentenced Black to 42 months.

Black continued to assert that he was railroaded by "Nazi" prosecutors, but he did see some benefit from his incarceration, saying it gave him "a greater sense of humility." After writing a book praising President Donald Trump, Black received a presidential pardon.

FOOL'S GOLD

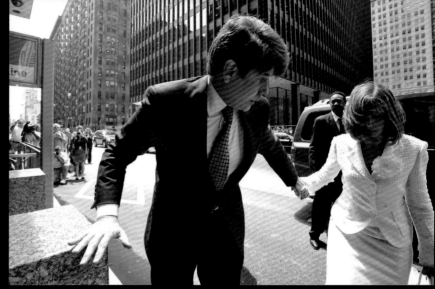

When Barack Obama won the presidency in 2008, Governor Rod Blagojevich had the duty of filling Obama's Senate seat. That opportunity wasn't just golden to Blagojevich—it was "f---ing golden."

Blagojevich was caught on federal recordings conspiring to sell the Senate seat for money or favors. He fought the government tooth-and-nail in two trials.

In the first, presided over by District Judge James Zagel, the governor was convicted of one count of lying to FBI agents, but a jury reached no verdict on 23 other counts. At a second trial under Zagel, jurors convicted Blagojevich on seventeen counts and acquitted him on one. The jury deadlocked on two more. Zagel sentenced Blagojevich to fourteen years in prison.

The Seventh Circuit overturned the convictions on five counts but affirmed the rest, including Blagojevich's attempt to sell the Senate seat. Zagel resentenced the ex-governor to the same fourteen-year sentence.

Blagojevich's signature dark, lush hair turned gray in prison.

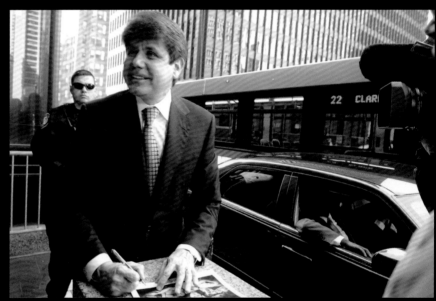

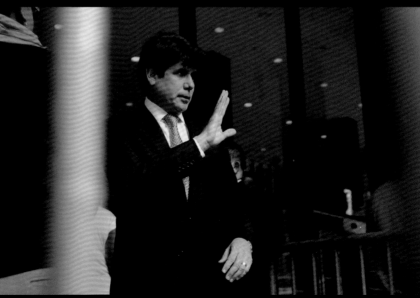

BELATED VERDICT ON BURGE'S TORTURE

No person symbolized Chicago's reputation for police brutality more than Jon Burge.

The South Side police commander and his "Midnight Crew" were accused of torturing more than one hundred suspects in the 1970s and '80s. The fact that Burge was white and most of the suspects were black was not lost on Chicago's African Americans. His action contributed to their widespread distrust of the police.

Burge's crew used cattle prods to shock suspects and even put guns in their mouths to extract confessions. Legal fees and settlements related to Burge's torture cost the city more than $100 million. And the discovery of Burge's misconduct in death penalty cases helped persuade Illinois Governor George Ryan to ban capital punishment in 2003.

Yet Burge got away with his abuses for a long time. He was fired in 1993, but was not prosecuted because the statute of limitations had lapsed. He was finally put behind bars for lying in a civil deposition. In 2011, District Judge Joan Lefkow sentenced Burge to more than four years in prison.

Even then, Burge kept his pension when the Illinois Supreme Court ruled that a police retirement board had the final word on that issue. He died in 2018.

TERROR IN THE MIDDLE EAST ...

Was Mohammed Salah a used car dealer from the southwest suburb of Bridgeview or a Hamas organizer financing terror attacks against Israel? Or both?

Salah (*above, center*) spent nearly five years imprisoned in Israel, and faced legal battles when he returned to Chicago in 1997.

The U.S. government used civil forfeiture to seize $1.4 million from him and an Islamic literacy group. He was sued by the parents

of a terror victim. In 2004, he was charged with racketeering conspiracy. A jury acquitted him of that charge, but found him guilty of obstruction of justice. District Judge Amy St. Eve sentenced him to 21 months in prison.

In another terrorism case, suburban teenager Adel Daoud was convicted of plotting to blow up a Chicago bar in 2012. An undercover FBI agent talked to Daoud about the plot, and watched as Daoud

went through a process that he thought would detonate a bomb. District Judge Sharon Johnson Coleman sentenced Daoud to sixteen years in prison.

In a case overseen by District Judge Andrea Wood, two suburban men—Edward Schimenti and Joseph Jones—were convicted of terror-related charges. They were allegedly caught on tape hoping that the Islamic State flag flew "on top of the White House."

... AND IN INDIA'S CITY OF MUMBAI

The Mumbai, India, terrorist attacks of 2008 killed about 170 people, including six Americans. Attackers linked to Pakistan's Lashkar-e-Taiba group hit multiple targets, including two hotels, a Jewish community center, a restaurant, a railway station, and a hospital.

The investigation led to two Chicagoans being charged with helping prepare the Mumbai attack. The defendants, David Coleman Headley and Tahawwur Rana, were also charged with a plot to behead staffers at a Danish newspaper that printed cartoons of the prophet Muhammad. That attack never occurred.

Headley cut a cooperation deal with the feds to avoid the death penalty and extradition to India. Rana went to trial, with District Judge Harry Leinenweber presiding. The proceedings were closely watched in India, as evidenced by the coverage of New Delhi television reporter Sarah Jacob, shown above.

The Chicago jury found Rana not guilty in the Mumbai attack but convicted him in the Danish plot. He received a fourteen-year sentence. The next week, Headley was sentenced to 35 years.

An American witness to the attacks, Linda Ragsdale, testified before Headley's sentencing. "I know the sweet, sickening smell of gunfire and blood," she said.

INVASION OF THE 'RIVER RABBITS,' ALSO KNOWN AS ASIAN CARP

The advance of Asian carp was an alarming development. The invasive species, once stocked in catfish ponds to control algae blooms, spread in floodwaters through the Mississippi River basin. The carp reached Illinois waterways, moving toward Lake Michigan and raising fears that they would blot out native creatures if they reached the Great Lakes.

Nicknamed "river rabbits" for their reproduction rates, the carp are ravenous eaters, sometimes consuming their own weight in a day.

Illinois took various actions to fend off the fish—including electric barriers and chemical fish kills like the one shown here in 2009 in the Chicago Sanitary and Ship Canal near Lockport. Other Great Lakes states didn't think Illinois was doing enough. They went to court to demand that Chicago-area shipping locks be closed to traffic.

Illinois fought back, saying that would severely damage the local economy. A key ruling came in 2010 when District Judge Robert Dow rejected the neighboring states' legal efforts.

As of 2019, efforts to prevent an Asian carp takeover of the lake appeared to be successful. So far. Ironically, Chinese scientists have come to Illinois to study why the carp are doing so well in the Midwest. In China, where the carp is a valued food source, its population is threatened by pollution, overfishing, and dam construction.

THEY FINALLY NOTICED THAT $54 MILLION WAS MISSING

FBI agents visited City Hall in Dixon, Illinois, on April 16, 2012, and left with Comptroller Rita Crundwell in custody. She had stolen a staggering $54 million from the town over 22 years, spending much of it on a quarter horse breeding farm.

At one point, the amount she stole in a single year exceeded the combined budgets of the town's police and fire departments.

In the end, her passion for horses was her undoing. While Crundwell was away from work for horse shows, a fill-in accountant discovered her secret fund and alerted authorities. When Crundwell pleaded guilty and was sentenced to nearly twenty years in prison, District Judge Philip Reinhard told her: "You showed much greater passion for the welfare of your horses than the people of Dixon you represented."

Dixon recovered nearly $40 million through an auction (*left*) of Crundwell's ill-gotten assets and a lawsuit against the auditors and bank that had failed to detect the financial misdeeds.

PHOTOS BY SHANE T. MCCOY

CONTROL YOURSELF, MR. TRUMP

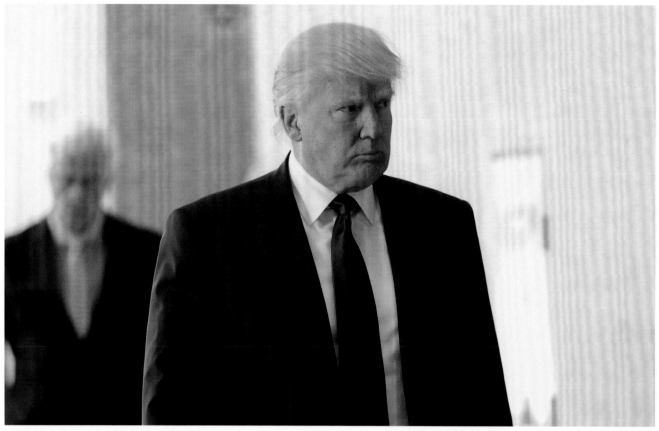

Two years before Donald Trump launched his successful bid for the presidency, he was scolded in Chicago by District Judge Amy St. Eve, who ordered him to "get control" of himself.

Trump was sued by Jacqueline Goldberg, who bought two units in Trump Tower Chicago. Trump offered financial incentives to early investors like Goldberg, but his contract included a clause allowing him to pull the incentives later. Trump testified in 2013 that Goldberg asked for that clause to be cut, but he refused, and she signed anyway. And sure enough, he yanked the incentives.

"And then she sued me! Unbelievable!" Trump said.

When Trump clashed angrily with Goldberg's attorney, Shelly Kulwin, St. Eve lectured the two: "You've been dancing around and boxing with each other for the last 45 minutes. . . . You've got to stop it. Let's get control of ourselves."

A jury found Trump not guilty of fraud. Later, he gloated on Twitter: "Mrs. Goldberg, who filed the Chicago case many years ago, is a vicious and conniving woman–loved beating her."

At a scheduling meeting, the judge reportedly said, "I'll see you all Monday morning."

"Your Honor, could we make that Tuesday," asked Trump's lawyer. "Mr. Trump has a prior commitment for Monday."

"What prior commitment?" the judge asked.

"Taping for *The Apprentice*," said the lawyer.

"That's nice," St. Eve replied. "I'll see you all on Monday morning."

WHEN 'DIBS' HAD A RESERVED SPOT IN COURT

Chicagoans are familiar with "dibs," the tradition of shoveling out a parking space after a snowstorm and then putting furniture or other items there to reserve it. In 2008, Oscar Flores made a federal case out of it.

Flores shoveled out a spot near his home in the Hermosa neighborhood. His wife put a chair there and drove away. A neighbor moved the chair and parked in the space, triggering a confrontation with Flores. The neighbor called 911 and the police showed up. They told Flores he couldn't reserve a spot that way, and a struggle—involving pepper spray—erupted. Flores was arrested.

He sued two officers and the city, alleging false arrest and excessive force. District Judge Edmond Chang declined to rule on the legality of "dibs," though he noted the "Lockean view of the right to the fruits of one's labor." Chang did rule on the main issue, saying police committed a warrantless entry into Flores' home. The case was settled for $20,500 plus attorney's fees.

PHOTO BY EDWARD DELUGA

TAINTED WATER ON A TIGHT BUDGET

A shameful breach of the public trust occurred over two decades in the south suburb of Crestwood when town officials concealed their use of a tainted well for drinking water to avoid having to pay for repairs to water mains.

The well contained two cancer-causing compounds and was blamed for higher-than-normal cancer rates in the village of 11,000.

In 2013, a federal jury convicted Theresa Neubauer, Crestwood's former water department supervisor. District Judge Joan Gottschall sentenced Neubauer to two years' probation.

Neubauer deflected blame, saying, "I was on the bottom of the food chain, just there to do my job. But I'm the only one standing here today answering for these charges while everybody else is off enjoying their life."

Former Mayor Chester Stranczek, described as Public Official A in court documents, was widely suspected to be a primary instigator of the scheme. But experts hired by Stranczek's lawyers stated that he was unfit to stand trial because of dementia caused by Parkinson's disease, so he was not charged.

Oddly, the supermarket tabloid *National Enquirer* once wrote about Stranczek's tight-budget policies and called Crestwood the "best-run town in America."

A TAX CHEAT STUFFED WITH GUILT

Ty Warner's Beanie Babies were simply a brand of stuffed toys, but for a brief time they were a huge consumer sensation, with people putting irrational values on them because of demand. Warner became a billionaire, but in 2013 he pleaded guilty to evading taxes on millions of dollars stashed in Swiss bank accounts.

He told District Judge Charles Kocoras: "When I signed those returns, I knew those moneys were missing. It was not accurate. I apologize for my conduct. It's a terrible way to meet you."

To the dismay of prosecutors, Warner avoiding prison, getting two years' probation.

In 2013, the Chicago Board of Education voted to close about fifty schools, the vast majority in minority neighborhoods. That triggered an uproar in a city known for racial disparities.

The Chicago Teachers Union, headed by Karen Lewis (*upper left photo*), filed two lawsuits on behalf of parents, arguing that African Americans would be unfairly affected and that the district was violating the Americans with Disabilities Act by disrupting the education of special-needs children.

Supporters of the school board argued that Chicago's system of school choice meant that underperforming schools sometimes lost enrollment and warranted closing. Critics saw the closings as undermining Chicago's minority neighborhoods.

The cases went to District Judge John Lee. He promptly denied class-action status, saying the plaintiffs didn't demonstrate that black and disabled students would suffer "a common class-wide injury."

Then he took testimony. University of Illinois education expert Pauline Lipman cited research on the impact of switching schools. "Mobility is harmful to students," she said.

A gang expert testified that the school closings would put some students in danger by forcing them to cross gang lines to get to their new schools. But a school district safety official gave assurances that measures had been taken to protect kids, including the Safe Passages program in which community workers watched over students walking to school.

Lee cleared the way for the school closings by dismissing both lawsuits. In a separate case, District Judge Gary Feinerman denied an injunction to block the closing of Trumbull School, which had a large special-needs enrollment.

In Cook County Circuit Court, the teachers union sued to keep ten schools open, citing the view of hearing officers that state law had not been followed. The court rejected that argument, saying the hearing officers' conclusions were not binding.

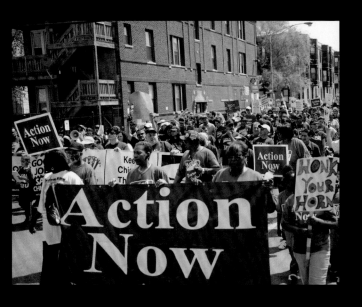
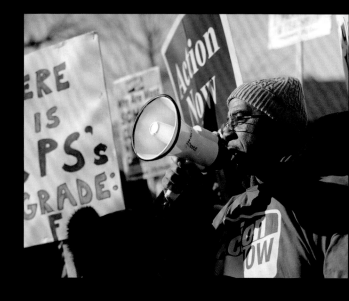
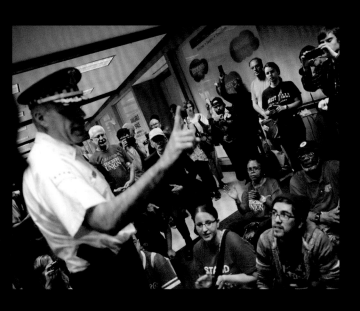

Filmmaker George Lucas wanted to create a museum to house his impressive collection of narrative art—not just items from his *Star Wars* movie series, but also Norman Rockwell paintings and book illustrations by N.C. Wyeth.

First, Lucas negotiated with San Francisco, but city officials couldn't agree on a location. Then he tried Chicago, where an enthusiastic Mayor Rahm Emanuel offered a high-profile site on the lakefront between Soldier Field and McCormick Place. But Friends of the Parks, a park advocacy group, objected, contending that a museum there was a violation of Chicago's ideal that the lakefront should be "forever open, clear and free." The group filed a federal lawsuit, arguing that the site would benefit a private party more than the public, thus breaching the state's public trust doctrine.

Meanwhile, Chinese architect Ma Yansong's designs for the building left some people cold. *Chicago Tribune* architecture critic Blair Kamin compared the proposed building to one of Lucas' characters—the fat, toad-like Jabba the Hutt.

In 2016, when District Judge John Darrah denied a motion to dismiss the suit, Lucas and Emanuel realized they had a protracted fight on their hands. The city, citing impatience on Lucas' part, asked the Seventh Circuit to dismiss the suit on an emergency basis even before Darrah had a chance to rule on it.

When that tactic didn't get immediate results, Lucas pulled the plug.

"No one benefits from continuing their seemingly unending litigation to protect a parking lot," Lucas said, a reference to the fact that the proposed site was being used for Soldier Field parking.

Emanuel bemoaned the loss of a "once-in-a-generation opportunity."

And Los Angeles celebrated Lucas' decision to build his museum there.

APPALLING CRIMES BY A FORMER SPEAKER

Dennis Hastert is among the highest-ranking U.S. officials convicted of a felony. He had retired as Speaker of the U.S. House, second in line to the presidency, when crimes from his distant past came to light in 2015.

Hastert, a former wrestling coach in Yorkville, west of Chicago, sexually abused boys there in the 1960s and '70s. A victim contacted Hastert in recent years and demanded financial compensation for the abuse. Hastert came to federal attention when he structured bank withdrawals to avoid detection—a felony. FBI agents said that during questioning, Hastert lied— also a felony.

No charges of sexual abuse were filed because the statute of limitations had run out.

Hastert agreed to plead guilty to the banking charge, and District Judge Thomas Durkin sentenced him to fifteen months in prison.

"Nothing is more stunning than having 'serial child molester' and 'speaker of the House' in the same sentence," Durkin said.

Illinois made gay marriage legal in November 2013, with the effective date of June 1, 2014. But two Chicago federal judges decided that couples didn't need to wait that long.

First, District Judge Thomas Durkin ruled in favor of Patricia Ewert and Vernita Gray, who had sued for the right to marry

immediately because Gray suffered from terminal cancer. "The judge was an amazing human being who understands our struggle," said Ewert.

In February, District Judge Sharon Coleman issued a wider ruling that allowed marriage equality in Cook County right away. That set off a rush of

couples to the Cook County clerk's office, among them the pair shown here, Charlie Gurlon and David Wilk, who were first in line after Coleman's ruling.

Saying it was pointless to deny gay couples' right to marry any longer, Coleman cited Martin Luther King Jr.'s quote that "the time is always ripe to do right."

BE CAREFUL WHEN YOU CONGRATULATE MICHAEL JORDAN

When Chicago Bulls star Michael Jordan made the Basketball Hall of Fame in 2009, two grocery chains took out ads congratulating him. Or, from Jordan's point of view, used his fame for free promotion. He sued.

The lawsuits went to separate judges, neither of whom seemed sympathetic to Jordan. District Judge Gary Feinerman ruled that Jewel's ad was protected "noncommercial speech." But the Seventh Circuit disagreed, ordering that the case proceed.

District Judge Milton Shadur ruled that Dominick's was at fault for its ad, but he said Jordan was "greedy" to seek millions of dollars. Jordan's lawyers asked that Shadur be pulled from the case, and Shadur stepped aside in favor of District Judge John Robert Blakey. A jury awarded the basketball star $8.9 million. Afterward, Jordan thanked two jurors and posed for a photo with them.

Before Jewel's case went to trial or the Dominick's award could be appealed, Jordan reached an undisclosed settlement with both. A Jordan spokesperson said the net proceeds went to children's charities.

SLAM CHAMP

Gatorade Gatorade Gatorade
Gatorade
Slam-Dunk Championship

PHOTO BY TOM CRUZE

There have been many cases in which artists claimed they created valuable works.

But in a 2016 Chicago case, an artist denied creating a painting.

Peter Doig, whose work can sell for millions, was sued by a former Canadian corrections officer who owned a painting signed by "Pete Doige 76." The corrections officer said he saw Doig paint the desert landscape in a prison near Thunder Bay, Ontario, in the 1970s and bought the artwork for $100. His lawsuit demanded $8 million from artist Doig for denying authorship as well as a court finding that Doig had indeed painted the picture.

Doig's lawyers said the work was by a different man named Peter Edward Doige, now dead. That man's sister testified that her brother had been in that prison and enjoyed painting. Artist Doig's lawyers also offered evidence that their client was not in an Ontario prison at that time.

As the evidence piled up, court observers marveled that the case ever went to trial. After seven days of testimony, District Judge Gary Feinerman ruled: "Peter Doig could not have been the author of this work."

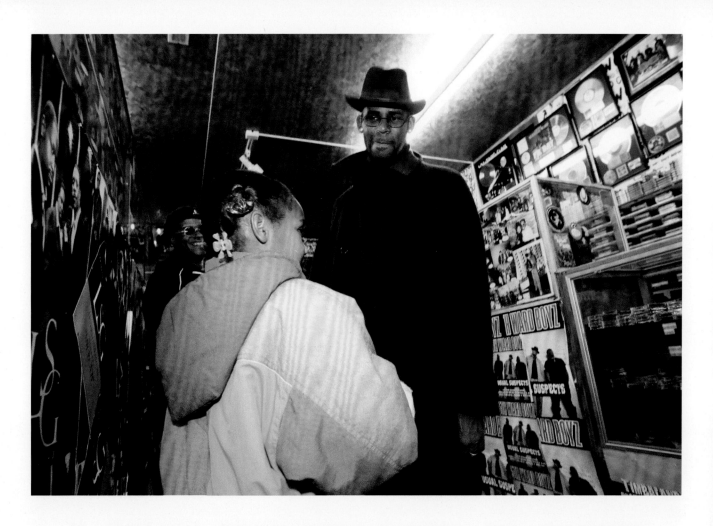

R. KELLY BROUGHT DOWN TO EARTH

R Kelly, the singer known for the hit "I Believe I Can Fly," faced legal battles for more than a decade and won the most serious of them. But allegations of the sexual abuse of children eventually led to major state and federal charges in 2019.

Kelly was linked to a District Court case in 2005. A defendant in Judge Samuel Der-Yeghiayan's courtroom was convicted of trying to extort $20,000 from a gospel singer over videos that he claimed showed Kelly and her

having sex. Kelly was not accused of any crime in that case.

In a 2008 trial in Cook County Circuit Court, prosecutors said a video showed Kelly having sex with an underage girl, but he was acquitted of child pornography.

In February 2019, a month after the airing of the TV documentary *Surviving R. Kelly,* about Kelly's troubling relationship with underage girls, Cook County charged Kelly with aggravated criminal sexual abuse, and it added more

charges three months later.

Then came federal charges in Chicago and New York, including production of child pornography, racketeering, and conspiracy to obstruct justice. The three-time Grammy winner was accused of committing crimes against ten females, eight of whom were minors. He was held without bond. The Chicago federal case was assigned to District Judge Harry Leinenweber, who said he didn't know who Kelly was until recently.

Chicago, a city of immigrants, has seen many federal cases involving the legal status of foreigners.

Shown here are Brazilian asylum seeker Sirley Silveira Paixao and her 10-year-old son Diego Magalhaes after they were reunified in 2018 under an order by District Judge Manish Shah. The two had been separated near the United States' southern border under President Donald Trump's "zero tolerance" policy. In a similar case that same year, District Judge Edmond Chang ordered the reunification of two Brazilian boys with their fathers.

The City of Chicago, under Mayor Rahm Emanuel, sued the U.S. Justice Department in 2017 to push back against Trump's threat to withhold public safety grants if the city did not stop its "sanctuary city" policies, in which it limited cooperation with immigration authorities. District Judge Harry Leinenweber issued a nationwide temporary injunction against withholding the grants, and the Seventh Circuit backed that up. In 2018, Leinenweber made his injunction permanent. Later in the year, the Trump administration issued new restrictions on the grants, and Emanuel's administration sued again.

Other immigration cases:

• In 1938, District Judge Philip Sullivan blocked the deportation of Jewish refugee Sol Weinberg to Czechoslovakia, citing the rise of Nazism in Central Europe.

• In 2006, District Judge Ronald Guzman barred a car wash in the northern suburb of Glenview from asking employees about their immigration status until a pending sexual-harassment lawsuit was resolved. Guzman said the immigration question was "not-so-subtle intimidation."

NO FRIES—CHEEPS

The Billy Goat Tavern is a legendary Chicago institution that drew nationwide fame after a *Saturday Night Live* skit highlighted its Greek-accented owner's limited menu: "No Coke—Pepsi. No fries—cheeps."

But in 2017, the tavern came out against chips, too, at least those produced by an outside operation called the Billy Goat Chip Company. The tavern sued the St. Louis-based firm for trademark infringement and unfair competition. The chip company countersued.

The Billy Goat Tavern was founded in 1934, and first thrust into notoriety when owner Sam Sianis tried to bring his pet goat to the 1945 World Series at Wrigley Field. Both man and beast were turned away, so Sianis placed a curse on the team. A legendary curse. The chip company, founded in 2009, said its name didn't come from the Chicago tavern but from the Billy Goat Hill section of St. Louis.

The tavern noted that it had begun selling Billy Goat beer and frozen hamburgers in supermarkets, and said its customers mistakenly assumed the Billy Goat chips were affiliated with the bar. Attorneys for the chip company argued that the confusion must not have been too serious since the tavern owners waited years to sue.

The parties reached an undisclosed settlement in 2019.

THE HEARING WITH NINE JUDGES

The hearing seemed more like a Supreme Court session than a routine case in the Northern District of Illinois. Why? Because nine judges sat together in the Dirksen Federal Building's large ceremonial courtroom at a hearing that drew a capacity crowd.

So many judges assembled in late 2017 because the hearing involved a dozen cases with scores of defendants. The U.S. Bureau of Alcohol, Tobacco, Firearms and Explosives had set up stings in which undercover agents offered unwitting targets an easy chance to score big by stealing narcotics from illegal drug "stash houses." When they showed up for the purported robberies, they were arrested.

Some of the targets had only minor criminal records. A majority were African Americans, a fact that raised questions about racial discrimination. In the cases before the nine judges, attorneys sought the dismissal of charges against 43 defendants—but the implications were far wider

in the nationally watched hearing.

Chief District Judge Rubén Castillo ended up ruling that the stings were troubling but not illegal. Castillo, who years earlier had ordered prosecutors to turn over information on the racial makeup of stash house targets, "reluctantly" declined to dismiss charges against defendants in his cases because discrimination

was not proven. But he also called on the ATF to end such stings and urged prosecutors to resolve their cases quickly and fairly.

The district judges involved, in addition to Castillo, were Edmond Chang, Sharon Coleman, Thomas Durkin, Sara Ellis, Gary Feinerman, Robert Gettleman, Harry Leinenweber, and Amy St. Eve.

PHOTO BY DUSTIN PARK

NO BONGS IN MATH CLASS

The medical marijuana issue reached federal court in Chicago in 2018 when the parents of 11-year-old Ashley Surin sued to force her school in the northwest suburb of Hanover Park to let her use marijuana there. The sixth-grader took the drug to ease seizures that were a side effect of her treatment for leukemia.

A state law banned marijuana from school grounds. Ashley's parents went to District Judge John Blakey's courtroom seeking relief. Blakey told the family he could not order an exception without a legal basis. But in the end, no ruling was necessary because the Illinois attorney general's office and the school district agreed to overlook the law in this one case. They said the issue should be addressed by state lawmakers.

"This is not a drug, it's a medicine," said Ashley's mother, Maureen. "The law needs to catch up with reality."

Ashley took marijuana through a patch on her foot, and also rubbed an oil extract on her wrists. "No one's saying she wants to fire up a bong in math class," said Blakey.

THE TREASURE THAT WAS EBONY

EBONY

JOHNSON PUBLICATION

'I WAS A SPY FOR THE FBI'
—Mrs. Julia C. Brown—

'TO ELIOT, WITH LOVE'
Italian woman makes pilgrimage
to honor memory of coach

SPECIAL REPORT
ON INAUGURATION

MARCH 1961 35c

EBONY

JOHNSON PUBLICATION

SPECIAL FEATURE
Colorful Men's Wear
For Spring and Summer

HOW TO TELL WHEN
YOU'RE IN LOVE
LOST GOLD MINES
FAREWELL TO
'SWEET DADDY' GRACE

'WHY WE
ADOPTED KELLY'
By Nat King Cole

APRIL 1960 35c

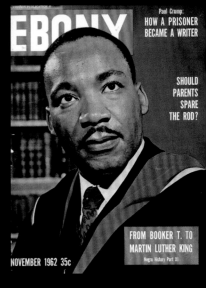

EBONY

JOHNSON PUBLICATION

Paul Crump:
HOW A PRISONER
BECAME A WRITER

SHOULD
PARENTS
SPARE
THE ROD?

FROM BOOKER T. TO
MARTIN LUTHER KING
Negro History Part XI

NOVEMBER 1962 35c

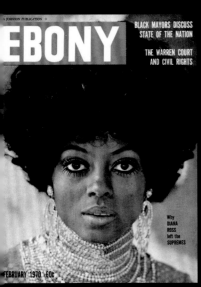

EBONY

JOHNSON PUBLICATION

BLACK MAYORS DISCUSS
STATE OF THE NATION

THE WARREN COURT
AND CIVIL RIGHTS

Why
DIANA
ROSS
left the
SUPREMES

FEBRUARY 1970 60c

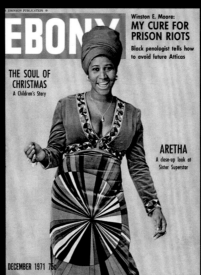

EBONY

JOHNSON PUBLICATION

Winston E. Moore:
MY CURE FOR
PRISON RIOTS
Black penologist tells how
to avoid future Atticas

THE SOUL OF
CHRISTMAS
A Children's Story

ARETHA
A close-up look at
Sister Superstar

DECEMBER 1971 75c

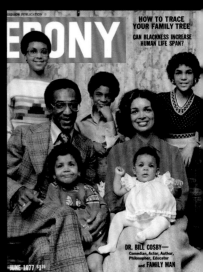

EBONY

JOHNSON PUBLICATION

HOW TO TRACE
YOUR FAMILY TREE

CAN BLACKNESS INCREASE
HUMAN LIFE SPAN?

DR. BILL COSBY—
Comedian, Actor, Author,
Philosopher, Educator
and FAMILY MAN

JUNE 1977 $1.25

EBONY

SEPTEMBER 1996 USA $2.25/CANADA $3.25

'Living My Wildest Dream'

TINA
TURNER

On Her Younger
Beau, Why She
Loves Europe And
Why She Didn't
Appreciate Her
Legs Until She
Was 40

What's
Behind The
Burning Of
Black
Churches

HARRY
BELAFONTE:
The Legend
Roars Back
With New Movie
And Old Fire

10 Best Places
To Meet A Man
Or A Woman

A JOHNSON PUBLICATION

EBONY

AUGUST 1996 USA $2.25/CANADA $3.25

THE NEW RACISM:
No Black Is Too
Rich Or Too
Famous
To Escape It

Will
Smith

On His Hot
Movie Career,
His Divorce,
His New Lady
Love And
The End Of
'The Fresh
Prince'

SUPER SINGLES:
Successful Sisters
Looking For
Brothers Who Can
Deal With It

A JOHNSON PUBLICATION

EBONY

AUGUST 2000 USA $2.50/CANADA $3.75

HALLE
BERRY
ON HER PUBLIC
TROUBLES, PRIVATE
JOYS & SUDDEN
DESIRE FOR
A BABY

THE CASE FOR
REPARATIONS
WHY?
HOW
MUCH?
WHEN?

SISQO
UNCENSORED

How To
Make Your
DREAMS
COME
TRUE

Monica
ON GROWING
UP & THE
PREGNANCY
RUMORS

A JOHNSON PUBLICATION
www.ebony.com

The U.S. Bankruptcy Court for the Northern District of Illinois helped save a cultural treasure—the photo archive of *Ebony* and *Jet* magazines—in 2019.

Federal district courts have jurisdiction over bankruptcy cases, but they refer almost all cases to bankruptcy courts, which serve as specialized units.

Chicago-based Johnson Publishing created *Ebony, Jet,* and other magazines. The company filed for bankruptcy in early 2019. The bankruptcy court authorized an auction of the archive, which contains four million prints and negatives that document African American life starting in the early 1940s. The archive was purchased for $30 million by four major foundations, which immediately donated it to the Smithsonian's National Museum of African American History and Culture and the Getty Research Institute so it would be publicly available.

The bankruptcy court has handled other major filings over the past two decades, including the 157-mile Indiana Toll Road; Caesars Entertainment Corporation, owner of Las Vegas' Caesars Palace and casinos; Kmart; and United Airlines.

HER PICTURES
LIVED ON

To call Vivian Maier a "nanny photographer" is accurate, but it doesn't come close to describing this artist whose improbable story caused a sensation in the 2010s.

Maier's job was caring for children in affluent families, mostly in Chicago's North Shore suburbs. Her hobby was taking photographs that showed an amazing command of detail and composition. Yet her work was almost lost to the world.

Maier died in obscurity in 2009, two years after her prints and negatives were auctioned off because she missed payments on a storage space. The collectors who acquired the images posted pictures online. That brought international acclaim—and disputes.

Just because the collectors owned the photos didn't mean they held the copyright, so they hunted for Maier's relatives. Two Chicago-area collectors, John Maloof and Jeffrey Goldstein, located Maier's first cousin once removed in France and signed a $5,000 rights deal. A Virginia lawyer interested in Maier said he tracked down a different cousin.

That's when the Cook County public administrator stepped in, claiming rights for any relatives and putting a damper on distribution of the Maier photos. Goldstein ultimately settled, with the help of a magistrate judge. The district's fourteen magistrate judges conduct settlement conferences for civil cases, supervise civil discovery, conduct the initial appearances of criminal defendants when they are arrested, set or deny bond, and sign search and arrest warrants.

The mural of Maier shown here was produced by Brazilian artist Eduardo Kobra on Chicago's North Avenue—a reminder of the enduring power of images.

JUDGES OF THE UNITED STATES DISTRICT COURT

Nathaniel Pope (1819-1850)
Thomas Drummond (1850-1869)
Henry Blodgett (1870-1892)
Peter Grosscup (1892-1899)

Christian Kohlsaat (1899-1905)
Solomon Bethea (1905-1909)
Kenesaw Mountain Landis (1905-1922)
George Carpenter (1910-1933)

James H. Wilkerson (1922-1948)
Adam Cliffe (1922-1928)
Charles Woodward (1929-1942)
John Peter Barnes (1931-1958)

George E.Q. Johnson (1932-1933)
William Holly (1933-1958)
Philip Sullivan (1933-1960)
Michael Igoe (1938-1967)

William Campbell (1940-1988)
Water LaBuy (1944-1967)
Elwyn Shaw (1944-1950)
Joseph Sam Perry (1951-1984)

Winfred Knoch (1953-1958)
Julius Hoffman (1953-1983)
Julius Miner (1958-1963)
Edwin Robson (1958-1986)

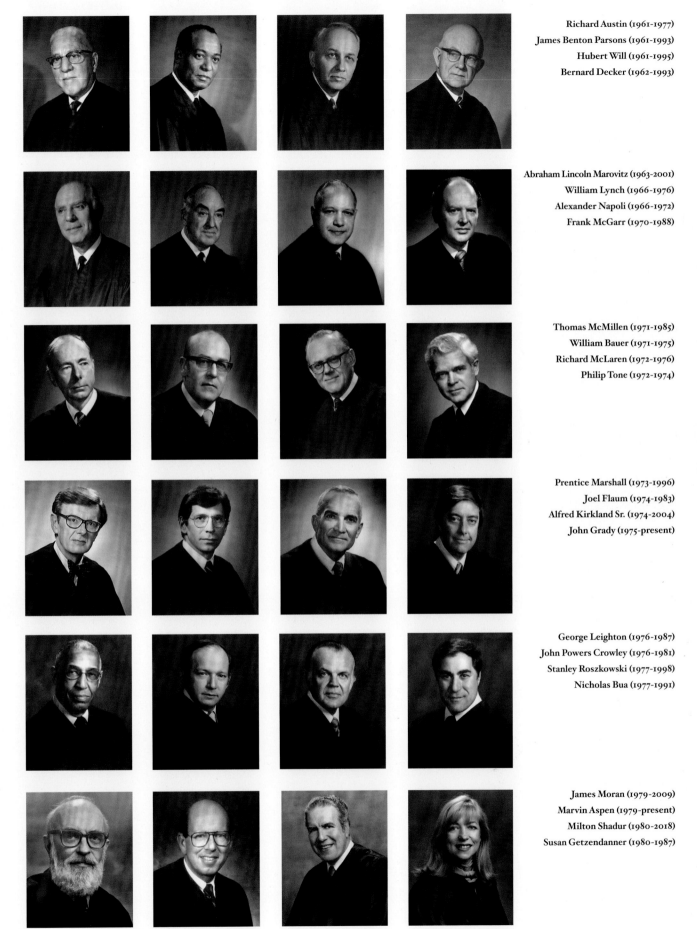

Richard Austin (1961-1977)
James Benton Parsons (1961-1993)
Hubert Will (1961-1995)
Bernard Decker (1962-1993)

Abraham Lincoln Marovitz (1963-2001)
William Lynch (1966-1976)
Alexander Napoli (1966-1972)
Frank McGarr (1970-1988)

Thomas McMillen (1971-1985)
William Bauer (1971-1975)
Richard McLaren (1972-1976)
Philip Tone (1972-1974)

Prentice Marshall (1973-1996)
Joel Flaum (1974-1983)
Alfred Kirkland Sr. (1974-2004)
John Grady (1975-present)

George Leighton (1976-1987)
John Powers Crowley (1976-1981)
Stanley Roszkowski (1977-1998)
Nicholas Bua (1977-1991)

James Moran (1979-2009)
Marvin Aspen (1979-present)
Milton Shadur (1980-2018)
Susan Getzendanner (1980-1987)

Charles Kocoras (1980-present)
William Hart (1982-present)
John Nordberg (1982-present)
Paul Plunkett (1982-2018)

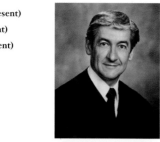 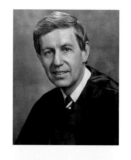 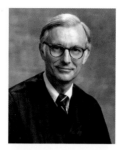

Ilana Rovner (1984-1992)
Charles Norgle (1984-present)
Ann Claire Williams (1985-1999)
James Holderman (1985-2015)

Brian Duff (1985-2016)
Harry Leinenweber (1985-present)
James Zagel (1987-present)
James Alesia (1987-2003)

Suzanne Conlon (1988-present)
George Marovich (1988-present)
George Lindberg (1989-2019)
Wayne Andersen (1991-2010)

Philip Reinhard (1992-present)
Rubén Castillo (1994-present)
Blanche Manning (1994-present)
David Coar (1994-2010)

Elaine Bucklo (1994-present)
Robert Gettleman (1994-present)
Joan Gottschall (1996-present)
Rebecca Pallmeyer (1998-present)

Matthew Kennelly (1999-present)
William Hibbler (1999-2012)
Ronald Guzman (1999-present)
Joan Lefkow (2000-present)

John Darrah (2000-2017)
Amy St. Eve (2002-2018)
Samuel Der-Yeghiayan (2003-2018)
Mark Filip (2004-2008)

Virginia Kendall (2006-present)
Frederick Kapala (2007-present)
Robert Dow Jr. (2007-present)
Gary Feinerman (2010-present)

Sharon Johnson Coleman
(2010-present)
Edmond Chang (2010-present)
John Lee (2012-present)
John Tharp (2012-present)

Thomas Durkin (2012-present)
Sara Ellis (2013-present)
Andrea Wood (2013-present)
Manish Shah (2014-present)

Jorge Alonso (2014-present)
John Blakey (2014-present)

To be installed:
Mary Rowland (2019-present)
Martha Pacold (2019-present)

233

CHIEF JUDGES

The head of the District Court was called
"senior judge" until 1948.

JUDGE	TENURE	JUDGE	TENURE
Solomon Bethea	1905-1909	James Benton Parsons	1975-1981
Kenesaw Mountain Landis	1909-1922	Frank McGarr	1981-1986
George Carpenter	1922-1933	John Grady	1986-1990
James H. Wilkerson	1933-1940	James Moran	1990-1995
Charles Woodward	1941-1942	Marvin Aspen	1995-2002
John Peter Barns	1942-1957	Charles Kocoras	2002-2006
Philip Sullivan	1957-1959	James Holderman	2006-2013
William J. Campbell	1959-1970	Rubén Castillo	2013-2019
Edwin Robson	1970-1975	Rebecca R. Pallmeyer	2019-present

MAGISTRATE JUDGES

The Federal Magistrates Act of 1968 created
the judicial post as it is known today. The title
was changed from magistrate to magistrate
judge in 1990. Prior to the act, commissioners
held a similar but more limited position.

JUDGE	TENURE	JUDGE	TENURE
James T. Balog	1967-1990	Nan R. Nolan	1998-2012
Robert J. French	1968-1976	Sidney I. Schenkier	1998-present
Steven F. Helfer	1968-1970	Geraldine Soat Brown	2000-2016
Olga Jurco	1971-1985	Michael T. Mason	2001-2019
Carl Sussman	1971-1984	Jeffrey Cole	2005-present
P. Michael Mahoney	1976-2014	Maria Valdez	2005-present
John W. Cooley	1979-1981	Susan E. Cox	2007-present
Joan Humphrey Lefkow	1982-1997	Sheila M. Finnegan	2010-present
Joan Gottschall	1984-1996	Jeffrey T. Gilbert	2010-present
Bernard Weisberg	1985-1994	Young B. Kim	2010-present
Elaine Bucklo	1985-1994	Mary Rowland	2012-present
Edward A. Bobrick	1990-2004	Daniel G. Martin	2012-2018
Ronald Guzman	1990-1999	Iain D. Johnston	2013-present
Rebecca R. Pallmeyer	1991-1998	M. David Weisman	2016-present
Arlander Keys	1995-2014	Sunil R. Harjani	2019-present
Martin C. Ashman	1995-2012	Jeffrey I. Cummings	2019-present
Morton Denlow	1996-2012	Lisa A. Jensen	2019-present
Ian H. Levin	1997-2006	Gabriel A. Fuentes	2019-present

CLERKS OF THE COURT

CLERK	TENURE	CLERK	TENURE
James F. Owing	1843-1844	Henry W. Freeman	1935-1938
William Pope	?-1855	Hoyt King	1939-1942
William H. Bradley	1855-1892	Roy H. Johnson	1942-1962
Sherburne W. Burnham	1892-1895	Elbert A. Wagner Jr.	1962-1970
Thomas C. McMillan	1895-1919	H. Stuart Cunningham	1970-1997
John H.R. Jamar	1919-1925	Michael W. Dobbins	1997-2011
Charles M. Bates	1925-1935	Thomas G. Bruton	2012-present

U.S. ATTORNEYS

ATTORNEY	TENURE	ATTORNEY	TENURE
Thomas A. Hoyne	1855-1857	Michael Igoe	1935-1938
A.M. Herrington	1857-1858	William Campbell	1938-1940
Henry S. Fitch	1858-1861	J. Albert Woll	1940-1947
Edwin C. Larned	1861-1863	Otto Kerner Jr.	1947-1954
Stephen A. Goodwin	1863-1864	Irwin N. Cohen	1954
Edwin C. Larned	1864-1865	Robert Tieken	1954-1961
Perkins Bass	1865-1869	James P. O'Brien	1961-1963
Joseph O. Glover	1869	Frank E. McDonald	1963-1964
Mark Bangs	1875-1879	Edward Hanrahan	1964-1968
Joseph B. Seake	1879-1884	Thomas Foran	1968-1970
Richard S. Tuthill	1884-1886	William Bauer	1970-1971
William G. Ewing	1886-1890	James R. Thompson	1971-1975
Thomas E. Milchrist	1891-1893	Samuel K. Skinner	1975-1977
Sherwood Dixon	1893-1894	Thomas P. Sullivan	1977-1981
John C. Black	1894-1899	Dan K. Webb	1981-1985
Solomon Bethea	1899-1905	Anton R. Valukas	1985-1989
Charles B. Morrison	1905-1906	Fred Foreman	1990-1993
Edward W. Sims	1906-1911	James Burns	1993-1997
James H. Wilkerson	1911-1914	Scott R. Lassar	1997-2001
Charles F. Clyne	1914-1922	Patrick J. Fitzgerald	2001-2012
Edwin Olson	1922-1927	Zachary T. Fardon	2013-2017
George E.Q. Johnson	1927-1931	John R. Lausch, Jr.	2017-present
Dwight Green	1931-1935		

U.S. MARSHALS

MARSHAL	APPOINTED	MARSHAL	APPOINTED
Robert Lemmon	1819	John J. Bradley	1914
Henry Conner	1820	Robert R. Levy	1921
Charles Slade	1829	Palmer E. Anderson	1925
Harry Wilson	1833	Henry Laubenheimer	1928
William Prentiss	1841	William H. McDonnell	1934
Thomas M. Hope	1844	Joseph E. Tobin	1946
Stinson H. Anderson	1845	Thomas P. O'Donovan	1946
Benjamin Bond	1850	William W. Kipp Sr.	1953
Harry Wilton	1853	Joseph N. Tierney	1961
Iram Nye	1856	John C. Meiszner	1968
James W. Davidson	1857	John J. Twomey	1973
Charles U. Pine	1858	Frank J. Roddy	1976
Thomas Hoyne	1860	Harvey N. Johnson Jr.	1977
Joseph Russell Jones	1861	John J. Adams	1978
Benjamin H. Campbell	1869	Peter J. Wilkes	1979
Jesse Hildrup	1877	John J. Adams	1986
Alfred M. Jones	1881	Marvin Lutes	1991
Frederick H. Marsh	1885	Joseph DiLeonardi	1994
Frank Hitchcock	1889	James L. Whigham	2000
John W. Arnold	1894	Kim Widup	2002
John C. Ames	1897	Darryl McPherson	2010
Lyman T. Hoy	1906	Edward Gilmore	2015

SELECTED BIBLIOGRAPHY

A major source of information for this book came from the National Archives at Chicago, the keeper of District Court papers. The authors also made use of the *Encyclopedia of Chicago, the Chicago Tribune,* and *Chicago Sun-Times* as sources for the text of this book. Here are some of the most helpful books and articles we consulted.

"3 Sentenced in Price-Fixing Plot at Archer Daniels." *Bloomberg News,* July 10, 1999

Ahmed, Noreen S. "Bean's Gleam Has Creator Beaming." *Chicago Tribune,* May 16, 2006.

Arndt, Michael. "Amoco Cadiz Is Mostly Financial." *Chicago Tribune,* Aug. 2, 1987.

Austen, Ben. *High-Risers: Cabrini-Green and the Fate of American Public Housing.* New York: HarperCollins, 2018.

Ballesteros, Carlos. "Judge Orders 10-Year-Old Brazilian Boy Released to Mom in Immigration Case." *Chicago Sun-Times,* July 5, 2018.

Beam, Alex. *American Crucifixion: The Murder of Joseph Smith and the Fate of the Mormon Church.* New York: PublicAffairs, 2015.

Bear, Marjorie Warvelle. *A Mile Square of Chicago.* Oak Brook, Ill.: TIPRAC, 2007.

Beauchamp, Christopher. *Invented by Law.* Cambridge, Mass.: Harvard University Press, 2015.

Berkowitz, Steve. "Judge OKs $75M Class Action Concussions Settlement Against NCAA." *USA Today,* July 14, 2016.

Bibb, Elizabeth. "Apple Wins Copyright Fight." *PC Magazine,* Feb. 21, 1984.

Bowean, Lolly. "Judge's Order Lets Same-Sex Couple Wed Early." *Chicago Tribune,* November 26, 2013.

Bowley, Graham, and Lori Rotenberk. "Artist Peter Doig Wins a Case Involving a Painting's Attribution." *The New York Times,* August 23, 2016.

Brandt, Nat. *Chicago Death Trap: The Iroquois Theatre Fire of 1903.* Carbondale, Ill.: Southern Illinois University Press, 2003.

Briscoe, Tony. "'Carp Cowboys' Round Up Invasive Asian Carp as Illinois, Federal Officials Debate Costly Measures to Protect Lake Michigan." *Chicago Tribune,* December 6, 2018.

Burns, Greg. "ADM Mole: 'I Did the Right Thing.'" *Chicago Tribune,* November 14, 1999.

Cahan, Richard. "A Terrorist's Tale." *Chicago* magazine, February 2002.

Cahan, Richard. *A Court That Shaped America: Chicago's Federal District Court From Abe Lincoln to Abbie Hoffman.* Evanston, Ill.: Northwestern University Press, 2002.

"The Chicago Custom-House Building Fraud," *Chicago Tribune,* May 24, 1878.

"Chicago Loses Bid to Censor Movie," United Press International, *Deseret News,* July 9, 1959.

Coen, Jeff. "Another Mob Boss Imprisoned for Life." *Chicago Tribune,* February 3, 2009.

Crawford, William B., Jr. "$5 Million Awarded in Jacobson Libel." *Chicago Tribune,* December 6, 1985.

Crawford, William B., Jr., and Mitchell Locin. "Ex-Gov. Walker Admits Bank Fraud." *Chicago Tribune,* August 6, 1987.

Cullen, Frank; Florence Hackman, Donald McNeilly. *Vaudeville Old & New: An Encyclopedia of Variety Performances in America.* New York, London: Routledge, Taylor & Francis, 2007.

Currah, Paisley, and Shannon Minter. "Unprincipled Exclusions: The Struggle to Achieve Judicial and Legislative Equality for Transgender People," in *Regulating Sex: The Politics of Intimacy and Identity*, edited by Elizabeth Bernstein and Laurie Schaffner. New York: Routledge, 2005.

Davey, Monica, and Julie Bosman, Mitch Smith. "Dennis Hastert Sentenced to 15 Months, and Apologizes for Sex Abuse." *The New York Times,* April 27, 2016.

Dizikes, Cynthia. "1980s newsmakers: Where are they now?" *Chicago Tribune,* Nov. 23, 2011.

Dubofsky, Melvyn. *We Shall Be All: A History of the Industrial Workers of the World.* Urbana, Ill.: University of Illinois Press, 2000.

Enstad, Robert, and Lee Strobel. "Charges Dropped Against Hanrahan, 20 Others in Raid." *Chicago Tribune,* April 16, 1977.

Ford, William K. "Copy Game for High Score: The First Video Game Lawsuit." John Marshall Law School, 20 J. Intell. Prop. L. 1, 2012.

"Gangster Touhy Set Free." *Chicago Tribune,* August 10, 1954.

Goldstein, Richard. "D'Aquino, Linked to Tokyo Rose Broadcasts, Dies." *The New York Times,* September 27, 2006.

Gordon, John Steele. "The Price of Success," *American Heritage,* May/June 1994, Vol. 45, Issue 3.

Grant, Colin. *Negro With a Hat: The Rise and Fall of Marcus Garvey.* Oxford; New York: Oxford University Press, 2008.

Grossman, Ron. "Krebiozen: The cancer 'cure' that was a fraud." *Chicago Tribune,* September 25, 2018.

Grossman, Ron. "50 Years Ago, Picasso's Sculpture Challenged Chicago's Imagination." *Chicago Tribune,* August 6, 2017.

Hake, Terrence, with Wayne Klatt. *Operation Greylord: The True Story of an Untrained Undercover Agent and America's Biggest Corruption Bust.* Chicago: American Bar Association, 2015.

Hawthorne, Michael. Ex-Official Guilty in Tainted Water Case." *Chicago Tribune,* April 29, 2013.

Hepp, Rick. "Judge Rules Against Winfrey in Fight Over Photos." *Chicago Tribune,* July 26, 2000.

Hill, Libby. *The Chicago River: A Natural and Unnatural History.* Chicago: Lake Claremont Press, 2000.

Hoffman, U.J. *History of LaSalle County, Illinois.* Chicago: S.J. Clarke Publishing, 1906.

Hood, Joel. "Judge: Leave the Locks Open." *Chicago Tribune,* December 2, 2010.

Ibata, David, "Cubs Bat Around Town Since Opening Day in 1876," *Chicago Tribune,* April 13, 1986.

"Insull Drops Dead in a Paris Station," Associated Press, *Montreal Gazette,* July 18, 1938.

James, George. "Elzire Dionne is Dead at 77; Gave Birth to 5 Identical Girls." *The New York Times,* November 23, 1986.

Jenco, Melissa. "Ex-official gets nearly 20 years." *Chicago Tribune,* February 15, 2013.

"Judge Lets Fathers Into Delivery Room," *Chicago Tribune,* June 2, 1970.

Karwath, Rob. "Gacy a Step Closer to Being Executed." *Chicago Tribune,* Aug. 20, 1992.

Kass, John. "Let's Make a Federal Case Out of Dibs." *Chicago Tribune,* Jan. 9, 2014.

Katznelson, Ira. *Fear Itself: The New Deal and the Origins of Our Time.* New York, London: Liveright Publishing, 2013.

Keilman, John. "Ex-College Football Player Claims Concussions Ruined His Life." *Chicago Tribune,* January 4, 2013.

Kocoras, Charles P. *May It Please the Court.* Chicago: Law Bulletin, 2015.

Kohler, Chris. "Q&A: Pac-Man Creator Reflects on 30 Years of Dot-Eating." Wired, May 21, 2010.

Lief, Michael S.; Ben Bycell, and Mitchell Caldwell. *Ladies and Gentlemen of the Jury: Greatest Closing Arguments.* New York: Scribner, 2014.

"Lifer Convicted of Rape Freed; 'Trial a Sham.'" *Chicago Tribune,* Aug. 11, 1949.

Logan, Robert. "File Suit to Block Pro Football Merger." *Chicago Tribune,* September 10, 1966.

MacDonald, Scott B. *Separating Fools from Their Money: A History of American Financial Scandals.* New Brunswick, N.J.: Transaction Publishers, 2015.

Manchir, Michelle. "No Waiting to Wed: Judge Opens Same-Sex Nuptials to All in Cook County." *Chicago Tribune,* February 22, 2014.

Malti-Douglas, Fedwa. *Partisan Sex: Bodies, Politics, and the Law in the Clinton Era.* New York: P. Lang, 2009.

Martin, James. "The Framing of Tokyo Rose," *Reason,* February, 1976.

McCoppin, Robert. "Sixth-Grader Will Be Allowed to Use Medical Pot in School." *Chicago Tribune,* January 13, 2018.

McGinty, Brian. *Lincoln's Greatest Case: The River, the Bridge, and the Making of America.* New York: Liveright Publishing, 2015.

Meisner, Jason. "Federal Judge Finds ATF Drug Stash House Stings Distasteful but Not Racially Biased." *Chicago Tribune,* March 13, 2018.

Meisner, Jason. "Hacker-for-Hire Pleads Guilty to Shutting Down Company Websites." *Chicago Tribune,* December 19, 2017.

Miller, James P. "Feds Indict Black." *Chicago Tribune,* November 18, 2005.

Myers, Linnet. "Aldermen Say Artist Benefited by Having His Painting Seized." *Chicago Tribune,* October 5, 1990.

Newton, Michael. *The Encyclopedia of Kidnappings.* New York: Facts on File, 2009.

O'Brien, John. "Hefner Blast Clouds Playboy Drug Probe." *Chicago Tribune,* January 19, 1975.

O'Brien, John. "New Details Revealed on '74 Purolator Theft." *Chicago Tribune,* July 9, 1979.

O'Connor, Matt. "Judge Halts Cubs' Shift to NL West." *Chicago Tribune,* July 23, 1992.

O'Connor, Matt, and John O'Brien. "Bloody End for Erickson Saga." *Chicago Tribune,* July 21, 1992.

"Packers Free; Plan End to National Co." *Chicago Tribune,* March 27, 1912.

Pallasch, Abdon M. "Judge Throws Book at Gang Chief Hoover." *Chicago Tribune,* June 19, 1998.

Papajohn, George. "Killer Hoover Tells Why He Should Go Free." *Chicago Tribune,* August 11, 1993.

Pendergast, Tom; and Sara Pendergast. *St. James Encyclopedia of Popular Culture.* Detroit: St. James Press, 2000.

Pietrusza, David. *Judge and Jury: The Life and Times of Judge Kenesaw Mountain Landis.* South Bend, Ind.: Diamond Communications, 1998.

Pitzulo, Carrie. *Bachelors and Bunnies: The Sexual Politics of Playboy.* Chicago: University of Chicago Press, 2011.

Possley, Maurice. "'The Girl Is Mine' Is Michael's," *Chicago Tribune,* Dec. 15, 1984.

Roberts, Sam. "Jon Burge, 70, Ex-Commander in Chicago Police Torture Cases, Dies." *The New York Times,* Sept. 20, 2018.

Rossi, Rosalind. "Sex, Drugs and Rukn Role." *Chicago Sun-Times,* June 10, 1993.

Sawyers, June. "A Fighter to the End Was Old Cap'n Streeter," *Chicago Tribune,* Dec. 18, 1988.

Schmich, Mary. "The Journey of Judge Joan Lefkow." *Chicago Tribune,* November 20, 2005.

Schmidt, Leigh Eric. *Heaven's Bride: The Unprintable Life of Ida C. Craddock, American Mystic, Scholar, Sexologist, Martyr, and Madwoman.* New York: Basic Books, 2010.

Stone, Alan. *Public Service Liberalism: Telecommunications and Transitions in Public Policy.* Princeton, N.J.: Princeton University Press, 2014.

Storch, Randi. *Red Chicago: American Communism at Its Grassroots, 1928-35.* Urbana, Ill.: University of Illinois Press, 2007.

Swanson, Stevenson. "Loyola Ends Controversial Lakefill Plan." *Chicago Tribune,* July 12, 1990.

Sweeney, Annie, and Ryan Haggerty. "Guilty of Terrorism Plot." *Chicago Tribune,* June 10, 2011.

Sweeney, Annie. "Trump, Lawyer Lock Horns at Breach-of-Contract Trial.'" *Chicago Tribune,* May 16, 2013.

"Takes a Large Photograph: George R. Lawrence Uses Twelve Pounds of Flashlight Powder in Board of Trade." *Chicago Tribune,* April 5, 1903.

"Telephone Pioneer Dead," *Telephony,* Vol. 15, No. 4, April 1908.

Trotter, Greg. "Billy Goat Tavern's Suit to Go On." *Chicago Tribune,* August 10, 2018.

"U.S. Appeals Court Overturns $29 Million Fine Imposed on Standard Oil." United Press International, July 22, 1908.

Warren, James, and Paul Galloway. "Quick Death to Victims, Endless Pain to Families." *Chicago Tribune,* May 20, 1984.

Warren, James. "Airline Ends Sex-Bias Suit for $33 Million." *Chicago Tribune,* July 10, 1986.

Wiggins, Robert Peyton. *The Federal League of Base Ball Clubs: The History of an Outlaw Major League, 1914-1925.* Jefferson, N.C.: McFarland & Co., 2009.

Winn, Marcia. "Fame of Quints Is Fleeting to Jury in Big Suit." *Chicago Tribune,* September 28, 1938.

Yerak, Becky, and Jason Meisner. "Ty Warner: 'I am guilty.'" *Chicago Tribune,* October 3, 2013.

Zeiler, Thomas W. *Ambassadors in Pinstripes: The Spalding World Baseball Tour and the Birth of the American Empire.* Washington, D.C.: Selous Foundation Press, 1989.

Other websites consulted include archives. gov, automotivehalloffame.org, bpichicago. com, chicagobusiness.com, DNAInfo.com, fbi.com, law.justia.com, law.mich.edu, loc. gov, iroquoistheater.com, threadsofourgame. com, wikimedia.org, and wikipedia.org.

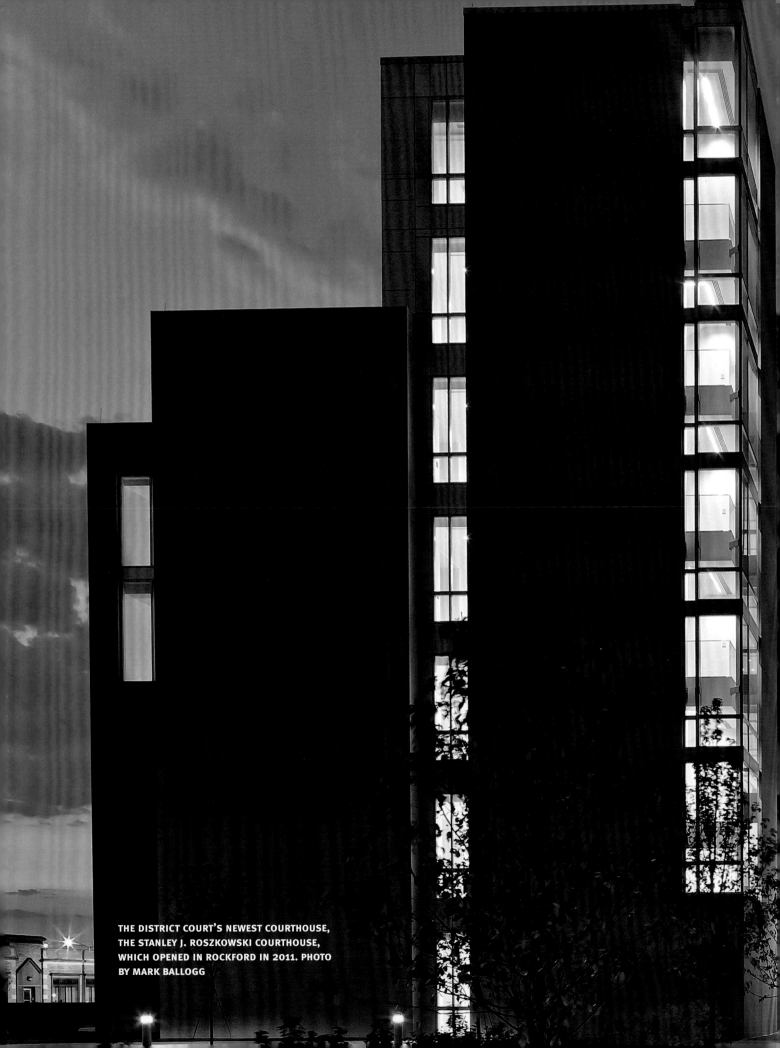

THE DISTRICT COURT'S NEWEST COURTHOUSE,
THE STANLEY J. ROSZKOWSKI COURTHOUSE,
WHICH OPENED IN ROCKFORD IN 2011. PHOTO
BY MARK BALLOGG

PHOTO CREDITS

INDEX